A SURVIVAL GUIDE
FOR BRONZE
SCULPTORS

Walk in beauty
Gabe and Mandy
Gabe Gabel

A SURVIVAL GUIDE FOR **BRONZE** SCULPTORS

GABE GABEL

Copyright © 2008 by Gabe Gabel.

Library of Congress Control Number: 2008903732
ISBN: Hardcover 978-1-4363-3778-6
Softcover 978-1-4363-3777-9

All rights reserved. No part of this book may be reproduced or transmitted in any form or by any means, electronic or mechanical, including photocopying, recording, or by any information storage and retrieval system, without permission in writing from the copyright owner.

This book was printed in the United States of America.

To order additional copies of this book, contact:
Xlibris Corporation
1-888-795-4274
www.Xlibris.com
Orders@Xlibris.com

CONTENTS

INTRODUCTION ... 11

GETTING STARTED WITH YOUR SCULPTURE 13
 Sculpting Materials .. 13
 Armatures and Other Start-up Considerations 18
 Let's Take a Sculpture All the Way Through the Original 24
 Tools and Other Materials ... 32
 Surface Finishing ... 38
 Multiple Sizes, Point-ups, and Enlargements 44
 Bonnie Shields and Jack Horner .. 44
 Sculpture Design and Composition 56
 Castability .. 61
 Making Fountains and Outdoor Sculptures 77
 Patina Thoughts .. 84
 Polychrome .. 92
 Working with the Foundry .. 95

CASTING YOUR SCULPTURE AT THE FOUNDRY 104
 First Steps ... 104
 The Mold ... 105
 The Casting Wax .. 110
 The Ceramic Mold .. 124
 The Pouring Room ... 128
 The Metal Room ... 138
 Patination ... 142
 Caring for Your Bronze .. 146
 Recasts and Other "Bronzes" .. 147

MARKETING YOUR WORK ... 149
 Edition Size .. 151
 Pricing Your Sculpture .. 152

Multiple Sizes and Partial Casts .. 155
Some Ideas About Legal Issues .. 157
Art Galleries .. 159
The Studio Gallery .. 165
Art Shows, Craft Shows, and Exhibitions 170
 Other Show Manners ... 171
 Indoor Craft Shows and Shopping Mall Shows 175
 Invitational Art Shows ... 177
Displays and Booth Requirements ... 182
Handling the Money ... 194
After the Sale ... 198
Self-promotion ... 199
 Get a Computer ... 199
 Mailing Lists, Mailing Lists, Mailing Lists 201
 Offering Precast Bronzes ... 209
 Advertisements ... 213
 Newspaper Releases, Interviews, and Articles 214
 Web Sites ... 216
 Flyers and Other Business Materials 217
 Photograph Albums, Brag Books, and Awards 219
 Your Home Office .. 224

THE ART AND SCIENCE OF SELLING 227
 Respect the Public ... 227
 Show Clothing . . . Your Image 232

OTHER STUFF .. 236
 Resource Collection, References 236
 Schools and Workshops .. 240
 Family Affairs .. 242
 What Is Bronze? ... 246

TWO DEAD SHEEP ... 247

HOW I GOT STARTED SCULPTING .. 250

ARTISTS MENTIONED IN THE BOOK 253

SHOW ORGANIZERS ... 255

FOUNDRIES .. 257

INDEX TO SCULPTURES ... 259

QUICK PHOTO REFERENCE TO CASTING PROCESS 261

INDEX ... 277

DEDICATION

First and always, Dorothy D. Gabel, my mother, who never stopped believing in me, my art, and in wonderful possibilities.

And to all the others who have made my career possible, the artists, the foundry personnel, the art show promoters, the gallery people, and the wonderful buyers and collectors. There are a few who should be named, my daughter, Teanna Lee Kurtz, Joella and Fred Oldfield, Lanny and Carole Wigren, Mike and Pat Gustafson, Don and Gert Walsdorf, my late husband Dennis Lee Day, and my husband Emmette E. Jorden Sr.

I cannot thank you all enough for a wonderful life.

INTRODUCTION

In 1976, I made a decision to open a box I had closed in my early twenties. Artwork was simply a part of my life as I grew up, but the need to prepare for a responsible career, to be practical as it were, meant at that point I needed to put away my "hobby" and get real. Then life gave me a space of time to find out if I could still draw, and a local craft show provided a chance at a way to market whatever I could do. Well, I can't say I sold much, but the doing of it brought the realization that I needed to try, and that I needed to truly commit myself to follow this to the end this time.

The end still isn't in sight over thirty years later.

This will be a book not only about the art and process of bronze sculpture, with a bit about two-dimensional media, but also general marketing and professional standards of a working successful artist. In other words, I have done it, and here is how I did it. Hopefully, I can help you do it too and save you, by my experience, some of the hassle and money it cost me to learn how.

I'm going to write just like I'd talk to you if you were drinking coffee with me in my studio. I'm an artist, not a writer, but I am a successful artist so I do know what I am talking about. I will be the first to admit there are other ways of getting the job done. But this is what I have learned and experienced, and I hope it is helpful. It is time to pass it on and, yeah, maybe make some money selling you this book. You'll pay a lot less than I did for these lessons.

Putting your work out in front of the public, the best of yourself, asking to be judged, is a risky, scary thing to do. You won't believe, until you do it, the things people will say to you, the insults, most of them unintentional (people don't realize what they are actually saying), and the put-downs. And there will be the failures and rejections, the no sales in the shows and galleries you do get in. But no risk, no gain. And you will be at the very least one who has had the guts to try. One other thing I can guarantee, many of the people who say upsetting things are frustrated artists themselves.

And the joys. You make time to create, you work at your art, you interact with your peers in an art world with constant stimulation, and you

grow as an artist. You get compliments and even awe about your work. And you get paid for doing what you love to do. Get real. Awards are wonderful and reaffirmation of your abilities, acceptance to top quality shows makes you feel great, but the bottom line is taking home a pocket full of money from sales so you can pay bills and buy more supplies and pay more show fees and *keep going*! (You can look people straight in the eye when they ask you when you are going to get a *real* job and laugh all the way to the bank.)

Determination, I will be talking about this again. More important than talent. I have seen so many really fine artists over the years disappear, finer artists than I am. It can be a very hard road. "I can't sell." "I can't talk to the public." "I can't do the kind of work that is selling." "I can't, I can't, I can't." Well, yes you can. You can learn how. You can force yourself to do what has to be done if you are determined enough. You can do it ethically, professionally, morally, and legally. But there is more to it than just doing the artwork. These other things are part of the real job of being a professional artist. If you want to succeed, you will learn to do them. They apply whether you are a sculptor, painter, jeweler, potter, whatever your media.

This book will cover what I know about the rest of the job too. You'll need it.

BEFORE I BEGIN

I will be mentioning many times the dangers in working with some of the materials I use in my artwork. I cannot promise to cover all the dangers and problems. The chemistry of art materials will vary from product to product. I just want to make each of you aware that there are concerns, and it is up to you, the artist, to become knowledgeable about them.

I also mention in the course of this book some legal issues. I am not an attorney; I do not know all the laws that may affect you in whatever area you live, and tax laws change constantly. Again, it is up to you, the artist and business person, to learn what you need to know. You must be informed about those, and the rule seems to be that ignorance is no excuse. I must recommend that you seek professional legal advice and have a good professional accountant. Some things are legal in one area and not in another. Nothing in this book is intended to give you legal, tax, or accounting advice.

GETTING STARTED WITH YOUR SCULPTURE

Dear Aunt Gabby,

I am an artist, but I have always wanted to try sculpture. I feel I could really be good at it. How do I learn, what do I do, where do I start?

<div style="text-align: right">Inspired</div>

Dear Inspired,
Keep reading. Aunt Gabby has just what you need.

Sculpting Materials

Thirty odd years ago, when I was handed my first chunk of sculpting wax, I knew absolutely nothing about what to do with it. You may or may not be in that state of ignorance; I suspect that many of you will know quite a bit about what you are doing, you would just like to find out more. I will write this for someone who is in the same position I was in and add thirty years of learning about it. In other words, you get it all. Wade through it. There are the absolute basics, common sense, and quite a bit to keep you out of trouble too.

Bronzes are cast with molds taken from the original sculpture. Since there is a mold to be made, nearly anything can be used to create the original artwork. You can use waxes, clays of all types, blends, wood, metals, fabric, and probably even ivory soap. I have seen all sorts of items added to sculptures, keys, thimbles, rocks. Well, I think you get the idea. I

have also seen molds taken from skulls and plant materials. Years ago, an insect that was to be part of one of my castings was somehow lost when the ceramic mold was removed. The metal artisan offered me a large beetle in bronze that he had stuck in his toolbox. Let's just say the original sculptor of that bug was God. There are wood-carvers who have their creations cast in bronze to have an edition to offer buyers, and also utilize some of the new gorgeous patinas on their sculptures.

Some of the oldest materials were beeswax or various plant-source waxes. Powdered clay, mixed with oils instead of water so that it doesn't lose its pliability by drying out, has also been used for a long time, what we call oil clay. For many years, a by-product of the petroleum-refining industry was cheaply available, some of it was sold as Victory Brown. Many beautiful works have been made of this material, and many artists still use it in spite of some of its difficulties. I started with it, but for me, it was gummy and hard to hold fine detail. It did at one time have the benefit of low cost, but today with the increased demand for sculpting media, it is usually further refined into a more-easily worked material; and yes, it does cost a lot more. It has gone from being a waste product to a salable commodity. (It also smells a lot better these days.)

Most sculptors use a blend of some sort of wax and oil clay. There are many commercial products for sale at art supply houses; many companies offer several types with differing firmness. I recommend trying as many types as you can to find the blend that works best for you. Most companies will make samples available for you to try. I have found that a lot depends on exactly what I am doing on my sculpture; in some places I may choose a very soft blend, in others, hard, even a stove-cured hard clay like Sculpey. (Sculpey makes several types too. You can bake these in a kitchen oven to a permanent hard form.) I know many sculptors who will use this type of clay for delicate parts they want to make certain won't distort as the work progresses, such as hands or faces or figurative equipment. For some of my fountain pieces, I have made the bowls out of a hard-bake clay so that the sides of the bowl remain rigid while I work on the hands holding the item.

There have been some other types of blended materials used for years, like Plastalina and the type of commercial product used in industries such as car and boat design. There were problems with the sulphur content of some; chemicals being absorbed through the sculptor's skin over time proved very much a health hazard. Many of today's compounds are labeled sulphur free or nontoxic. Watch for this for your own safety. More important words about safety and health hazards later.

Every time I open a new art supply catalog, it seems that there are more new products on the market for sculpting media. Better living through chemistry, I guess. Here again, the increase in sculptors has opened the door to more research and development. There are products that I would love to try someday, even those that have nothing to do with sculpting for lost wax casting. I cannot mention all of them; more will be available all the time. Try things. Ask other artists.

To say that one product is best, other than safety issues, is impossible. Artists prefer different materials depending on what is easily available, what they are used to, and the type of sculpting they do. And yes, you can use many different materials in one sculpture, remember.

I use all types, depending on my needs and what I have. After thirty years, I have collected many kinds; and as my originals are molded, I get the usually disassembled sculptures back from the foundry after they have cast several and proved the molds. They go back in the pot to reuse the material.

I blend my own media as I need it. There are two ways I do this. If you are careful, you can melt down wax and clay into a liquid and stir it all together, then pour it out into containers and let it cool. The way I prefer is to soften the pieces in a hot water bath and just knead the different types together. You have to heat it until it is really soft (it is about as hot as you can stand to hold in your hands) and then work it in your hands, somewhat like making a "mud pie." Each type has a little bit different melting point, but you will learn this as you work with them. As I prepare the blended stuff, I do make mud pie patties about a half-inch thick. That size heats up and softens rapidly when I need more in the hot water kettle ready to use.

NOTE: Large blocks of wax or clay or blends are easily broken into usable chunks by freezing them. Here in North Idaho, I can leave them outside for a part of the year; hey, it's cold up here. Or stick the blocks in the freezer overnight, place in a good plastic bag, and hit with a hammer.

Some fine-art foundries do sell various sculpting media, some even blend their own from reclaimed wax (from the burn out of the casting molds). Others will sell you the "raw" reclaimed wax because they don't want to bother with it, and recycling is good, right? Raw reclaimed wax may be full of impurities, bits of ceramic mold, grit, and charcoal, that you may want to remove before using. And it is otherwise pure wax, no part oil clay. It can be carefully melted and the floating garbage skimmed off

and the cleaned wax poured off, leaving the solid debris in the bottom of the melt kettle.

(There is liable to be quite a bit of what can only be called Sludge; I just discard it.) I have carefully poured the cleaned wax into a large bucket partway full of water. The first part of the pour is very interesting. Lots of strange shapes and wax swirls, and you may think of a way to use them. In fact, you may wish to experiment with this technique intentionally someday. It has made me wish I did fantasy pieces; the shapes can be very attractive. As the wax cools completely, it will shrink, and you can remove the disk fairly easily. Or you can pour the wax into other containers, old bread pans, pie plates. But the melting temperature of most waxes is around two hundred degrees. The flash point of wax will vary; *never melt wax* without constant supervision, and I mean I recommend you don't leave the room. When I say constant, I mean constant. If it starts to smoke, pull the plug immediately. Some kettles heat unevenly. If I still had an electric stove, I would melt it in the oven slowly. I have a gas range now, and I don't know the types of oils used in my oil clays. I don't want to take the chance of vapors possibly igniting. Oil clays and waxes are *flammable*! Don't mess around with this stuff.

This is why I use a hot water bath to keep my working media at the proper temperature to use when sculpting. I use an electric roaster oven with an interior pan with the control set at about 102 degrees. Remember what I said about these different materials each having its own properties. You will have to find the best setting for the media you are using. It sure feels good when your hands are stiff or feeling arthritic. Smaller deep fat fryers also work, but slow cookers usually don't have a low enough setting. Yes, I started years ago buying my initial equipment at garage sales and thrift stores. I still look for things there, turntables, possible sculpting tools, and, of course, pans and containers. But now the price of portable roasters has come way down to a third of what it was years ago, and it is safer to use electric appliances that are new.

One comment here, if your wax or wax blend gets too hot to work with your hands, I have found out the best thing to do is to turn it off and let it cool slowly and naturally. Trying to rush it by adding cold water has changed the character of the material for me. It seems to revert to its different types of wax, and the result is unworkable at best and gross at its worst. (I won't describe it, but if it happens to you, you'll recognize what it looks like. A ten-year-old boy would find lots of uses for it, none good.)

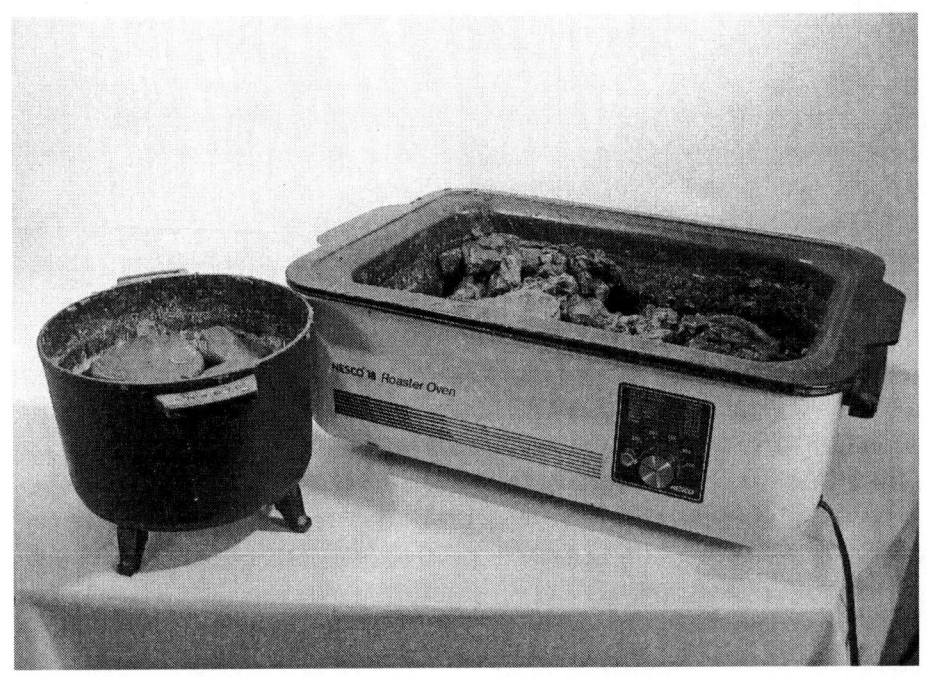

The kettles to keep the wax and clay at temperature. Notice that there isn't any water in these; they would have been too heavy for me to carry in to photograph. Please add water nearly to the top!

Some artists use another method of softening media. Heat lamps are common. I have heard of at least two fires that destroyed studios from using heat lamps. Just a thought. It was suggested that I take an old refrigerator, and with just a constantly on lightbulb inside, I would have soft wax/clay whenever I wanted it. Well, it might work well. I don't know. At this time, I don't need that much sculpting material at one time.

Another method I have seen used is to take one of the metal food drying boxes with the wire trays stacked inside. The heat and the fan keep the trays warm enough. It worked with pure oil clay in my shop where a friend was renting space to do a very large life-sized sculpture. She could keep filling the trays and using the material and had a constant supply. There are wax-warming cabinets also in the market.

There are, I am sure, many other methods. I'll tell you what I know about and what works for me. I have noticed more and more commercial products for sale to meet every need an artist has, and I am certain some of them are wonderful.

Armatures and Other Start-up Considerations

You have to have something to work on and a way to transport your sculpture from place to place. I have found that having a big base plate initially that is larger than the future sculpture is the easiest way to solve some later problems. I have many pieces of scrap fairly thin plywood that I use for this. I have it big enough to either attach handles or screw down to a transport crate. I screw the actual work plate or base to that, usually from the bottom side. Sometimes the work base is about the size of the wood base I will install on the finished casting; sometimes it is actually cast as part of the bronze sculpture.

Lately I have been using some of the inexpensive craft project wood shapes with their routed edges as part of the "lily pad" under my bronze. Lily pad is the ground under your sculpture figure if your composition has one. A common mistake with starting sculptors is to place figures on a larger-than-needed lily pad. I have seen the subject of a sculpture looking like a frog on a lily pad; the amount of ground area is so large. And no, you don't have to have any type of a base for your sculpture. Some of mine are freestanding. But your piece has to be stable; the base is often the anchor. My personal opinion is that no one should usually notice the base; all attention should be on the figure and its movement. That is where the eye should focus.

The routed edge of the base does not add a great deal to the cost of casting. It can add a touch of elegance and also mean you have to spend less on a wood or marble under base to balance the sculpture. It isn't going to work on all types of sculpture, but it does on some.

The next step is to find a way to attach your sculpture firmly to the base plate. There are interior armatures and exterior armatures. You can buy armature rods with sliding arms to support your figure. I imagine they are very effective, but I have never owned or used one. My primary support starts with as small a pipe flange as I can locate. Yep, the hardware store. Or the man who installs gas lines in homes, a personal friend. Most of my career as an artist I have had more hardware stores available than art supply houses, and usually when I need something, I need it now.

I don't want to wait for an order to come in from Loveland, Colorado. (For those of us in the West, Loveland is practically supply central for anything you might need. They have probably more outdoor public sculpture, sculptors, and sources than any other location at this time.)

A Survival Guide for Bronze Sculptors 19

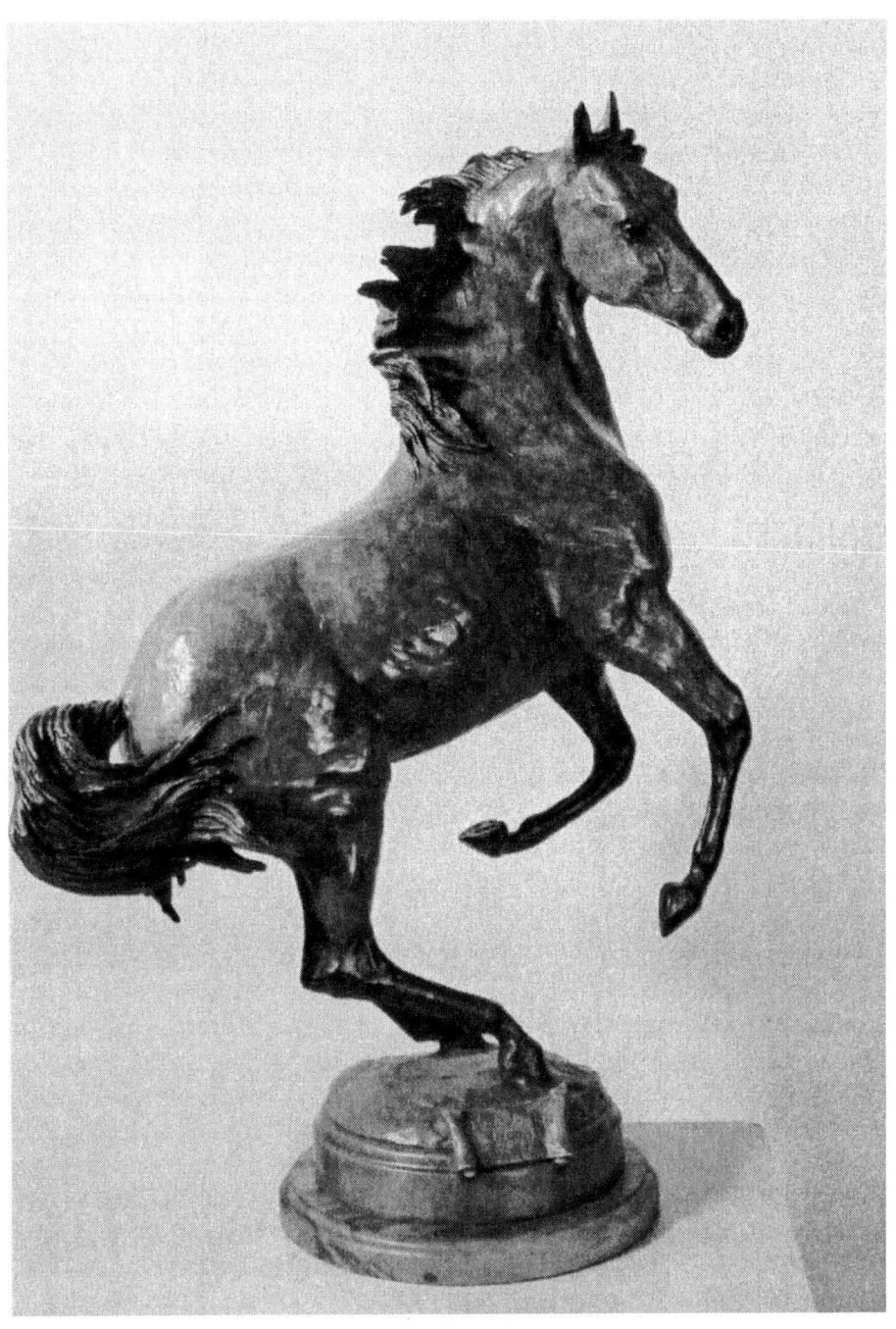

Foundation Blood The main base of this sculpture is actually cast bronze with just a narrow wood under base.

Use quarter inch, three-eighth inch, as small as you can find iron pipe. I have purchased larger flanges and adaptors. In fact, I recommend a whole box of different lengths of pipe, connectors, bends, and Ts. (My foundry is very good about sending them back to me after they have made the molds.) A three-eighth-inch pipe with its flange firmly screwed down to a base will support an awful lot. For a big horse sculpture, I will use two under the body of the horse.

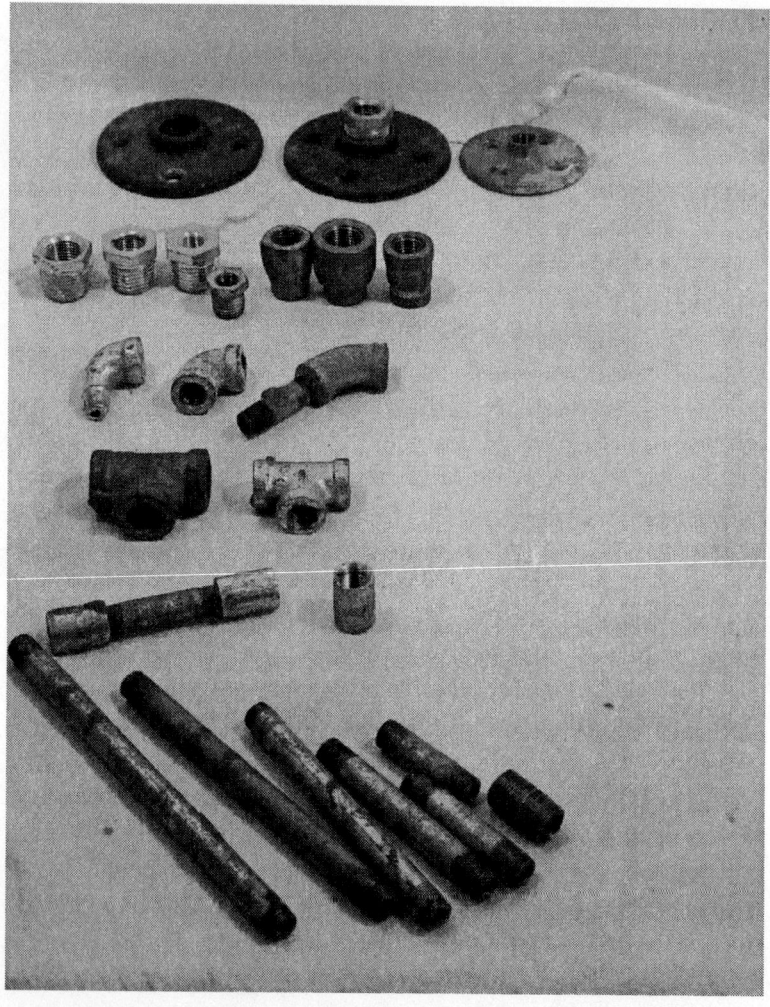

Assorted types of pipes that I use to make the basic under armature. I have many types of adaptors so that if I don't

have the length I need of one kind of pipe, or the right size flange, I can make do. (I often start things rather late at night so going into town is not an option when I want to start *right now*.)

At the top of the pipe, I screw on a T joint. I can add "arms" from the T for more support if I need them, and the rounded T does not cut through the wax/clay over time, letting the whole sculpture start to collapse.

When I am installing the vertical pipe, I use two sections with a connector to make the length I need. If you find you need to, you can unscrew your figure (on a single-pipe armature) and replace one pipe with a shorter or longer one. Hey, I don't always know just where I am going when I start or where I will end up on my way to someplace else. It gives me options. Options are good.

Foundries prefer that you use aluminum wire for any needed wire supports in your armature. You can purchase it from art material suppliers. You can also stop at a site where they are wiring a home or business and ask for scrap electrical cable. It is a bundle of aluminum wires wrapped with a plastic coating. Slice the plastic with a box knife, pull it off, and untwist the wires. Most of the wires I use are two to three feet long, definitely scrap to an electrician. Foundries prefer wires inside sculptures that they can cut with a wire knife; it does not damage the wax or clay as much. It is a good idea to keep your foundry happy when you can. They can do a better job for you. When you are getting started with a new foundry, they will want to know just what and how your armature is put together.

If you do have to use stiffer wire, make certain that it is bent into place and not under tension or torque. When the foundry cuts it, it can spring back straight and distort or destroy the original. The foundry has told me that really hard wire combined with soft oil clay can be a nightmare in the mold room.

If I am doing a human figure, then I will usually install an exterior pipe armature, usually with two arms of pipe into the body. This keeps the form from rotating back and forth like a pendulum as I work. Then I will run the aluminum wires through the Ts inside the body to go up to the head and down each leg. I will wrap the wires for the arms around the "spinal column" up to the head.

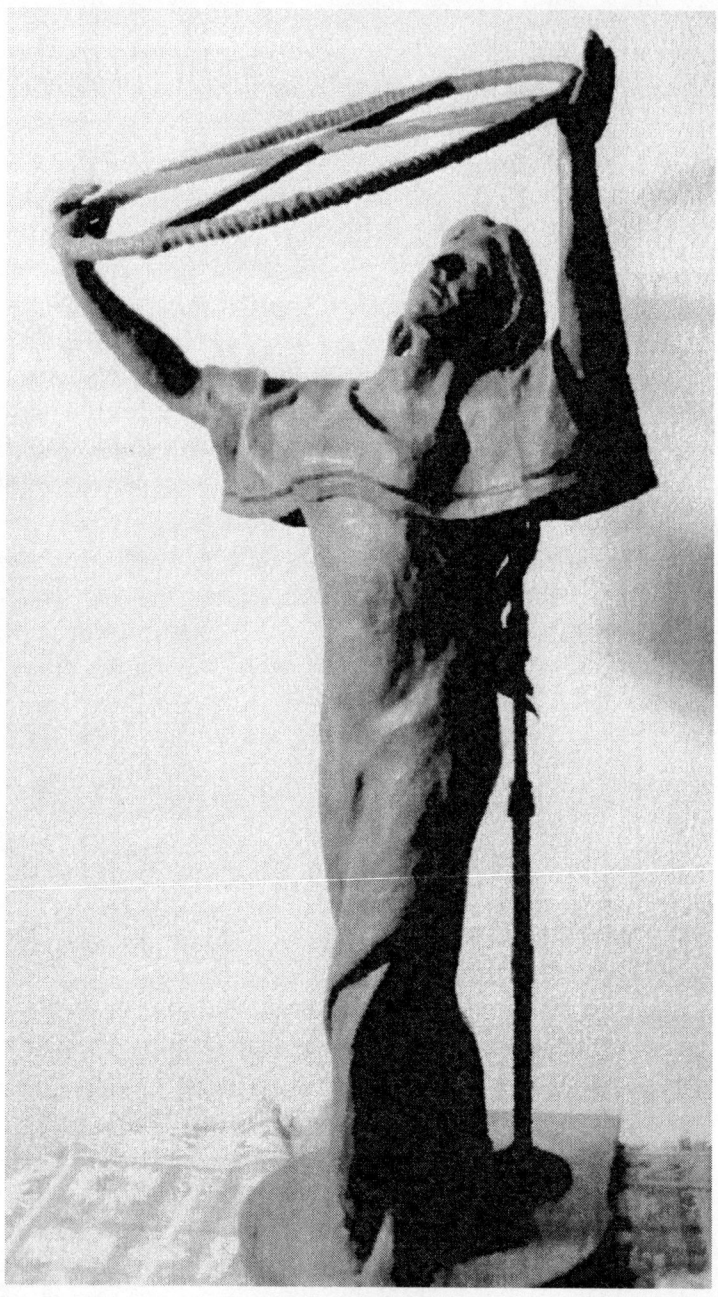

She's the Circle of Life wax showing the rear-supporting armature. Notice that the pipe size changed; the only reason is that I needed the pipe lengths and didn't have all the same-sized pipe.

A Survival Guide for Bronze Sculptors

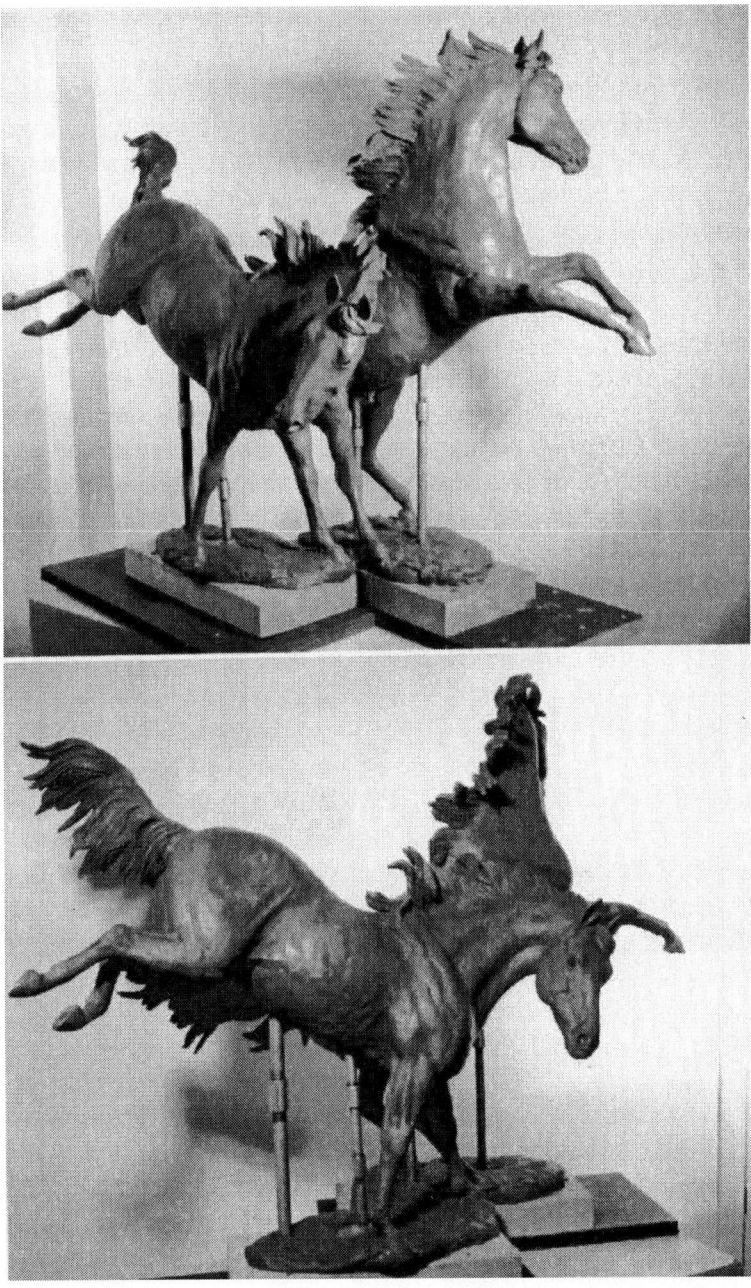

These photos of the wax originals of *His and Her High Spirits* show that they were designed to be a pair, and the lily pads fit together closely.

Let's Take a Sculpture All the Way Through the Original

The most complete example I will cover is the horse, since it will work for most animal forms. I will use photographs of the work in progress to take us through the entire process. A smaller horse, up to about sixteen inches tall, will need only one vertical pipe. I run three wires through the T. They are for the legs, head, and tail. The wires start longer than they need to be, they can be bent to show the major joints, and, if needed, the ends of the leg wires can be bent and screwed down in place on the base. (Did I mention that one of my basic tools is a cordless drill?)

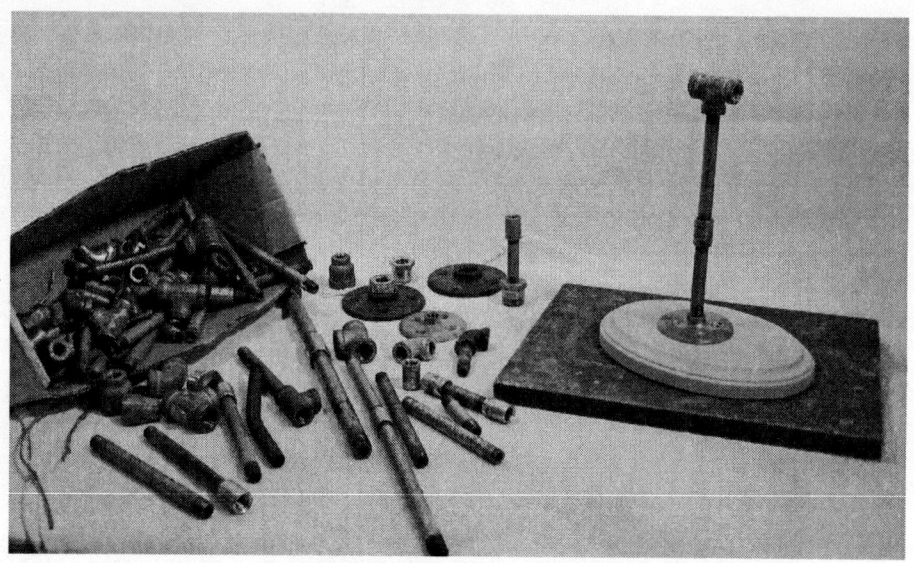

Starting to build the support armature for the *Good Example* sculpture. It has a routed wood base (from a craft store) for a lily pad attached to the transport base, then a flange, pipe sections, and a pipe T at the top.

With the wires firmly attached to the T, I can then "sketch" my figure by arranging the wires in different ways. The first bends in the wires follow somewhat the major joints in the animal. To bring life to the figure, remember that not all parts of a body are parallel unless you want the piece to look like it is standing at attention. (This can also be a good time to make certain that you start out with the legs the same length from joint to joint.)

A Survival Guide for Bronze Sculptors

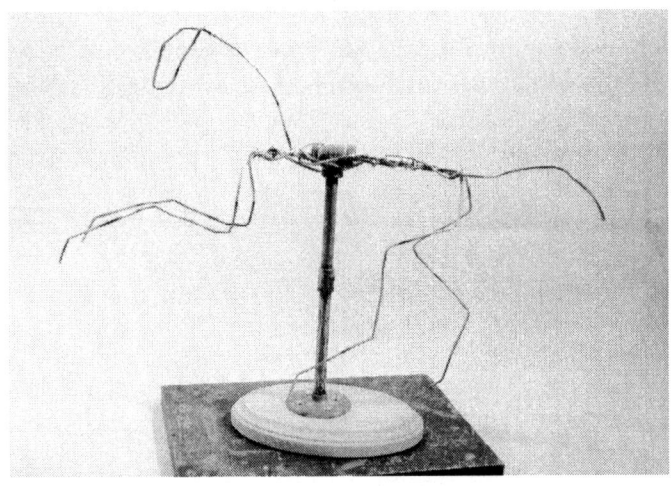

Add your aluminum wire armature. You can always cut the wires if they are too long. I rough out the main joints of the figure.

You can sketch with your aluminum wires, experimenting with various positions. If you have looked closely, you can tell I have already changed the length of the lower pipe for a longer one.

The other main armature that I use is a casting wax interior core. When this wax cools, it is very firm. I will be able to continue to move the position of the horse quite a bit easily, though the body should be about what you plan to use. Remember that I suggested you use a coupling or join in the pipe armature. I have already taken out the lower pipe section and changed it for a longer one. (The other benefit I have found is that you can also plan your sculpture so that you are ready to complete the bottom surface of the body before you actually attach the figure permanently to the lily pad. Unscrew the figure, turn it upside down in your hands or on padding on your worktable, and it will be a lot easier to work.) Don't worry about the pipe sticking out of your sculpture. The foundry is used to making that correction during the mold and tooling process. You should never be able to tell where it was located.

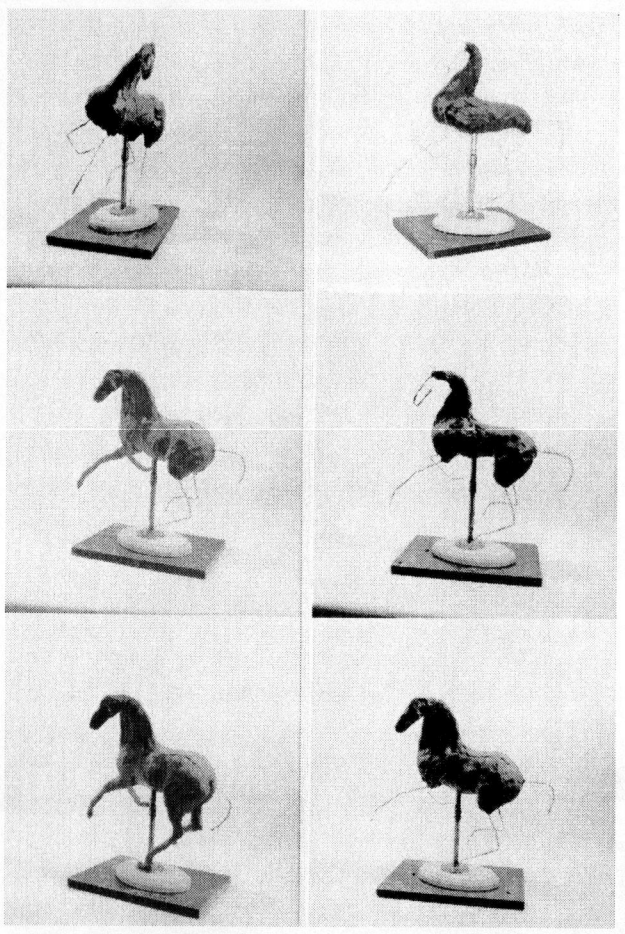

Starting to add the wax to the armature. In between layers, I cool the wax to make it get stiffer more rapidly.

As you can see, there are different colors of wax already on my sculpture. Color is not always a good indication on my pieces of a particular wax's properties. I have so much salvaged wax from so many sources that I have to work by feel with the reclaimed stuff. Hey, it has been thirty years! (It is a good thing I don't have all of it back; I'd need a bigger garage.) The material used to make the core of the legs is very stiff. I will have to do quite a bit of carving to reduce areas. My Exacto knife does a great job. I have even used scalpel blades in the handle, which carved very well except that I had to take time out of my workday to get three stitches at the medical clinic. (My Exacto knife doesn't cut me so badly.)

I will remove the shape of the horse's head from the wire armature and build it to size separately. It will be easy to use short wires and warm wax to rejoin the head to the neck.

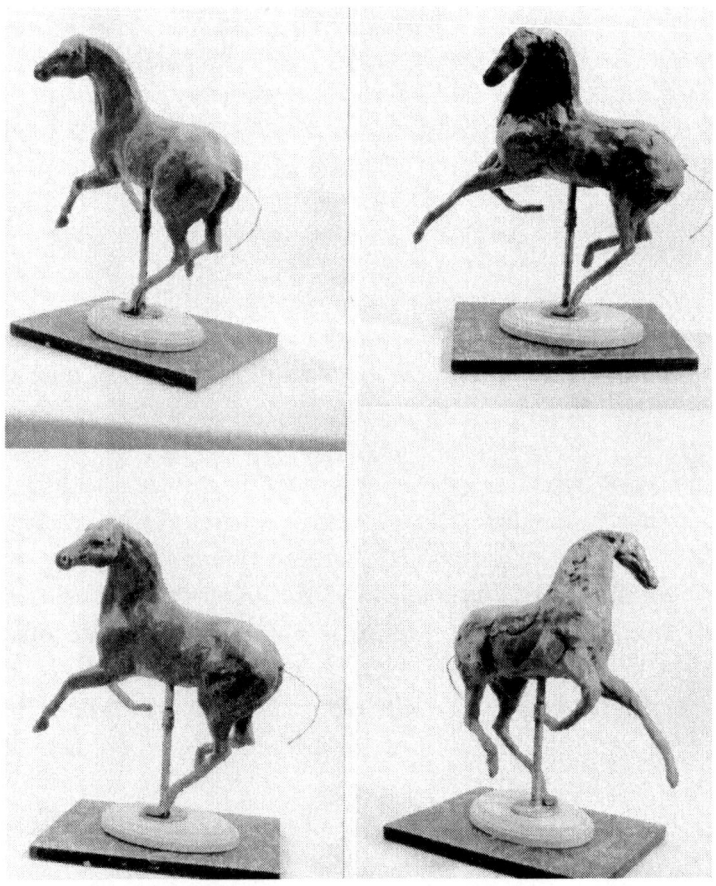

Now I am starting to work with a finer, smoother wax as I get the final shape. I have taken the head off to work on it and put it back on.

At this point, you should be checking your proportions closely. The lower legs can be easily shortened, and I usually have them longer to have more options with the pasterns and hooves. But your neck and body are getting to a point where it will be harder to alter. It can be done, either shorter or longer, with the use of your wire knife, cutting out wedges.

Notes About Horse Art

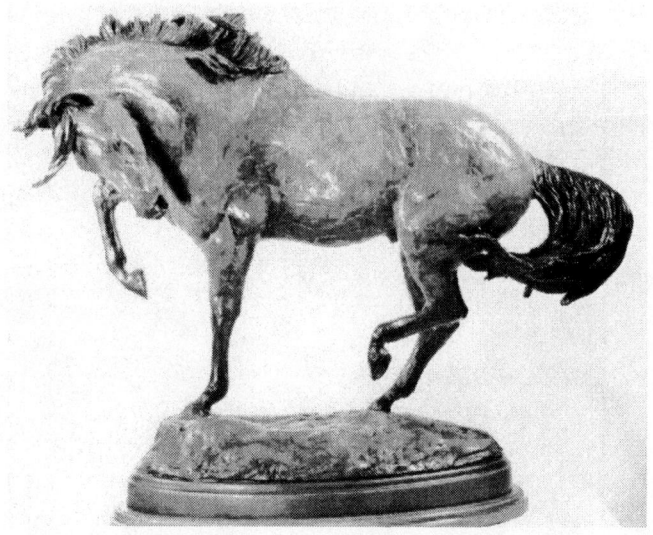

Majesty Doing equine art is about 50 percent realism and 50 percent romance.

One note here, which applies to paintings as well as sculptures, reality does not always make the best art. Arabian horses do have large eyes. I never did an Arabian horse portrait without being told the eyes weren't big enough until I started automatically enlarging them. (And no, not every horse with flared nostrils and an upraised tail is an Arabian, but a lot of people think they must be one.) Running horses can have a point in their stride where the pastern can look like the fetlock is lower than the top of the hoof. And it often is. But to most people, and I have even run into race horse owners who challenged this, it will look totally wrong. Also, I almost never argue with the breed a person sees in my sculpture. (The one firm breed is the Friesan horses I do. But that is also the only sculpture I patina only *black*. Coal black. If the buyer must have another patina color, they can take it back to the foundry themselves.)

Regal, a Friesian And very, very black

But I have seen Quarter Horses with Arab heads, Morgans with Arab heads, and Appaloosas that look like all kinds of breeds. You never know what your viewer has in his or her corral with paperwork to prove it any breed.

Usually I do horses with conformation I find beautiful. I am not concerned about the possible breed, just the individual. I have an aged Quarter Horse who in his day fit the shape I like best. He is balanced and muscled and moves fluidly. If he were two hands taller, he could be a Warmblood. (Okay, three hands taller.) *Charlie* has made his mark on my artwork. When my main friend was an Arabian, my sculptures and paintings tended to reflect this. My partner now is an Appaloosa Mollie mule. Well, she is beautiful to me, but I don't sculpt her that much. (Don't let me get started on mules; yes, I am now one of those people.)

I have done horses for over thirty years, but I still keep books on equine anatomy near my worktable along with those of other species.

* * *

Some artists use foam or tinfoil for an interior filler. Tinfoil as a filler has to be packed in very tightly, or it can collapse or sag under the weight of clay under time. It is also difficult for a foundry to cut apart when making the mold. I have found that as a work develops, I don't always end up where I thought

I would. I have ended up cutting deeply into a form, hitting foam, and getting the bits into the wax can make a real mess. The firm wax makes it harder to distort the form as you work, but you can gently warm it with a hairdryer, and it will bend nicely. Hard wax over an aluminum wire gives you legs that can take a lot of handling. If you find you need to use a wire knife, you can cut into the wax core relatively easily. (Darn it, that neck *is too short*!)

I have been warned by visitors to my studio that the first time a person sees an artist cut the head off a wax to correct it can be highly disconcerting. Even the removal of ears on a sculpture can be very upsetting if you have to correct their placement. The first time my father-in-law agreed with me that the neck of an elk was a tad short, and I removed the head to lengthen the neck, he nearly had a heart attack. (I really didn't think that would be alarming, honest!)

When you are starting to build the core of a piece, quite often you are putting a lot of warm wax on in a short time, and it may sag. Hold it in the sink and run cold water over it. Or even a large bucket of water you can dip it into works. Today, I've gone out and shoved the wax form into a snowbank for a few minutes. That really works. Got an oops you need to remove? Remember that hairdryer I mentioned? Well, pick one up at Goodwill the next time you are in town. You will use it more than you know. It can warm the parts you want to carve just enough; really hard wax when it is cold can destroy your wax working tools. The ribbon loop tools can pull out of the handle or even break the metal loop eventually if abused by too much pressure on hard wax. (I get in a hurry when I am working and break a lot of tools.)

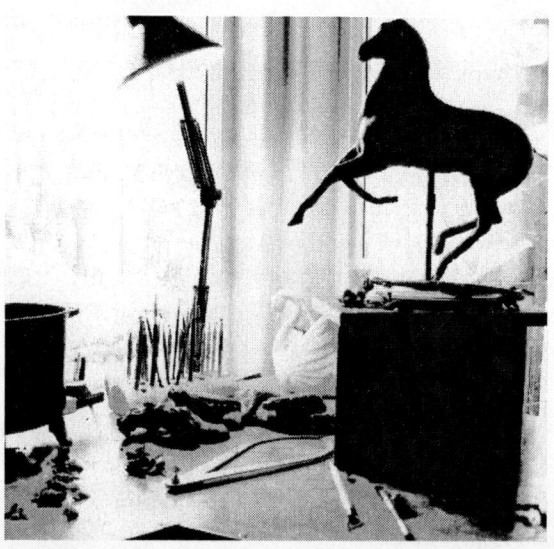

My studio starts to get messy. The silhouette is showing potential.

The view out the window behind the sculpture table.

There is one exception to the use of foam as a core material for me. You can find the foam "heads" that are sometimes used to display hats or wigs in thrift stores. I have used these in the past with success and will probably use them again as the inside of a bust. I dig out the eye chambers before I start, and the base has to be reshaped or removed. This gets rid of the excess parts of the foam before you begin. Since some of them want to come apart in bits, painting a layer of hot wax over the broken surface seals it.

Using hot melted wax can help in many ways. It seals broken foam. It can soak in to dry wood if you are including pieces in your sculpture. Dipping ribbon or string into liquid wax gives you cords and "rope" and straps for your sculpture that don't break. You can either dip pieces of fabric in it or paint the hot wax on fabric to stiffen it. I have used small hot plates with inexpensive smaller saucepans to melt the wax. Now I prefer a one-hamburger-sized electric skillet; I can control the heat better. *Watch for overheating!* Remember, wax is flammable! Don't let it get hotter than it has to be.

Another use for melted wax is creating textures on your sculpture. You will have to experiment with various brushes and temperatures, but you can get some great effects brushing on layers of liquid wax.

I have seen types of aluminum wire "cloth" being offered as sculpture material in craft stores. At this time, I can't tell you about using it. I have bought some, just haven't tried it yet. It could prove very handy and fun.

One more type of armature I have seen used is the type needed for some bas-relief larger scale work. The artist drilled holes in his base surface and put dowels through the areas that were raised. He was creating a large piece that needed to be held vertically while he worked. It was fascinating. Maybe you'll need this information. So far I haven't had to use it, but maybe someday?

Tools and Other Materials

Dear Aunt Gabby,

I want to start sculpting, but I don't have that much money for all that fancy equipment I see in catalogs and art supply stores.

<div align="right">On a Budget</div>

Dear Budget,

You have two hands; the only thing you need to buy is a sculpture medium of some sort. In a pinch, you can soften wax in a coffee can of hot water from the sink (I have). Then head to the thrift stores. Your kitchen and garage are full of things you can adapt as tools. You have no idea just how broke I was when I started.

Anything that can carve, gouge, texture, detail, smooth, and that can take the pressure can be used. Yes, you can buy a wonderful selection of sculpting tools if you have the right catalogs. I have also gone to craft stores for basic pottery tools, those with wooden shapes at the end. Ribbon tools come in all sizes and shapes. Some are strong enough to cut into harder waxes; others work best on softer oil clays and will break if forced into wax. (I've broken dozens, but sometimes they are just the shape I needed at the time, so it was worth it to me.)

A Survival Guide for Bronze Sculptors

These are variously shaped flattened wire, i.e., ribbon loops at the ends of a handle. Old dental tools are used for many fine details, and some dentists will give away worn and dull tools for the asking. A wire knife, fine wire with wooden handles at each end, can cut through very thick parts of your sculpture. A note here, I have learned to make an extra loop and knot with the wire around each handle; since they are usually made for cutting wet clay, the wires pull out of the handles without the reinforcing knots I add.

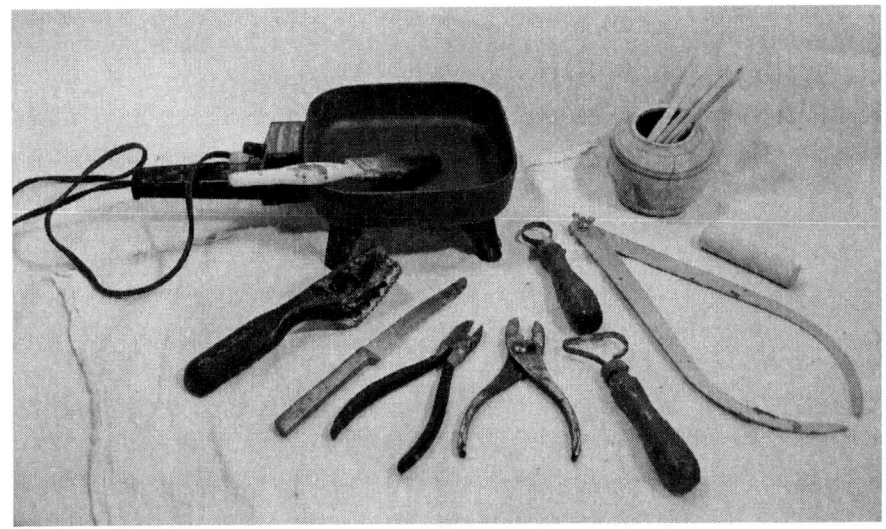

More equipment: the little electric skillet I use to melt wax to paint it on, the curved face wood rasp to carve away wax, dykes to cut wires, heavy-duty ribbon tools to gouge away wax, calipers to compare lengths, and the dowel that I stole from my grandson's toy box to flatten out thin sheets of warm wax.

Many art catalogs don't actually list wax-working tools; most of them fall under Clay Tool headings. They have lovely carved wooden tools in so many shapes for you to try. Some craft stores also sell cheap plastic versions, and I have found many of those very effective. There is something satisfying about a quality tool that is inherently lovely in itself. However, money is often a factor in this occupation.

I have used Stanley wood rasps, the smaller ones, to shape and remove lumpy wax areas. If you keep putting them back in your hot water,

they don't stay clogged up with hard wax. Remember that hairdryer I suggested you consider earlier. Turning it on an area you need to have softer works great.

For surface texture, try combs or wire brushes. Consider anything that could make a mark. I have no idea just what your needs may be as you work; I just want to encourage you to experiment and be willing to try different things. An art supply catalog will give you many ideas and one source to obtain them. It can also give you ideas of things you may already have that you can adapt to sculpting.

You will find your favorites over time and panic and turn your studio upside down when a pet tool comes up missing. Which leads me to advise you that you need to have a pretty high housekeeping standard in your work area. When you want it, you need it, and frustration makes you even harder to live with. I have containers that hold my bigger tools. For the smaller ones, I have taken blocks of wood and drilled lots of one-fourth- to three-fourth-inch holes, deep enough to hold the tools upright and easy to find.

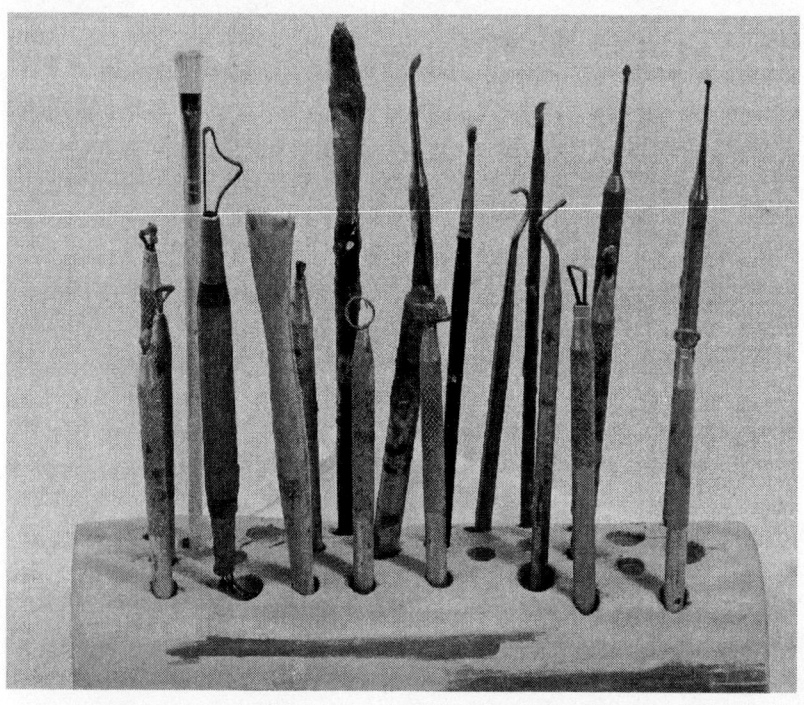

Some of my favorite wax working tools.

A Survival Guide for Bronze Sculptors

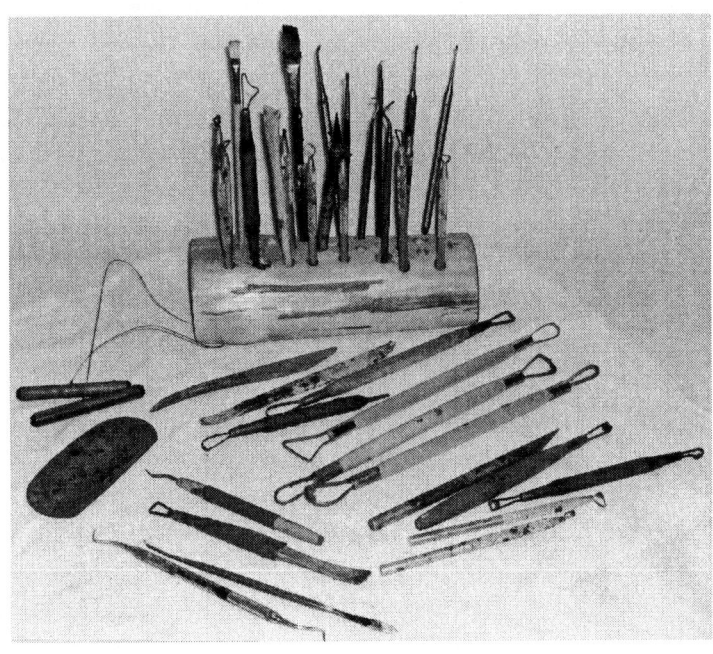

There are a lot more. You can see the dowel handles of the wire knife used to cut wax and the flat aluminum scraper that will help keep the surface of your wax table flat (from wax buildup).

I save the shorter pieces of aluminum wire in case I need to "pin" parts together. I have a set of small pliers, a needle nose, as well as blunt nose, and wire cutters always at my table. (They are in such bad shape and so covered with wax that nobody borrows them.) Aluminum wire can also be bent to form bridle bit rings and other shapes if you need them. Trying to force flexible wire into cold hard wax, even with pliers, can be pretty futile. Take a candle flame, or cigarette lighter, and heat the end of the wire. It will go right in. (Yes, hold the wire with the pliers while you do this!)

**

Dear Aunt Gabby,

I'd love to sculpt, but I don't have a studio. How does an artist get anything done without a place to work?

Spaceless

Dear Spaceless,

Do you have a kitchen table? I'd suggest the dining room table, but you may have *furniture* (the stuff you need to polish and take care of). I have worked on a desk in the corner of a bedroom, the kitchen table, and now I work in a corner of the living room. (We live *really* country!)

Put down a cheap area rug to catch the mess; wax and clay track less if there are carpet fibers to stick to it. Put down a board or section of Formica to have a tough work surface. Put your half-finished sculpture on top of the refrigerator when you have to eat on the table. (Well, move the other stuff that is already up there.) Artists can work nearly anywhere. The big problem is usually time. You are an artist, be creative. You'll find a corner.

If you have a limited area to work on your sculpture, you can purchase scrap Formica counter pieces. (These are the ones with the Formica already glued to thick particleboard.) They are firm and smooth and will protect other tables and counters from damage. You can use the scraper to clean dropped wax bits, and the surface is good for rolling and flattening wax if you need pieces like that. I worked for years at a hundred-year-old oak round pedestal table that is still in service as my dinner table. The wax mostly stayed on the Formica. They don't last forever, especially if you splash water around like I do from the kettle. When it starts to rock, it has warped. Replace it. I have two commercial sculpture stands. Sometimes I even use them. (I have been known to work in odd places in my home, which is why I utilize the counter pieces a lot.) I also have several low tables that I use when I am working on a taller piece and need to have it down lower than my bench, or the sculpture stands will go. (Also, at my age, I work a lot more sitting down than I used to.)

Turntables are needed as you work. I have found mounted ones at my "sale" places, but most hardware stores sell dolly bases. These are the metal ball-bearing turntables; I have them from three to sixteen inches. They are reasonably priced. It is handy when you are working, and it makes it really nice when you are showing your work to someone.

A Survival Guide for Bronze Sculptors

Hot tools are basically electric wood-burning tools. You can get various tips for them. Some come with rheostats to control the heat, or you can put a small soldering iron on a rheostat-controlled outlet. There are very expensive ones in sculpting catalogs. You don't need to spend that much money. These hot tools are used for melting wax together to make a smooth join or doing some types of detailing. Since I started using a blend of clay and wax, I don't think I have used one for years. If you choose to tool your own casting waxes, you will need one. Some people use them all the time. So I thought I'd better mention what they are. Many artists simply heated their metal tools in a spirit lamp (which is a small alcohol-fueled flame) or candle if they needed a hot tool. This is an art form that goes back centuries.

I realize that I keep mentioning the cost of things. For years, as a self-supporting artist, cost mattered a very great deal. I can only assume that for many of you, it quite possibly may matter too. If it doesn't, bless you. There goes one excuse for not producing your work. You can work with just two tools, your right hand and your left hand. All else is optional. Your fingernails can be very effective, or you can cut them short so they don't get in your way. The heat of your hands is also one of your tools. You don't need much more than the will to do it to get started. Tableware, forks, spoons, and knives are within your reach. Again, be open to possibilities. Look around

you; you have a world full of tools already. Many people would just like to try this art form to see if they will like it. If you are one of them, I am trying to give you a way to get started inexpensively. Then, if you feel an addiction coming on, spend money on your tools and equipment. (You will spend enough when you get to the foundry anyway.)

Surface Finishing

There are several techniques to smooth the final surface of your sculpture. Not all works will require this; you may wish to have various textures. But if you do wish it smooth, there are things that will make it easier than just using only your fingers. This becomes more of a problem if you are sculpting with a firm wax or blend.

This is the time for protective gloves and lots of ventilation. I buy boxes of the latex or vinyl gloves. The two liquids I use most are lighter fluid and unscented lamp oil. Both are toxic, both are highly flammable! Don't treat them casually! And don't use either of them with open flame in your studio. I respect these vapors. I even turn off the wall heater or take the piece into another room. You may think that I am being too cautious, but I have never had a studio fire, and I'd rather not take any chances. Breathing these vapors is not a good idea either.

The original wax is getting there. Notice the gloves that I use when working with the solvents to smooth the surface.

Notice how the solvent has softened the edges and textures of the surface of the wax. The tiny lines have been filled in too.

One of the problems with this learn-it-yourself method of being an artist is that you are not always aware of the hazards of the materials

you use. Hopefully taking a more formal approach to an art education would have made you fully knowledgeable of the dangers. I will mention hazards time and again. I have lost many good friends over the years, and some of their health problems have related to art media. It builds up over time in your system, absorbing these chemicals. Just like so many of the pigments in paint are highly toxic too. Example, cobalts and cadmiums are bad stuff. But I'd hate to live without the colors. Lead white too. There is constant work being done to provide safer pigments, mediums, and sculpture materials. People, we are dealing with things that can cause liver failure and cancers to mention two. When in doubt, put on the gloves and open all the windows.

Both lighter fluid and lamp oil dissolve the surface of wax, oil clay, and blends. Use brushes or your gloved fingers to smooth and fill the fine cracks and edges. The lighter fluid cuts quickly. I use this mainly on delicate areas like faces and hands. There is a lot of detail I don't want to blur. Just smoothly blend edges in places where it is hard to get even a fine tool. I use a small soft brush and work quickly. The fluid evaporates in seconds, and in a few minutes, you have a surface you can work with.

Lamp oil is better for bigger areas. I will use a bigger stiffer brush or pieces of a cellulose sponge. Eventually I can get to a point where my fingers (in those darn gloves) can do the final smoothing. This surface will take longer to completely solidify. If you have used quite a bit of oil, then it may take several days to become completely nonsticky. Drying time is affected by temperature and humidity. Once either surface is solid again, it is completely workable.

I have just been informed of a product that will do the job that is nontoxic and nonflamable. It is a citrus oil-based solvent that is used by hospitals to remove adhesive bandage glue from skin. So far, I have not been able to locate it at a store to try it, but a foundry artisan recommended that it really works. At this time, I cannot guarantee it since I have not been able to try it. But if they use it at the foundry, it must work well. It is called Medisol.

There are always new products coming on the market that will make sculpting safer and better. Foundries and other artists are good sources for this information. Do keep an eye on art supply catalogs and stores too.

Another way to smooth your surface is to use a thin layer of a soft oil clay as a final "skin." It does smooth easily with your hands, but on the other side of the equation, it also is subject to being marked or damaged when touched. Smoothing becomes a constant process. I show my sculptures to future buyers; each one may be taken to several shows. I need a surface that can take being touched. I believe that sculptures are made to be handled. Buyers like to touch too. If you won't be doing this with your art, then it isn't a problem for you.

Dear Aunt Gabby,

I wish I had your book earlier; I am so upset! My first original sculpture clay has gotten damaged so badly; it came apart, and it is basically gone past repair. I don't know if I can redo it. I've just lost heart.

<div style="text-align: right">Brokenhearted</div>

Dear Brokenhearted,

Redoing a sculpture from scratch is rather like remarrying your ex. You know what you are getting; there isn't a lot of the thrill of discovery, but just maybe you'll do it much better and get it exactly right this time.

Last-minute Changes

My horse sculpture original was basically done, but I decided to hedge my bets and add a bit of driftwood to the bottom of the horse's leg for a touch of more support. I have gouged out a channel in the base to seat the wood and only expose as much as I need. Then I filled in around it and textured the base lily pad with melted wax applied with a brush. Note: some of my buyers may recognize that little piece of driftwood. I have used it time and again, turned one way or another, in several sculptures. It is just the right size and works perfectly so many ways.

It may take some cutting and fitting to make an addition such as this lay right, but the wax lily pad is easy to gouge out as needed. Remember to check the way it looks from all views of your sculpture.

A Survival Guide for Bronze Sculptors

The final original wax of *Good Example* as the foundry will receive it.

**

Dear Aunt Gabby,

I've bought every tool and piece of equipment you've suggested. I have ten pounds of every sculpting media you've recommended. I'm still waiting for inspiration. What's wrong?

Still Waiting for Success

Dear Still Waiting,

You have to open the packages and use them. Any of them. Start somewhere, or let me know when you plan to have a garage sale.

**

Multiple Sizes, Point-ups, and Enlargements

There are different attitudes about doing multiple sizes of the same sculpture. A monument project is the reason many of them are done. Some public art is funded by the sale of smaller versions of the final statue. Usually a monument begins with the creation of a maquette, a small preliminary model. The actual monument is an enlargement, and the re-creation is done by the point-up method.

One way of doing a point-up is to take the hollow casting waxes and slice them in layers. The outline on paper of these slices is then enlarged to the desired size. A ten-inch tall horse figure would have the outline of each slice enlarged to the desired size, even life-size or better. These outlines are then cut out of plywood and fastened together on to a truly massive support armature. The gaps between plywood shapes are then filled. Spray foam is one material used to do this. The bulked form is then cut and shaped and smoothed as closely as possible to the original maquette. Finally, a layer of oil clay is added as the final "skin."

Bonnie Shields and Jack Horner

The Creation Of A Life-size Bronze

Bonnie Shields is known all over the nation as the country's best mule and donkey artist, as well as quite an authority on the critters. (She holds the official title of the Tennessee Mule Artist.) Meredith Hodges is probably one of the nation's best trainers of mules and donkeys, as well as an author of considerable note with many published books and articles about them. So it figures that not only are they good friends, but when Meredith wanted a life-size bronze to honor Jack Horner, her record-holding jumping jack donkey, she also called Bonnie. I got involved because I had an empty bay in our shop big enough to hold the figure of an airborne donkey and rider.

The first step was the creation of the maquette for Meredith's approval. A mold was taken, the wax was sliced, the shapes of the slices enlarged, and the shapes then cut out of plywood.

A Survival Guide for Bronze Sculptors

This shows the starting assembly of the plywood.

You can see the spaces around the plywood filled with spray on urethane foam, which is then cut and sanded into the rounded form of the donkey. The form of the rider is built separately at this point; it will later be mounted in place on the saddle.

The urethane is then painted with melted wax to seal it. As the form takes its final shape, at times a saw is needed to modify the plywood under structure.

The outer layer of clay is smoothed over the waxed urethane and the details of the figure start being added. You can see the still rough form of the rider is in process on the worktable in front of the donkey. Like the ears of the donkey, the fingers of the hands are just wires at this point, and the layers of clay that form Meredith's face will be very thick. Her form has yet to have its wax coat applied.

A Survival Guide for Bronze Sculptors 47

At least the face of Jack Horner is nearly complete, though the bridle will be added later.

Meredith rides! Still a long way to go, but the nearly completed rider is lifted up and tested for fit on the saddle.

The real bridle is fitted to the head of the donkey. The center of the bit has been cut to allow the ends to be fitted into the mouth. All the spaces under the leather will be filled in with clay so that the bridle is fully connected to the head underneath.

Disassembly is started by the foundry. Since we are close, the foundry people have come up to cut it apart in my shop before transporting it. (Yes, in a horse trailer, naturally.)

A Survival Guide for Bronze Sculptors 49

Arrival at the foundry. Even Meredith was taken apart to travel; now the sculpture is ready to have the silicone mold made.

Two arms and Jack Horner's hind leg get their first coats of silicone rubber mold material.

The bronze pour is completed, and welding the pieces together is well under way. (Hopefully they don't plan of welding Jack's front legs to Meredith's torso.)

A Survival Guide for Bronze Sculptors

Nope, they figured out what went where just right, and the bronze is nearly ready for patina.

The sculpture is delivered to Meredith's ranch. (I did mention that Jack Horner held the record for a jumping donkey.) A crane is used to lift the bronze from the truck to the installation site.

A Survival Guide for Bronze Sculptors

53

The crate the sculpture traveled in is moved away, and Meredith and Jack are lowered into the site prepared to receive them.

The real Meredith and Jack, both far less formal, check out their likenesses.

The whole process of creation through installation took over eight months. There were unbelievable hours spent in my shop completing it. The end result was worth it. After final landscaping, and the addition of the actual jump, the sculpture looks marvelous at Meredith's ranch.

I have only worked directly on my life-size pieces since they were being done as my own project and did not have to pass a committee for approval. In my experience, larger is easier. You have a much-bigger margin of error; there is a big difference in a sixteenth of an inch and a half inch. You do get more exercise stepping back to see the total of what you have done, and you can't do it sitting down.

On the other hand, there is nothing like enlarging a maquette to magnify your errors made on the smaller piece. Another tool you will need if you have used a plywood and foam point-up is a reciprocating saw to cut the plywood where you see you need to make alterations. The foam cuts with a knife; the plywood doesn't. And I do warn you, it is messy. I used the cans of insulating expanding spray urethane foam. I bought a box of it when I made my life-sized fountain figure. I can guarantee dropped wet foam will not come out of a studio carpet, and when you carve the excess away, tiny bits of dry foam are with you for years. Okay, I'll admit it was great fun to do, but pick your work location carefully.

Technology, it can be a grand thing! We now have available to artists the use of computers. Companies can scan your original work, be it still the wax/clay or a final casting. Once scanned, it can be re-created in foam to any size or sizes you would wish. All foam, no inconvenient plywood, no heavy armature mounted on a massive base. You have done your maquette, you send it off, and get back a small version to be cast in a limited edition to be sold to fund the monument. Sell enough to go ahead and order your foam version in the final size. Again, each foam needs a clay "skin" I have been told, and experience tells me that you will notice some areas you wish to work over.

All it takes is money to pay for it. And it does cost. However, as a working artist, especially if you also have a life in addition to being an artist, time is also a valuable commodity. Doing the older plywood-foam method of point-up takes an incredible amount of time. An artist can spend a year on a monument, and unless you have a well-known reputation in the art world, you may not get very much if you break your commission down to an hourly rate. Many artists would nearly work for free just to have a monumental work installed. And if you are building your name recognition and credibility, it may be worth

it to you. And the future payoff may well be great. Me, I have needed to eat and pay the bills. This computer program method would make it possible for artists in my position to happily accept a commission for a major piece. I would be able to have a pretty firm idea of the cost of the computer-generated figure instead of a guess of the hours I would be committing to the sculpture.

Sculpture Design and Composition

My purpose is not to teach anatomy for sculpting. You are on your own. Anatomy of anything may not even enter into your work. Art is what you think it is; selling, it means you have convinced a buyer to agree with you. But there are a few things about composition I will mention that are part of most bronze sculptures.

You are working on a piece that will more likely be viewed from all sides. (Exception, bas-relief of course.) It may have a "best" side, but all sides have to work. Some ideas make better paintings than sculptures. It doesn't matter how great it looks on one side if the back side falls apart or looks awkward. With a realistic subject, is this the place to add an item of interest? A gnarly piece of wood, a stone, or even another critter. Hey, I can't help it here, as a Western artist, I tend to think this way, and I suspect that most readers will be starting from figurative work. The rest of you can ignore this part. At times I have even worked with a mirror on the other side of the piece to keep an eye on the back.

I mentioned the size of your base, the lily pad under your work, earlier. This will be the part that makes your sculpture stable. At this time, you can also be considering how the under base, wood or stone or both, will add to its stability. Make every square inch of it matter. If it doesn't contribute to the piece, cut it down in size. First of all, why pay for bronze you don't need (and the mold and the tooling), and it can kill the tension in your work. Or stop the action. One thing you must consider, your base must be at least thick enough that it can be tapped for a bolt to attach it to the wood or stone under base. It must be at least three-eighth of an inch thick, and at least parts of it are best if close to a half-inch thick.

Consider if your piece will work without a lily pad. I do many forms that have no base under them at all. My bears are done without bases, unless a buyer wishes to order one. The foundry will drill and tap the underside so that a base is easy to attach if desired. Another consideration is sculpting a piece so that the wood or marble base acts as the lily pad. It cannot be freestanding, but the bronze against the base material makes each aspect stand out sharply.

Trouble Bruin This bear can be freestanding as well as mounted on a base as shown.

The Entertainer: On Her Own Notice how the white marble base emphasizes the shapes of the lower area of the sculpture. I rarely use stone, but on this piece, it was very effective. A poor camera angle, but it illustrates my point.

Some sculpture is designed so that part of the bronze actually overhangs and drops down past the top of the base. This can be very effective. It is harder to grind the bottom of the bronze flat in the foundry so that it meets the base accurately; you may pay more for your casting because it will take a bit more time in the metal room.

The Messenger It is simple for the foundry to grind the bottom of this bronze flat before the feather that drops down below the edge is welded on. It can be a help if you as the artist can visualize the problems the foundry will have to handle.

About a 50/50 Chance The rabbit has been sculpted dropping down below the bronze base, but it adds enough to the composition to make it worth the trouble to build.

Bronze is a marvelous material. With quality castings, those poured without inclusions of slag or foreign matter in the metal, you can support a sculpture with relatively delicate forms. I have cast the figures of horses standing on one foot, though these are usually under fifteen inches tall. With a bigger sculpture, a decorative part of the base can touch the leg of the horse partway up for additional support.

It is surprising to me how little has to be added to be sufficient. The strongest forms have a three-point support. It doesn't take much; very delicate features can be all that it takes, if the placement is right. I will take a sculpture with two figures and have them touch in one hard to see area. A spot weld there can make the composition absolutely rigid. I have found that some work that is designed with delicate support is just fine on display, but special care needs to be taken in shipping these pieces because they will be subjected to a great deal of stress in route.

The Wolves of Winter

Art bronze is not tested in the way that industrial castings have to be, and flaws in the casting metal can occur. These may not be visible

as the bronze is assembled in the metal room, but it may show up later in the life of the artwork. You must choose a foundry that will stand behind their castings and make the repairs if ever needed at their own cost. In my thirty years of having my work cast, less than half a dozen castings have needed this. Improper packing for shipping caused part of the problems; the others were caused by faulty metal. Quality foundries all use basically the same casting alloy of bronze. This means that nearly any good art foundry can repair a bronze.

The fact that quality bronze castings are repairable is one good sales point. I have seen bronzes returned to the foundry for repairs after earthquakes, fires, and even damage caused by a runaway pickup breaking through the wall of a house. All the pieces were recovered, parts that were bent were straightened, broken parts rewelded, scratches were filled and polished, and the works repatinaed. The end result was an as-new sculpture. Sometimes lost pieces can be replaced by being resculpted and recast. This is possible with quality castings, and established art foundries in this country, as I mentioned, work much the same way. There are many companies offering casting services in other parts of the world for much less cost. Some of them do excellent work to the same standards. Some don't. I want a foundry I can visit and contact easily.

Castability

A good foundry can cast anything. I assume that you want the best casting for your money, and if you are hoping to make a living at this, you need to be competitively priced. The castability of your sculpture is critical. A good foundry will discuss this aspect of your sculpture with you and make suggestions that if you are wise, you will consider. I have taken many pieces back to the studio to make changes that do not affect the power of my concept but sure do affect the price I will be paying the foundry. The cost of a bronze does have to do with the cost of the metal, but it is small compared to the part you pay for each hour of foundry artisan effort.

The easiest form to cast is a "bell." My bears are usually bell castings. These are shapes without a lot of parts that stick out from the body of the work and are open at the bottom like a bell. The mold is often just a two-part mold; nothing has to be cut off and molded separately.

The Bear This bear and the following sculptures are all basically "bell" castings with simple two-part molds for the casting wax. On a couple of them, small items have been molded separately, but relatively little welding has been needed to build them.

Bear Foots

Bear in Mind and *Watchful Eyes*

Old Wolf Remembers

The Guardian Yes, this wolf was sculpted directly on to a rock, which was then molded and cast as part of the sculpture. I did carve the marks in the surface of the stone.

Each part of your sculpture that has to be cut off the original, cast separately, and rewelded and tooled costs time. Think of a hole surrounded by bronze. The bigger the single hole, usually the better. Each separate hollow in your sculpture has to have a "window" cut open in it to allow the final mold slurry to flow inside. Each window then has to be welded back in place and tooled. Even a "bell" casting may have to be windowed.

Think of a rider on a horse. (Remember I am a Western artist; my examples will tend to be of this genre.) The closer the rider is in contact with the body of the horse, the more easily the legs can be cast as part of the horse. The depth of undercuts can be intensified by patina color so that they look deeper. Smooth joins are easier than sharp ones and less subject to damage in the casting pour. Where the eye does not see, fill it in. Consider a hanging coat on a figure. Fill under the coat nearly to the bottom of the edge. Think about the flow of the molten bronze. As the bronze is poured, it starts to cool. The further it has to flow, the cooler it gets. The thinner the area, the faster it will cool. For massive simple shapes, things are easier. Detailed figurative work presents more possible problems. Try to make your composition as foundry friendly as you can. The foundry can be your partner in the production of your art, work with them.

In the two figures of the mountain men, I have marked the areas where filling in under clothing made a difference in the ease of casting and yet was invisible while viewing the sculpture. Elbows that blend into the main figure, gear like the pack and the shooting bag and powder horn will look clear and sharp even if the under edge is filled most of the way. On horses, where the mane falls over the neck, I fill in underneath. The fur on the robes helps blend the edges of gear together. Even the flowing straps, ribbons, and fringes actually are filled underneath to the body of the sculpture wherever possible. Take a close look at the shaded areas I have marked on the photographs. The better that you have designed your sculpture so that you can reduce the number of small pieces that need to be welded onto it, the more reasonable the cost of casting (and the happier the metal artisan is).

A Survival Guide for Bronze Sculptors

Born Ornery The following photos will show the points that needed to be under filled or smoothly joined to make them more castable. I spend a lot of time going back around each edge to check they all are done.

A Survival Guide for Bronze Sculptors

To Live Free

A Survival Guide for Bronze Sculptors

The inside of the open shirt, under the breechcloth, inside the folds of the blanket, all those areas are under filled.

The buffalo robe stands out from the horse's body; it is filled, and the fur flows into the horse's skin.

The Prized One You can see all the detailed gear on the horse; none of it has to be cast separately and welded on. Notice also the rope that is formed of twisted wires by the foundry.

A Survival Guide for Bronze Sculptors

Parade, the wax original. It is under filled even under the strings of beads dangling from the breast collar.

A View of the Valley This is a life-sized bust, and the woodblock it rests on has become an integral part of the sculpture. Even though it is larger, because it is well under filled, it too is actually a "bell" casting.

I will mention this later, but all parts of the foundry can contribute to your knowledge. The people in the mold room, the wax-tooling people, the metalworkers. A knowledge of their concerns will make you a better sculptor. Ignorance may be bliss, but it is also expensive. Respect their areas of expertise. They work on many different types of sculpture and have even been known to make suggestions to help artists. Each of them can't spend too much time with you; they have deadlines on other artist's work besides yours, but a few words can be very helpful at times if they know you will listen. The foundry manager who bids the cost of casting is your best place to start. He or she can identify areas that add to the difficulty of your sculpture. Remember, they aren't being critical of your ability as an artist; they are just trying to work with you to create the best bronze possible.

So you have completed your piece, and now you are at the foundry for your price bid. How you handle the information I have given you in the earlier paragraphs will have a great deal to do with the price.

Parts of your piece can either be cast or manufactured. For instance, the form of rope on a sculpture. (Cowboys and Indians, remember?) It can either be cast from your wax-dipped string or made from twisted wire. Will it matter? That is up to you. To me, much of the twisted-wire-formed rope looks artificial. Usually it is only two-ply, and most rope is at least three- or four-ply, and its regularity makes it look applied. My foundry will often grind part of the rope to make the texture less even if I have made that choice. I have even made yards of "barbed wire" from thin copper for some of my pieces and had the foundry weld it in place. We did run into a problem trying to string a guitar with wire; my metal artisan had words with me about that. Wire is also used for flying fringe on clothing. Leather straps can be made by flattening thicker wire; think reins on a horse for instance.

Making Fountains and Outdoor Sculptures

I have made many fountain sculptures, smaller ones that can be used indoors as well as outdoors, and one life-size figure. The first thing is that they are beautiful sculptures. Many of my fountains are used just as a sculpture; they have never had a fountain pump attached. But they are all sold prepiped, and the collector always has the option.

Your foundry can build the pipe in as part of the bid for the sculpture. Copper pipe is used, and it is simple just to fit a plastic or rubber hose over the end to connect to the pump. The pipe should be about an inch shorter than the bottom edge of the sculpture to allow for room for the hose to bend. The actual water "basin" in the bronze will have to be designed for proper water flow. The edge where the water flows off the sculpture has to be angled properly for the water tension to break free of the metal instead of following the metal down the side of the piece. When I make a sculptural fountain, I plumb the wax original so that I can test it once it is completed and modify it if I need to.

I have sold a small pump with some of my fountains, but how well a pump works depends on the actual site where it is used. The height of the sculpture above the pump affects the amount of water it can lift.

Fountains that may be installed outside must be drilled and tapped so that they can be at least semipermanently fixed in place if need be. All sculpture that is placed outside is a risk in many neighborhoods, so they must be made difficult to remove easily. Some larger pieces are permanently set, and your foundry can prepare them for this. Let your patina artisan know that this will be an outdoor piece. This can affect the way the surface is protected.

Indoor fountains can use distilled water. Hard water can leave watermarks from the minerals on the surface of the bronze. Your buyer may be happier if they are warned of this in the beginning. A certain amount of wear is more likely expected on an outdoor installation. I mean, well, there are liable to be birds, aren't there, for instance. Fountains *do* attract them.

Daughter of the Land This is a six-foot-high fountain. The jar she carries was formed from a salvaged model globe; it was made of cardboard and easy to cut open to form the jar mouth.

Estella del Agua She is only twenty inches tall, so most of the time she is used as an indoor fountain.

Sonrisa She is about the same height as *Estella*, but the bulk of her structure makes her more suitable for an outdoor setting. The core of her water jar was a cheap thin plastic vase.

The Hunter He is crouched on a rock made originally of scraps of foam. The foundry can patina "my rock" to blend in with whatever type of stone the landscaper has used. For transport, the front half of his spear unscrews from his hand.

The Hunter is half life-size, a perfect size for most home garden pools.

Little Brother life-size, in the snow.

Patina Thoughts

We will go into patinas in more detail in the Casting Your Sculpture section, but there are some things to consider about patina in the composition of your sculpture. So we will do a bit of an overview about patinas here.

Some sculptures are simple to patina. Multiple figures can present problems if you are having each one patinaed differently. The possibilities should be discussed at the time the sculpture is bid. It will affect your costs. I have done pieces where it was necessary to patina parts of the sculpture before it was assembled. Not all patinas are possible for all sculptures. Just because you have seen a lovely color on a bronze does not mean your foundry can do it. Some formulas are carefully guarded by the patina artisan as a trade secret; artists will choose a bronze to be cast by that foundry just for access to that special effect.

You may choose to do your own patinas. I can do some simple ones myself at home. But remember, you are dealing with some serious chemicals and acids; the extra has to be safely handled for disposal. There are serious vapor problems as patinas are applied. This is an area that

deserves special training and a carefully setup workstation. While I am at the foundry for the patina part of the process, I have been allowed at times to pick up a brush and do part of the piece, particularly if I am trying to show the artisan exactly what I want on a small area. This has been a considerable favor on their part and not usually something that happens. Don't expect this of your foundry, at least not until you have worked with them for many years. Another note here. Hanging over the patina artist's shoulder will distract him or her and make the whole process take longer. I have learned to wait in the car with a good book until the artist comes to get me to take a look or answer a question about the progress.

Patinas are an art, not a spray can! If your foundry tells you that a certain patina may not work, listen to them. And each patination is going to be unique. Some are easier to nearly duplicate. Some can never be duplicated, the lucky accident no one can explain. Contamination can happen, and things are created of incredible beauty you may never see again. (Your patina person may spend hours later trying to figure it out.) If the foundry believes a patina should work on your piece, you should get a similar effect. *Not an exact one!* Understand the true nature of a patina.

When I started so many years ago, we had about only six basic patinas to work with. Now there are hundreds of types and variations, depending on the skills of the artisans in your foundry. New patinas have to be tested for permanence over time. Some are photoreactive, and even though the final coating applied by the foundry of wax or spray acrylic will seal the surface to keep it from reacting to the air, the effect of sunlight will cause changes. You may choose one of these, but both you and the buyer have to understand it must be treated with respect or the color will change. I have had buyers who were willing to accept the responsibility because they loved that particular patina color. Your foundry will warn you if a patina needs special care.

If you fall in love with a color sample, the actual surface texture of your bronze may change the way it will look. Occasionally for some unknown reason, a patina may change color over the first few weeks. It is fair then to ask for a repatina by the foundry. But don't expect an exact duplication of the patina sample you are looking at. At times, if a patina does turn out to be a more than little different than I expected, I will go ahead and offer the sculpture for sale and often a collector will find it just perfect.

To Dream This sculpture has a polished silver patina; it is not silver plated, but it shines almost as brightly. If you could see the actual sculpture, you could see the subtle variations.

Chiaro and Scuro These are patinaed with silver threads over a dark and very dark under patina. Although this is one of the newer patinas, it is a classic effect for classic sculptures.

Spanish This Lipizzaner horse is not painted white; it is a pure white patina, titanium in acid.

Pirouette There is a classic ferric patina over a liver of sulfur dark-base coat. Over that is a pattern of circles; the last tone is created with another spray coat of ferric acid.

The Good Neighbor This sculpture has a matte finish, with the titanium white brushed over the undercoat to give the effect of heavy snow. The artist created the barbed wire with fine copper wire that also takes a patina.

Showin' Promise This dappled grey is created with a textured spray of the white patina over a very dark liver of sulfur-based patina.

There was the time I had a patina done by a new company located quite away from my home base. Too far to go back for a repatina at the last minute when I unpacked it just before a show. It had changed. And I mean really changed in the two weeks since I had picked it up. It had turned into a color I really did not care for. But I needed it, so I packed it up and set it up for display. Once home from the show, I arranged for my regular foundry to repatina (at my cost of course). Three days later, I received a call from a collector who had not been able to get the piece out of his mind; and if it was still available, could I ship it to him. You guessed it; the foundry had just sandblasted the old patina off. Could they try to recreate it? They thought they could. Two days later I got a call. Could I come down and see what had happened? No, they hadn't recreated the patina, but they had gotten an effect they couldn't explain, but it was too beautiful to destroy. And it was. It was breathtaking! (I had never seen one like it and never since either.) I

called the collector, explained that the sculpture had been repatinaed and said I would like to ship it to him on approval, but would he live with it for a week before he sent it back. After a week then, we would try again for his patina. A week later, he called to tell me; no way was I getting the sculpture back. His first reaction had been disappointment since it was not as he remembered, though he had been warned. By the end of the week, he was thoroughly in love with it and knew he had a rare treasure.

Polychrome

One other way to color and finish a bronze is polychrome, a long word that means paint it. I have used acrylic colors with patina to accent a bronze as well as completely painting one. You can use a little to accent areas or use it as a glaze over the patina. The foundry finishes the surface of a bronze with either a hot wax or acrylic topcoat spray to seal the surface from air, which stops further oxidation of the metal. If you are going to use polychrome, request that they do not seal with wax. After painting, you can use the spray acrylic in either matte or gloss to seal the work.

All Around The body color of the horse is patina; the white markings are done with acrylic paint.

Calls the Buffalo Dream This sculpture is completely patinaed except for the buffalo that are painted on the robe on the horse's back and the face of the shield. Each shield in this edition is painted differently than the others.

The Blanket Gun This piece is also a combination of patina and paint.

If you wish, any or none of the bronzes in a limited edition can be colored the same way. I have started with one patina I liked and later found a new patina that worked even better. From time to time, my patina person has developed a new patina and suggested I try it. I do offer patina to order as a service to my collectors. Many bronzes look good many ways, and a change in patina color may enhance the sculpture in the location the buyer has in mind. Patinas can be changed without damaging the bronze surface and detail, since it just involves the surface molecules, and the bronze is sandblasted many times as the sculpture is completed.

Dear Aunt Gabby,

I am so afraid of failure. What if what I do is not any good?

<div align="right">No Confidence</div>

Dear No Confidence,

And you think I am not afraid of failure? If I let it stop me, I'd still be painting unicorns. You won't know until you get started, and then, just how good do you expect to be the first time you do anything? Your first piece probably won't be that good. Maybe not even your second or third. (You don't have to cast them, you know.) But you'll never get to that fourth piece that shows real promise until you do the first three of them. (Yes, there are superhuman beings that do excellent first sculptures, but only my mother could have been impressed by my first piece. And she was, come to think of it, but she always was my kindest critic.)

Working with the Foundry

I have worked with quite a few foundries in my thirty years of casting. Like any other organization, you need to be able to work with the personnel comfortably, from the owner who sets policy to the person who puts the final touch-ups on your based bronze. But first and foremost, you need a foundry that feels professional pride in each and every piece they turn out

and stands behind their casting. Cost is not always the best indication of quality, but a company that bids too low will not be in business very long either or will not be able to devote enough time in the production of your sculpture. Foundries are a business that must make a profit to survive and be able to pay top quality artisans to do the work. Size has little to do with the quality of the work. I am working with a relatively small organization now, and I am delighted with them. I have worked with big art foundries where I did not know all the people, but I did know those who usually handled my pieces.

You need to be able to talk with the people you work with. You need to be able to discuss price with the person who bids the cost of casting your bronze. You can learn why some things cost more and how you can increase the castability of that piece. Your foundry should adhere to the quoted cost, with the understanding that sometimes the cost may go up in future castings if they run into unforeseen problems once in a while. If they constantly run into problems, somebody else should be doing the bidding. The price of everything does go up over time. A bid may only be good for six months or a year. If you make a later special request about your sculpture, say you find something that you decide needs to be altered on each piece, do expect to possibly pay for the increased time they have to spend on your sculpture. A more involved patina will mean a price increase on the bronze sculpture using that patina. A rush order may mean an increased cost, if they can even accommodate you. It may mean that someone may have to work overtime, certainly, and someone else's work is being put on hold to get yours through.

A foundry should be able to give you a firm idea of when your sculpture will be ready for you. Most foundries give themselves a little leeway with the idea that they can bring the casting in under the time allotted. When you promise a bronze on order to a buyer, it is a good idea to do the same thing. A couple of weeks overtime does happen. Three or more months overdue are not acceptable. It helps if the foundry knows your deadlines, such as being ready for a certain show date.

A good foundry stands solidly behind their work. If problems occur in the casting metal or the patina, they should be ready to correct this at their expense. There are some lovely patinas that are light sensitive, photoreactive. If you have chosen one of these, you and your collector should be aware that special care needs to be taken with the artwork. Color changes on one of these are not the responsibility of the foundry. Abused

bronzes, such as those damaged through a fall or natural disaster are not the foundry's problem, although they can correct the damage. Payment for work done in this situation is the responsibility of the owner of the artwork or possibly an insurance company.

"Full service" is the term for they do it all from bid to base. There are foundries that will arrange to do only part of it for you. You can do any of the steps yourself up to the slurry mold and the actual pour of molten bronze. I know artists who make their own molds, pour the casting waxes, and do the tooling. Some artists do these things because they haven't found a company that does those parts to their satisfaction. Others do it to save the cost of having the foundry do them. I like full service, and I work with the places that I can trust to do a great job with all the aspects of the process. But if you need to change the casting wax each time, like repair a wax from a damaged mold, it may make a great deal of sense for you to do it. There are artists who make variations in each casting; they change the casting wax themselves.

I prefer to spend my time on the creation of new sculptures. I would rather pay the foundry people. If there are any small corrections, when I come in for the 2 percent, I can catch them. What is 2 percent? The sculpture has been built by the metal room; it is sandblasted clean and hopefully patina ready. The artist is given a felt tip pen to go over the sculpture inch by inch. If there are errors, catch them now before the time is spent on the patina. Once the artist approves the piece, any errors discovered after patina are the responsibility of the artist to at least pay for the cost of repatina needed after the corrections have been made.

With the way I texture my surfaces, there are bumps and fine lines in the wax in some areas. I have left them there for good reason. The ones I watch for are those that aren't mine. A leg may have gotten bumped in the wax model and become lightly bent; this is easy to correct in the metal. (Yes, they bang on it with a hammer.) A tiny bubble may have been cast in bronze and not noticed by the metal artisan. All big errors should have been caught by him or her by now.

From time to time, especially the first casting a foundry completes in an edition, there may be questions about assembly and angles. The artist may be called down to explain his or her desires, and sometimes 2 percent is done during this visit. If the metal artisan has not completed that part, there may be many little corrections. Most of those would have been caught as the work is completed. Usually a file follows the

sculpture as the piece moves from area to area. Each artisan may make notes for reference on future castings. The photos of the newly delivered original sculpture are also in this file for comparison. I recommend that you have taken your own set of photographs before the sculpture ever leaves your studio. These do not have to be really top quality but good enough to show detail.

Many foundries require that the cost of the primary mold be completely paid at the time it is ordered. Usually half the casting cost of bronzes is due at the time they are ordered. The balance is due when the work is picked up by the artist. Most foundries have people who can supply finished bases; very special ones may require advance payment too. Most foundries can arrange packing and shipping of your work to galleries or buyers. I recommend it. They are expert at handling the bronze and will know just how much crating and packing is needed to safely transport artwork.

The foundry will keep a record of the edition number of each sculpture they cast. If for any reason you call in a number change, say a buyer wants an anniversary number so a piece is cast out of order, the system can break down. You are the one responsible of keeping track of the actual numbers in your own records. (At this point, Pat at the foundry I use, if she is reading this, is in hysterics! She is always having to call me to find out what I did this time. It helps if your foundry has a sense of humor about dealing with artists.) I have collectors who always want a certain number. Several of them. Just for the record, unless your editions are huge, the number of the edition makes no difference in the quality of the casting. Concern about numbers goes back to old printing methods when the plate would start to show wear, so lower numbers were usually sharper. This does not affect us, but some buyers still like lower numbers.

Now that I have mentioned Pat and her blessed sense of humor, let me say that everyone you deal with at your foundry deserves your consideration and appreciation. They are doing the very best that they can. They are dealing with artists who as a group can be a bit unreasonable or at the least a tad unrealistic. Individually, we can be flat impossible. We are communicating with shapes and textures.

They have to understand us with words. Request, don't demand. Say thank you. This is no place for arrogance, you idiot! Without the foundry artisans, buddy, you are a candlemaker. If you know it all, run

your own foundry for a while. You may get things done the way you want, subject to how much knowledge you have and your craftsman skills, but you sure won't get much original work done. And if you cast for other artists to help pay for all that expensive equipment, you'll be dealing with unrealistic artists yourself and still won't have time to do your own work.

Besides, many of the artisans in a foundry are also artists themselves and good ones too. Many are working in a foundry to learn how to best use lost wax-casting methods or to support their art habit. (Some foundries offer special arrangements to artisans who want to get their own work cast.) They can be your best allies in the world of art. And I have never had an artisan in a foundry object when a sculpture turns out to far exceed my expectations, and I show my obvious delight with it and them. They made it for me. Thank you, all of you.

Dear Aunt Gabby,

How do I find a good foundry? I don't know of any near where I live.

<div style="text-align: right;">Seeker</div>

Dear Seeker,

Most of the time, foundries aren't near where you live. Artists have moved to be near foundries.

Local galleries and art stores may not know of area foundries. Go to art shows where you can find other sculptors from your area and ask them. (Getting to know area artists who use the same foundry can be a big help. I have carried work to the foundry for artists, and they have picked up sculpture for me.)

Many foundries are located in relatively rural areas. Come to think of it, my foundry opened up here because there are so many artists located out here in the boondocks. Like under every rock.

Doing Your Own Molds

Contributed by John X. Geis

If you plan on doing the molds yourself, you need to give careful consideration to several things. First is your material that you use to do your sculpting. If you use anything other than an oil-base clay, you will have to use a parting compound to get the mold off your sculpture. The other thing is your armature. Since you will have to cut your sculpture apart to make a mold, you will want an armature you can cut apart easily.

I use an oil-base clay and an armature made of copper or aluminum wire. After your sculpture is complete, then you have the pleasure of cutting it all apart. I cut off all undercuts and small appendages that are not strong enough to pull from a larger mold. For instance, on a horse, I cut off all legs, the ears, and if the head is in a down or turned position, I also cut off the head and tail. I then make a pouring sprue out of clay and attach it to each piece I have cut off.

Then by using a caulking gun, I first applied a layer of flowable silicone over each piece.

I give it at least twenty-four hours to set up and then put on another coat. I do this for four layers of flowable silicone. When this is completely cured, I will use the caulking gun and put on four layers of regular window-sealer type clear silicone that you can get from any hardware store. Make sure that each layer is completely set before putting on the next coat. (The flowable silicone is a little harder to obtain. I use DOW 734 that is sold wherever they sell DOW products.)

The next step is cutting the mold open. I never cut it completely around the piece. I leave one side of the mold intact. In this way, it stays aligned. I then remove the sculpture from the mold and with straight pins and rubber bands pin the mold back together again. You now have a mold of your original piece. In this mold, I pour hot wax (about 180 degrees). Let the wax cool a couple of minutes and then pour the wax out. I do this several times; this recreates your piece in a hollow wax form. Next, unpin the mold and remove your duplicate wax.

Put all the pieces back together using a small electric soldering iron. You now have your original sculpture in the wax form.

I like doing my molds this way because it gives me the chance to correct any mistakes I might have put in the original when I put the wax back together (chasing the wax). The main advantage of doing your own molds is cost. It costs about one fourth of what a foundry would have to charge for the same mold. Also a full silicone mold will last for a very long time. I have some still good after twenty years.

The disadvantage is the time it takes to make a mold and working with raw silicone is highly toxic. It is hard on your eyes, and you should wear a mask so you don't breathe the fumes. You need to work in a well-ventilated area at least at seventy-six degrees. It is better if it is about eighty degrees. Your molds need to keep warm while you are using them. I do this by laying them under a lightbulb.

John's beautiful mare and foal. The foal is held in midleap by a tiny hidden weld to the side of the mare.

CASTING YOUR SCULPTURE AT THE FOUNDRY

THE CASTING PROCESS

First Steps

The artist has already received the foundry's bid on the cost of casting, checked the piece for castability (any potential design problems have been discussed), and any recommended changes have been made. The original on the table is exactly the way the final bronze will be. At this point, the foundry personnel have been known to slap my hands and tell me enough already; it looks great, so stop tweaking it. They are waiting to get started.

Delivery to the foundry to start casting *Good Example*. On the same day, seven of my bronzes are waiting on the table for me to pick them up.

(Artists, at this point, remember to *sign* your sculpture. My foundry has been willing to put the limited edition mark on it for me, but they draw the line at my signature. If you don't sign the original, you will be making a lot of trips to the foundry to sign each casting wax.)

They are ready to take any reference photographs that will be needed. This is the beginning of the file they will keep on the bronze. I would advise the artist to have also taken photographs of the sculpture, too, before it left the studio. The more involved the piece, the more photographs. It is good assurance to know they are available. One note here, take at least one set with the original at the same level, keeping the camera on a tripod as the work is turned. This gives you the best reference of the relative position of the sculptural elements. I learned this the hard way on a multifigure piece.

Next, if needed, any angles and distances are measured from a tiny mark the foundry may put on the base. Nearly all sculptures are cut in pieces during the molding process and having these measurements will assure assembly is accurate.

The Mold

In the mold room, the sculpture is carefully cut apart with a fine wire. Any armature elements are cut, the reason that foundries prefer aluminum wire armatures wherever possible. It cuts with the least damage to the sculpture surfaces. The main armature pipe supports may or may not have to be cut too. Each piece of the sculpture is prepared by adding additional wax or clay for the mouth of each mold. They are then attached to a board base. Quite often, wax sprues are added to the original pieces to provide channels to enable the wax to fill all the parts of the mold.

Good Example has been cut apart and mounted on the boards for molding. Then the first thin coat of silicone mold material has been painted on.

Parade is starting through at the same time. You can clearly see the wax sprues that have been added to the ears and chin. The woodblock that is part of the sculpture base helps make this piece a relatively simple "bell" casting too. The second photo shows that the mold parting fins have been added, and a thicker coat of silicone has been applied.

Good Example with the fins added and a heavy coat of silicone painted on the sculpture. You can still see the form of the horse's body in the one mold.

 This first part of the mold is soft and flexible. Latex or silicone rubber is often used. (I have actually made very simple molds in my studio with bathtub caulking, cut with solvent, but I don't recommend doing it. I just had to try. The solvent I used was extremely toxic!) Over the years, many new products have been developed, but the goal is to get an exact duplication of the surface of the sculpture. The first coats are thin to be sure that they flow freely into each texture. The foundry may use compressed air to blow those first coats of rubber into each nook and cranny.
 After the first couple of thin layers, fins, also called shims, are attached along the parting line of the mold. This will be where the completed mold separates and opens to release the wax copy. These fins will have silicone buttons or keylocks on them so that the two halves of the mold will line up exactly when put together. Then more and more coats are applied until the mold is sufficiently thick. For smaller molds, a "box" is put around the mold and filled with the rubber.

The original sculpture of *Parade* beside the dark brown hollow wax duplicate from the three-part mold. Notice the buttons or keylocks on the rubber mold that interlock with the matching holes to keep the sides of the mold in perfect alignment.

The bigger pieces of the sculpture will have one final step in the mold-making process. A mother mold is formed over the top of the silicone rubber, usually made of plaster, but sometimes it is fiberglass. This will be the rigid mold that supports the soft rubber while it is handled.

I have done sculptures that end up having several huge molds and an armload of the smaller solid rubber molds that contain the bits and pieces of detail work. Just keeping track of all the parts of a sculpture takes exact organization on the part of the foundry; when you see their mold storage area, you will wonder how they do it. But they do.

Most foundries guarantee the life of the mold to be two years. Some molds made of my work have lasted for a decade. It depends on the manufacturer and the conditions of storage. If a mold does start to show signs of problems, many times the foundry will pour the rest of the waxes in the edition and let the artist store them until they are needed. Which is why I have a large area in a cool part of my basement with large bundles of Bubble Wrap. The waxes in them can be kept for a very long time.

The mold rubber does get weaker over time. The sculptures with roughly textured surfaces get more wear and tear on the mold, shortening its life. As the mold ages, it may be necessary for the foundry to pour more than one copy of the wax each time to finally get a good one for the wax toolers to chase. In larger editions, the artist may have to make more than one set of molds to get enough waxes to cast.

The Casting Wax

Each bronze poured in the lost wax process must have its own casting wax copy. A wax will be melted out and destroyed, i.e., "lost" in the actual casting. The rubber mold provides each of these duplicate waxes, and each wax must be perfect.

I think of a chocolate factory. Huge tubs of melted pure brown casting wax. Each silicone mold is carefully filled with hot wax, and then dumped, leaving a thin coating of wax inside the mold. The process is repeated, and each time another layer of wax is added. The end result is a hollow duplicate of the sculpture. I describe it as similar to a cheap chocolate Easter rabbit, remember the first time you bit the ear off and found it hollow?

There is one other type of mold, an open mold, usually for parts of very large sculptures, sometimes for the base part of the sculpture. My life-sized fountain figure *Daughter of the Land* has many sections of open molds, and the hot wax was painted in layers over the rubber part of the mold. These open molds are also called panel molds. If they are made so that wax can be poured into them, then they may only need to have wax painted over the areas where the wax is thinner.

The melted wax filling an open-faced mold in the top picture. The extra wax is being poured from the closed mold in the bottom photograph.

Once the wax has cooled, each form is removed from the rubber mold. This casting wax is very firm, far stiffer than the wax the artist would want to use for sculpting. And it does look like dark rich chocolate. It duplicates

the surface details of the sculpture exactly, and the soft rubber makes it peel away easily from undercuts. The number of wax forms, also called "positives" taken from the mold depends on the limited edition number that the artist has set. The mold can produce a large number of waxes, usually far more than the artist would want in the edition.

Next, each wax duplicate is chased, meaning that any lines from the mold or tiny flaws are corrected in the wax surface. From time to time, the artist may have discovered little things that he or she would like to have changed, perhaps a surface detail they missed in the original sculpture. These small things can be easily corrected in the wax-chasing process. Hot soldering irons and other hand tools are used to make corrections. The wax chaser must have a very good eye to make certain nothing is missed. Here again, they may resort to the photographs of the original to check that details are exact. Once it leaves the wax-chasing room, the form of the wax will be the final form of the bronze.

The hollow wax duplicate of *Good Example* is carefully chased to make certain it is flawless.

A Survival Guide for Bronze Sculptors

Two shelves in the mold storage. You can see the closed plaster-sided molds, an open-faced mold, and the block molds used to make the smaller pieces of the sculptures. Each mold is named and numbered; the 6/6 means that it is the sixth piece of a six-part mold for my sculpture *His High Spirits*.

Note: At this time, the artist may choose to make alterations or variations of the original sculpture. As long as a pure wax is used, other elements may be added to a particular casting in the edition. I have made specific changes for certain collectors, a little bit of carving on the wax to make it look more like a person's own horse for instance or a more flowing mane and tail. If handled carefully, I have even been able to make changes in the position of parts of the sculpture. On my *Waltz Time* horse, I changed the position of the legs and head of the figure and created a sculpture of a pair of horses, which I subtitled *Six-eight Time*, using two edition numbers on the mark at the bottom of the bronze, i.e., 4/5 of 30. At other times, I have offered an equine sculpture in two ways, either "formally" or with a free-flowing mane and tail. It is possible to have one sculpture and extra molds for two kinds of tails or a different mane. Other variations may occur to an artist, depending on the subject of the original.

The original form of *Waltz Time* and the double variation done as a one-of-a-kind sculpture.

Something Magic has a choice of two tails and with or without a mane.

I ask the foundry to pour me a "wax" (the term used this way refers to the complete set of wax parts of the sculpture) that I can take home with me to rework at my leisure. I have to make certain that I do have available the type of pure wax I need to make any additions. I prefer to use the red sprue wax; it is nice to work with. Sometimes the foundry will sell you enough of the red wax to make your changes.

Arabesque has been done as a Native American horse with the creation of casting wax feathers.

If you notice the unicorn variation sculpture, there are plenty of loops and whirls on the mane and tail. You can have fun with a one-of-a-kind sculpture variation like this because you don't have to be worried about having to make the rubber mold. What goes back to the foundry will be burned out or "lost" in the furnace. I have even had the foundry burn out delicate branches of sagebrush that I have added to the sculpture. (Warning, they really *don't* like to do this anymore. But they did do it for me several times.)

The Power and the Glory was a powerful draft horse but made an incredible unicorn.

The silver-plated unicorn, a one-of-a-kind sculpture.

When I was just getting started and wanted to have several different sculptures in my display, I could do variations from the same original mold, and the sculptures were not at all similar. Technically they were one-of-a-kind bronzes, especially after I spent days making great changes.

As the wax chaser works, "windows" are often cut out of the sculpture as needed for the final ceramic mold. Remember, these figures are hollow. The final ceramic slurry mold must be able to flow into the inside of the sculpture wax to get a proper casting. The cutout parts are also carefully prepared for casting too. The larger waxes, ones from the huge molds, are also often cut into smaller pieces.

This shows the window cut in the neck of *Parade*.

Good Example has been chased and windowed and is now waiting to be sprued and gated. Unfortunately, I was not able to be at the foundry for the gating of this sculpture so I missed my photo opportunity.

Now each piece is ready for "gating." It must be attached to a wax cup where the molten bronze can be easily poured. Think of a small wedding-bell shape. Sometimes a long piece of wax is melted to the top of the bell like the trunk of a Christmas tree is stuck into a stand, and the various pieces of the wax sculpture are attached like branches. More wax pieces, called sprues, hold each piece to the trunk and provide channels for a free flow of bronze through the mold. They will also help allow a way for gases to pass out of the mold as bronze is poured in.

Each section of wax is gated and sprued as it is needed for the form to accept the molten bronze as quickly and easily as possible. Some larger flat sections of wax may be sprued flat and actually look more like mushrooms.

You will be seeing the sculpture progression of a local hero named *Mudgy*, in the example photographs. Terry Lee has created the bronze of the moose, *Mudgy*, and his little friend, Millie, to celebrate their children's book. (Usually Terry Lee's moose are just a bit different in anatomy.) I thought it was time for a formal introduction at this point. You will see more than one Mudgy since several are going to be installed around Coeur d'Alene to follow the story in the book.

Terry Lee's *Bayeti Inkinyama*, more typical of his usual art.

Mudgy is a half life-sized figure, and the body molds are very large. The wax chaser is working on one-half of *Mudgy*'s body.

A Survival Guide for Bronze Sculptors 123

The large sections of *Mudgy*'s body are cut into smaller parts for gating.

These gated waxes are parts of *Mudgy*'s legs and antlers.

The Ceramic Mold

The gated waxes are now taken to the slurry room where the ceramic mold will be built around the sculpture. Nearly all fine-art foundries use the ceramic mold or "shell casting" method for the pouring mold.

The round tubs are slurry, and the square bins contain the fine silica sand.

Layers of ceramic liquid slurry and coatings of silica sand will build the final mold. There are huge vats of slurry and tubs of various fine grits of sand. A dip in slurry, a coating of sand, and the gated wax is left to dry in carefully controlled temperature and humidity. Over a period of about a week, the layers are built up until the ceramic shell is about a half-inch thick. After the final drying period, it is ready to go into the furnace.

The shelves in the slurry room hold the gated waxes as they cure between layers of slurry and sand.

A thin layer of the liquid ceramic slurry, then a dusting of sand, and the layers of the mold get thicker.

A Survival Guide for Bronze Sculptors

Sections of *Mudgy* get thicker and thicker.

This is the gated wax of *Good Example* with the ceramic mold about halfway built.

You can still see the window in the hip of *The Prized One* and make out some details in the intricate gear on the saddle.

The old way of building the pouring molds involved lots of layers, and the molds were huge and heavy; many looked like barrels made of plaster. This new ceramic shell is not only easier to handle, but if cracks have developed as they are burned out, the molds can also be pulled and repaired before the bronze is poured into them. If need be, they can even be refired after being fixed, salvaging all the hours of work that has already gone into each casting wax.

The Pouring Room

The ceramic shell molds fill the huge gas-fired furnace or kiln. As the temperature rises, the wax inside the shell molds melts out (is "lost") and runs out through a collection pipe into a recovery basin under the kiln. Any wax residue in the mold is completely burned, and carbon remaining is vaporized too. As the mold is cured and hardened in the fire, the temperature is raised to 1,400 degrees. The ceramic becomes bright cherry red.

A Survival Guide for Bronze Sculptors 129

The temperature of the molten bronze in the furnace is checked with a pyrometer while the kiln is opened to remove the hot molds. Notice the protective clothing worn by the workers. The temperatures are intense near the molds.

Across the room, another furnace prepares the bronze for pouring. Ingots of bronze are melted in a carbon crucible at a temperature of over two thousand degrees. Impurities that rise to the surface are skimmed off.

Once the bronze has reached pouring temperature, the molds are removed from the kiln and hung on the waiting steel frame. As each is placed, it is checked for any possible cracks in the ceramic, and patching compound is applied as needed. Every minute counts while the molds are hot.

The steel tray holding the molds is removed from the kiln, and each mold is carefully hung on the rack ready for the pour.

A Survival Guide for Bronze Sculptors

Any repairs to the ceramic molds are done as needed.

The oven is finally opened, and the crucible is clamped and lifted with a hoist.

Strong steel brackets clamp around the crucible, and a chain hoist raises the basin of liquid bronze like gold from its furnace. Long handles are attached so that the workers can control and tip the molten bronze into the mouth of each waiting mold. The flickers of color that play over the surface of the glowing golden metal are incredible. Thirty-two years later, I still love to watch the moment of pouring. To me, this is the time the sculpture becomes real. In a few minutes, the tops of the bronze in the molds cool and scale over black. Nothing can be done now but wait until two thousand degrees becomes room temperature. But inside the ceramic shell is the art, hours away from its true final form, but it now exists, well on its way.

The lifting clamp is replaced with a pouring clamp that is also supported with the hoist.

The workers control the pour into the open mouth of each mold. One worker watches to skim off any slag that has formed before it can flow into the mold. The ceramic molds have turned white, but if you were to look down the open mouth, you would still see a glow of cherry red.

Any remaining molten bronze left in the crucible after all the molds are filled is then poured into an ingot mold for use in a later pour. The molds are cooling in the rack. You can see the darker areas on the body of some of the molds where the patching cement was used.

As the bronze cools, it shrinks enough to start breaking the ceramic shell mold. Very little more is needed to complete the process; any more bits are sandblasted off the metal, inside and outside. The entire gated "tree" has become bronze, and now all the sculpture parts are cut free from the "branches," the sprues that connected them. The "tree" will be salvaged to become part of a future melt of metal. The sandblasting to remove the last traces of shell also removes the black scale, and the pieces are ready for building in the metal room.

As the ceramic mold cools, pieces start to break free. It is still too hot to touch. It is then put on the pile of broken molds for more ceramic removal.

The last big pieces of ceramic shell are knocked loose with an air hammer.

You can see the shape of the original gated wax with all the sprues still attached. There is still some shell to be removed with the air hammer, and the sandblast box will take care of the rest.

The Metal Room

Now the building process begins. As the pieces are fit back together, they are welded, often with welding rod poured at the same time as the other molds were poured. It is important that the metal of the welds be of the same alloy of bronze so that the patination process will be without visible seams on the surface. As the welds are completed, the original surface of the sculpture is tooled back so that the welds become invisible. There is much grinding needed to make certain all the elements of the artist's hand are recreated in the textures. Here again, the photographs are checked for accuracy.

Good Example is having the welds ground back to the original surface.

A Survival Guide for Bronze Sculptors

The window in the neck of *Parade* is readied to be welded closed.

Mustang and *Grandee* in the metal room. They have been welded together, and the marks of the weld already ground smooth.

Mudgy the moose being assembled. You can see he has a steel support inner structure. He and his friends will be subject to lots of attention from children so he needs to be very sturdy.

One of the poured sections of *Mudgy*'s body. And now *Mudgy* has most of his head.

Even more of *Mudgy*, nearly complete.

At any point, the artist may be contacted and asked to come in if there is any question that arises. The last part of the time in the metal room quite often involves the artist, for 2 percent, as it is called. The artist will be asked to go over every inch of the sculpture to make certain that nothing has been missed, and the sculpture is built to his or her absolute satisfaction.

Bear Foots is completely built, sandblasted, and waiting for his turn in the patina room.

One final trip through the sandblast box to remove any welding scale and fingerprint residue, and the bronze, now handled with gloves, is placed on the shelf outside the patina room.

Patination

"Patina" is an Italian word for color. The waiting bronze is a dull gold color, unless a high-polished surface has been ordered. Bronze is an alloy that is mainly copper. There are variations developed commercially so that the foundry has a consistent metal that can be easily welded and worked, and one that will react reliably to most patinas. The copper makes the bronze oxidize readily in the presence of acids, caustics, and other chemicals. Like copper, untreated bronze will eventually oxidize in air, with

the trace elements most atmospheres contain. Once patinaed, the sculpture must be sealed against more oxidation, not only from the air but also from the acids in your hands too.

Nearly everything can affect the patina results. The temperature of the bronze as the acids are applied, the rate of cooling, minerals in the water used to dilute the acids, or even the water used to wash the surface of the bronze. Patina chemicals can be applied in endless ways, each having its own effect. They can be a bath for the sculpture, they can be sprayed on, brushed on, splattered on, and layered on. The patina artisan has to be incredibly knowledgeable to be able to handle so many of today's new patinas.

When I started thirty years ago, there were only about six to eight usual patinas available that the artist could rely on for permanence and consistency. Now there are hundreds that have been developed. Many are a foundry's secret formulas, but most patina people I have worked with are always on the lookout for new results. A patina must be permanent; the art the buyer receives must not change over time.

The New Blanket on the patina turntable. The big table shows a selection of some of the bottles of acids needed to create the patinas.

The New Blanket completed.

Good Example getting its patina.

 Each patina is going to be unique, unless you choose jet-black. There are just too many variables. Most patinas require at least two chemicals. Even the basic bronze color that many people still prefer. The name for that patina is classic ferric, a more or less reddish brown that is good for showing detail, shines like it is metal, and is what people traditionally think of a bronze appearance. Even it can be anywhere from a dark brown to a very light metallic tan. The under chemical provides the darker tones that emphasize its surfaces; the ferric acid gives it the warm color. Without the ferric acid, the bronze would appear to have olive green tones.

 When choosing a patina, the artist must consider the actual surface texture. If the patina artisan shows a sample, remember the result may not be exactly the same. And, of course, there are all those other chemical variables too. I will say it again and again, a patina is an art, not a spray can.

 A bronze may have many different types of base or none at all. The foundry will usually be able to provide wood and stone bases as the artist directs. The bottom of nearly all bronzes are drilled and tapped so that bases can be

securely bolted to them. Bases can be changed, marble substituted for wood, or even added between the wood base and sculpture. Whichever the artist has chosen, it should compliment the overall sculpture yet not overwhelm it. Again, the buyer may have special requests for their own work of art.

Each lost wax-cast bronze sculpture is a unique work of art. Each bronze in a collection is a treasure unlike any other. I hope the delighted owners of a bronze will not be able to keep from touching the surfaces and feeling its form with their hands. I know how they felt under my hands as I made them.

Good Example completed and based.

Caring for Your Bronze

The owner of a lost wax-cast bronze sculpture has one of the most enduring works of art. It is tough. It is close to permanent. It is the most repairable and restorable art form I know.

I have seen them pulled out of earthquake rubble, I have dropped them myself off the tailgate of a pickup truck, I have seen them knocked off a table in my display, and I have even seen them returned to a foundry with fire damage. Scratches are repairable, bends can be straightened, broken pieces can be rewelded, and bronzes can be repatinaed. Some collectors have asked to have this done because they want it changed for one reason or another. All of this without loss of value. I carry one of my bigger horse sculptures around by a slender foreleg. These things are hard to break or destroy.

So enjoy your work of art. Handle it. Let your children and grandchildren touch it. Experience it. Dust it with a soft clean cloth. For the intricate areas or heavily textured areas, I use a good four-inch paintbrush to get dust out of the crevices. I use neutral shoe polish to keep a coat of wax on the areas I touch the most. It is a hard wax that is just quite diluted. Dust your sculpture, then dab on the shoe polish, and let it thoroughly dry. Buff it gently until you have the amount of shine you want. This keeps a film of wax between your hands and the surface of the bronze.

Most wood bases that I use can be made to look their best with an Old English type furniture polish.

Understand, here I am speaking about contemporary sculptures done as I have described by foundries like Cire Perdue and others that I list. I cannot speak of imported bronzes, which may have used different alloys and finishes. I also cannot speak of antique bronzes; again, processes have changed, as have patina chemicals. I remember one semihysterical call from a lady who was trying to clean an antique bronze; it was a Charlie Russell bronze, one actually cast under his direction, not one of the new recasts that are now so common. It seems that the more she scrubbed it to get the dirt off, the more the color came off. There are patinas, and then there are "patinas." (I referred her to the experts at Valley Bronze of Oregon, an excellent foundry and the best I knew at the time.)

Recasts and Other "Bronzes"

"What is a recast, and how come I can get one for so much less money?" It is a bronze by a famous artist.

Yes, it is a bronze, but understand that a recast is a copy done after the copyright and control of the original artist has lapsed. It is rare that the molds can be taken from the actual edition of the sculpture; instead, someone has made a copy of the work, duplicating to the best of their ability the original.

Some copies are rather better than others. Some are pretty poor. Basically, they are worth about the price on them. Many copies made by nonhorsemen have large errors in tack and gear, not to forget the errors in anatomy either. I have seen some well-done recasts but if they are not cast by a quality foundry, they may not be as repairable as true fine-art castings. If something is inexpensive, there is usually a good reason.

Having said all that, yes, technology has now gotten to the point where a foam model of just about anything can be made with the right laser and computer program. I have talked with several representatives of companies that provide artists with this service; it can be priceless in pointing up a small sculpture to monument size. Conceivably, one of my buyers could take one of my bronzes to a company like this and turn out an unauthorized set of editions of the same piece from three inches tall to three feet tall. Until I caught them doing it, of course. My editions are copyrighted. But any art that is out in the public domain could be legally copied. But if you buy a sculpture by a famous artist for a really bargain price, you still have a copy, and it won't be worth what the same version in the Denver Art Museum is worth. Buying art from a reputable gallery or the artist himself (herself) assures you that you are getting the quality work I have described.

There are, of course, many exceptional artists all over the world. The increased market for outdoor sculpture has made imported life-sized work profitable for many places to produce. Just know what you are buying, and enjoy it for just what it is. And don't expect me to be able to meet their prices on my work. (But then I can give you a tour of my foundry without needing a passport.)

Cold cast bronze is bronze powder in resin. It is not restorable and repairable only with superglue. There are some lovely cold cast sculptures out there, but you do have a work of art that is about as fragile as clay or porcelain. It is usually produced in much-larger editions. Many fine artists have done originals for companies producing these works. I haven't, but yes, several companies have inquired. My name goes on work cast under my supervision, which is one reason I will not consider a foundry I cannot visit easily if I need to or one my buyers can't contact if they have questions. All my sculptures are cast bronze metal by the lost wax process.

Enjoy art wherever you find it. I've seen darling pieces at discount and dollar stores. Just know what you are buying. Yes, you can get great bargains at garage sales and thrift stores. Someone bought one of *my* older paintings at Goodwill. (At least they bought it quickly when they saw it!)

MARKETING YOUR WORK

Now What Do I Do?

Okay, you have read this book so far. Hopefully you couldn't wait to try the things I have suggested, and you have, just for fun, completed your first original wax/clay sculpture. (At this point, you haven't had to spend much money, you've had a great time, and you think maybe it doesn't look all that bad for a first effort.) You may even have decided to have it cast; your kids think it's great!

You may decide just to enjoy sculpting for yourself. If you can afford it, you may cast your sculpture as gifts and family treasures. You are a creative person, but you haven't taken your art that seriously in the past.

Would you dare take it seriously? Would you actually consider making a career of this?

Dear Aunt Gabby,

I loved the thought of sculpting, and when I tried it, it was just great. But I am forty (or fifty or sixty, etc.), and isn't it a little late for me to start getting in to this? How can I start a new career at my age?

<div align="right">Feeling Middle-aged</div>

Dear Feeling Middle-aged,

Okay, you are forty (or fifty or sixty, etc.), and nothing is going to change that. But what do you want to do with the rest of your life? Sculpting should come with a warning label. For some of us, it is instantly addictive. Why not consider spending the rest of your life as a sculptor? Maybe you aren't as young as you were, but all those years of living have given you material for your art. You didn't spend them in a windowless box. You had experiences,

you saw things, you learned things, you have so much more of you to give to your art now than you did in your twenties. Experience, insight, judgment, critical thinking, you have *maturity* to offer. Maturity isn't a crime; wrinkles aren't like prison tattoos. It can be an asset if you let it! Use it! Enjoy it!

**

If you want to keep sculpting, if you *need* to keep sculpting, then you will have to find a way to afford to do it. Find a way to sell it. I know what worked for me, and I will tell you. You may decide just to do it part time for a while. That is okay too. Start slowly and learn as you go. Maybe it will be the career you go into after you retire from whatever it is you have to do now. You can start building on the future today. Age is not always a detriment for an artist. People expect maturity in many parts of the art world. You can be taken more seriously; many early art careers are abandoned to the pressures of raising a family and getting a "job." (Besides, an older individual can often relate better to the buyers who are more mature themselves.)

Let's go back to the completed wax original on your worktable. You are happy with it, it is your best work, and I am assuming you would like to sell it. (There are people who sculpt just for their own enjoyment and cast only for family members.) There are some decisions that have to be made now, as you reach for the tool to sign it. One of them is to copyright it. *Do not assume* whatever I tell you about any *legal issues may still be accurate* the day or place you read this book! Laws change overnight, both federal and state. Laws also vary from state to state.

You are responsible for protecting yourself by getting current legal advice. Having said all that, at this date, putting a circled *C* and the year gives you a copyright protection. This does not mean people may not copy your work. Some do out of ignorance, and others do it because they assume an artist is not going to be able to afford taking them to court. (Yes, it has happened to me.) You can register a copyright; some artists do it. I never have; you will have to check for yourself. I understand it is easy, and you do not need an attorney to do it for you. I suggest you go online to start your research.

Personal Story

I did pencil drawings for many years and offered very nice prints of them. Since I was also wholesaling them, I had a good brochure printed that was a catalog showing them. At one show, I was approached by a man who gave

me his card and asked if I would be interested in designing for his jewelry business. He took a brochure and said he would contact me. Six months later, I was at a jewelry counter and found my print of a unicorn and baby redone in pewter as a pendant. You could say I was upset. I contacted the man only to be told that I should be flattered that he thought it was good enough to copy (from a copyrighted drawing, no less). He also went on to justify his theft by telling me that artists never had enough money to bring suit for copyright infringement anyway. (Which was absolutely accurate. I was paying for a divorce at the time.) (And no, when I asked, my divorce attorney knew nothing about copyright law and wasn't interested in learning.) I had enough hassle in my life at that time so I let it go. (Don't try it now, buddy, my life situation has changed, and I will take your a—to court!)

The follow-up to this learning experience. I was at a Renaissance Fair two years later and stopped to look at a booth featuring pewter ornamentation. Something looked familiar, and the vendor has handed me the piece I was looking at for closer examination. When I turned it over, the back side no longer showed the maker's mark. I mentioned that I thought all work was supposed to be the vendor's original creation and was assured that was true. "But I created that design myself." "No, this is all my work," he argued. I then asked if the name of the other jewelry maker was familiar to him. The pendant disappeared so fast it left a vapor trail across the counter. I told the vendor not to worry; I wouldn't challenge him in front of the show committee. And I suppose part of me was happy to have my design so popular. But I hope he learned something; he probably paid rather a lot of money for the right to have a booth there, and there are no refunds of booth fees when vendors are caught cheating. And somebody always knows.

Edition Size

The next decision is the size of an edition if you want it to be a limited edition. You have to make a primary mold to get the hollow casting wax; it is a one-time expense that for me is best spread over the sale of several bronzes. The fewer in the edition, usually the more each is valued. Also, as you are starting your marketing, you may not have outlets for a large number of castings of the same piece. (One artist I know makes his editions fifty, one for each gallery he has in each state.) I started with editions of only ten. As they started to sell better and I did more shows and had more galleries, the edition went to fifteen. Now most of my limited editions are either twenty or thirty, except my large works, which are editions of fifteen. You need to

decide now so that you can make the edition mark on the bronze before it goes to the foundry (1/20 etc.).

Another consideration is your likelihood of rather rapid growth as you start producing sculpture. Your first works may look to you rather rough in a relatively short time. Smaller editions may sell faster, and you won't have them around long. And every artist has pieces that they would rather not see very often. This does not mean they are loved less by their collectors, but you know by now, as an artist you see the things you would change if you could. We are hopefully our worst critics.

Pricing Your Sculpture

Pricing, what are you trying to pay for? The cost of casting or the cost of living? You have to pay for the mold cost, any costs traveling to the foundry, and the cost of the materials used in making the original (or you have a very expensive hobby.) Once you start marketing your art, you have to cover show fees, travel expenses, meals, display setup, business clothes, and then you may want to have brochures, business cards, advertising, and even setup a Web site. (Do you have the skills to do that yourself?) There was one show back East that I used to do that I had to sell $6,000 worth of art before I got out of the red and starting making a profit from the show. Then and only then do you start making a wage at this. If you elect to go the gallery sales route, you will be paying 30 to 50 percent commission when they do sell your work.

Hey, it can be done. I've been doing it, and so have a lot of my friends. *But it is a business.* Treat it as one.

Back to pricing. To make a profit, you will need to price your work at least four times casting. Oh, if you have a house right by the "road" where you get lots of traffic and put in your own gallery in your living room and go nowhere else, fantastic, but you will still need to do some advertising. For the rest of us, four times casting. Three times casting may support your habit, but it won't support you. It does make you very competitive if you are just getting started and have other means to pay the bills. (One note here, there are buyers who are suspicious of lower-priced art; they wonder what is wrong with it. Really!) Pricing too high can mean that in a down market, you may not sell much of anything. Vanity pricing, what I call selling your art high because you are famous and your work is worth it because you are so well-known and everybody accepts how good you are, is wonderful, if you can do it. But if you are reading this to learn how to do it, I can only assume that you are a bit away from fame for your bronze sculpture. One actually famous artist told

me years ago that you price your work until you are selling faster than you can produce it, then raise your prices. The other consideration is your target market. If you are aiming at decorators and buyers who have multimillion dollar homes, then you will find that much artwork is valued only if the price is very high. Likewise many corporate buyers. If you have the contacts to those markets, price accordingly.

I am known for reasonably priced sculpture. Four times casting. (Now all my buyers know.) But now they know why. I sell lots of bronze. I sell bronze to people who pay as much as they can to own work they find extremely special, and they love each piece. I sell even in a down market. (Actually I am a helluva bargain!) I don't do hype or court corporate sales. I love my buyers; I mean I am comfortable and enjoy the people who collect my work. I travel to places I like to do shows. My foundry likes me; they get to cast lots of my bronzes.

Your pricing will depend on many different conditions. I have other variations on my actual sales price structure. I offer a percentage discount for repeat buyers at my own gallery and at selected shows. I cannot do this at other galleries that have my work or at commission shows. My buyers understand this. If someone makes a multiple purchase at a show, then I will work with them on a better price. And yes, since I am in business for myself, I have, once in a while, made very special deals to very special people in special situations. I also offer a discount to other working artists who wish to purchase my work. Many have extended the same professional courtesy to me.

Another marketing arrangement I make with a great deal of success is that of a precast sale price. Many sculptors do this. If someone is willing to order a future casting from just seeing the original wax sculpture, then I offer a discount price. (With an absolute satisfaction guarantee included.) Buyers can order the patina they wish and often the edition number they wish. Since a sculpture is part of a limited edition, buyers often think, "Well, if I don't buy it today, I can always get it the next time." More are available, so they may choose something else at a show to buy, from someone else. With only a limited time to be able to take advantage of the special price, the collector is much more likely to decide on the sculpture order immediately. Also, by offering the sculpture at a really good price, it is a way to test the salability of the sculpture. If no one orders it at the precast price, then chances are very good that it will not sell well once it is cast. Some of my most popular bronzes have been ones that went back to the studio for rethinking and reworking. By getting at least two orders at the precast price, I have enough funding up front, even at a payment of half the price down, to fund the primary mold and start the castings through.

But take warning on this; don't guess at the casting bid. Make sure you know. There was at least one bargain I did not mean to offer, even as much as I love my collectors. It took the precast sale of five sculptures to even pay for the primary mold as well as the sold bronzes. It was a major oops, and several collectors jumped on it. Bless them, they were all repeat buyers. I told them it was a once-in-a-lifetime deal they were getting and not to expect it again! Since I have a mailing list, and I send photos of new pieces at the precast price to everyone on it, many people order just from the mailer photo too.

And Then the SOBs Took Out the Whole Damn Corral is the best bargain I have ever offered to my collectors. Always *check* your bid on your bronze before making a precast special price offer.

Many artists have started by offering their works to people they know at a precast price, contacts through business or good friends or quite commonly

relatives. There are some lovely angels out there who are pleased to help an artist get started. God bless them all!

Bottom line for a precast: twice casting or better yet three times casting. Ideally, if you only sell one at precast, you can pay for the primary mold, the sold casting, and your own casting which you can put up for sale at full price. Sell two at a three times casting price, and you have made your first profit.

But especially as you are getting a feel for your sculpture and your foundry, get a firm bid before you start to sell your sculpture to anyone. (Later you can afford to make the mistake I made.)

Multiple Sizes and Partial Casts

I have mentioned the ways that sculptures can be enlarged. Now the question is, Why do artists release so may of their pieces in multiple sizes? There is a market for various sizes of the same sculpture. Not only can small versions be used to fund the creation of a monument, but many times people will desire a small size of a bigger piece they can't afford or have room to display. If an artist is trying to maximize the production of one sculpture as many ways as possible, multiple sizing is one way. Once an edition limit has been established, a different size can be considered a separate edition.

On the other hand, some collectors don't like seeing a piece they own in different sizes. They feel that if an edition is of say twenty pieces, then that is all there should be of the original work period. If the buyer is aware that several sizes will be available, they should have no complaint. I don't do it myself, although I have told the purchasers of one of my sculptures that if it is ever commissioned in monument size, I will allow the point-up. It happens to be a work I feel very strongly about; it honors a group of women who have run the ranch themselves, and they deserve recognition. The sculpture is *The Boss Lady*.

Partial casts are literally parts of a sculpture cast as separate editions. For instance, casting just the head of a horse when the original sculpture was the entire horse. Another way to do a partial cast is to just take one figure out of a group of subjects. It is common also to have just the bust or upper torso and head cast from a whole figure. Many artists do this. Many buyers collect them. Other buyers don't like the idea at all. Again, it maximizes the amount of art that can be sold as limited editions from one original work. And it gives a collector a way to have a smaller or cheaper piece of sculpture they like.

I don't sell limited editions of pieces of my original work as a different edition. If a person only wants one figure from a group of subjects that make up one original sculpture, then I may split that particular edition number into part A and part B. I have a pack train, two pack animals and a mounted rider. The rider and the first packhorse were cast as one sculpture (A1/15), and the pack mule was cast as another (B1/15). In other words, in the edition of fifteen, only fifteen casting waxes are poured for sale. Total: not fifteen pack trains plus fifteen more mules.

You can see the easy break possible in *The Long Road Home* between the mule and the rest of the piece. I used pouring wax to create a suitable base side on each half of the new sculptures.

I have modified a casting wax especially for a collector too. In one case, I turned a horse into a unicorn. It was titled *Power and Glory* (V6/15), so that if ever it needs to be verified in the future, there will be the clue that it is different from the rest of the limited edition. I suppose that legally, it could have been sold as one of a kind, but again, I don't work that way. Fifteen in the edition, fifteen casting waxes poured for sale.

Now, here I need to eat my words a mouthful or two. I do reserve the right on each limited edition to cast one artist's proof bronze. My verbal contract with my buyers is that artist's proofs will not be sold but remain in the family collection. Period. (It is a verbal contract, but so much of business is just one person's word. Your word is good, isn't it?)

For quite a few years, some artists used to market artist's proof 1, 2, 3 (AP1/20) and so on. Then there was the term foundry proof; supposedly the foundry had the right to have a casting or castings to keep checking against (FP1/20, FP2/20). I guess that in some ways, you could define the limits of your limited editions with any criteria you wanted, especially if the information was on the sales invoice given to the purchaser at the time of sale. (Oh, for goodness sake. Raise your limited edition to ten more castings, and don't confuse everyone.) I have heard in some states that there are now legal limits to what is defined as a "limited edition," but I don't know for sure. Bottom line, don't confuse your collectors. Uncomfortable buyers buy elsewhere.

Some Ideas About Legal Issues

Legal matters. I am not an attorney, and the laws change constantly. Things are much better for artists than they were thirty years ago. More money is being spent on art; there are more collectors, and more people care. Copyright laws are much stricter than they were.

Don't copy. Work derived from other work will be judged by some court somewhere, and it can be decided in court that a copyright has been violated. Of course, you may choose to copy from sculptures or paintings or photographs that are in the public domain. That means the copyright has long expired. Some artists label their sculpture as "after a work by_____." You can figure that sooner or later, someone will recognize your source material. Copying older work is legal *if* you are certain the copyright has expired. The current law extends it far longer than it used to, it can be renewed, and heirs often update it.

People also have a right to their own faces. Public personages, famous people, can sue if their image is used. Again, heirs may have legal rights to these images too. (I suspect anyone can sue if their image is used without their permission.)

If you want to use someone as a model for your work, get a legal release. Here again, I am not an attorney, and you will have to do your own research on whatever form it should take. But I know friends have run into problems with this. I used to paint portraits of mountain men I met at Rendezvous, which my attorney set me up with a release, and I exchanged a small bronze medallion as payment for them allowing the work. That was twenty years ago, more may be needed now.

Basically, you need to know that there are legal issues you must consider. If you are just doing a piece of art for your mother for her birthday, that is one thing. But if you are aiming for a large market and eventually national

advertising, you have to know some of the facts. And you never know when you are going to do that piece that will catapult you to major recognition.

Speaking of national advertising and copyrights, I have found that when I do a sculpture that not only turns out very well but is also a truly original concept, getting it in print such as in a national publication indicates that it was my idea first. At least, it would certainly appear so. People will get ideas from your work too.

Respect all copyrights. *She's the Circle of Life* started as an image in my mind from a song written and sung by Jack Gladstone. He sent me a signed release to use his song title on the sculpture.

Art Galleries

Good art galleries can be a wonderful asset to your marketing. They are selling for you while you are in your studio working. The best galleries have an established reputation; just having your work shown in one is enough to establish your credibility as a fine artist. They have a history of only carrying good art, and they have done the research on each artist for their collectors. They have a customer base that looks to them for the best for their collections and will buy art from a relatively unknown artist if the gallery recommends it. The sales people know just what many of their collectors are looking for and proudly announce a new "find" for them. They will take art to the buyer's home for a showing in place. They also handle the financing, sales tax, and packing and shipping if necessary. Nearly all my overseas sales have been handled by my galleries. The sales staff is also knowledgeable about media and processes and will answer any question the collector may have. They will have an advertising program, and you may even get a special gallery showing that is sure to be well attended.

You will pay a healthy commission for their services, but they will have earned it.

Nearly all galleries want consigned work. They pay you nothing until the art is sold. Contracts will vary, as will the commission that you pay them. This commission can range from 30 to 50 percent of the sales price. The artist will tell them the price they want for their art. At this point, things can get complicated, depending on the gallery. Contracts will vary from gallery to gallery. With sculpture, involving limited editions, you may be marketing other castings yourself or at other galleries. When you tell them the price, they know that a buyer can go to your Web site and see the same price there. Usually the gallery will price the sculpture the same. With a painting, they may decide to raise the price. If the contract says you are to receive 50 percent of the price you have put on the work, you may only get that amount, even if they have sold the work for more. Some galleries have sold my sculpture for more than my price. It all depends on the wording of the contract as to how much the artist actually gets.

There may be other fees you are charged. If advertising is done for your art, you may be asked to pay part of it. It may be the same for the added expenses of a special showing. This should be covered in the contract you sign with the gallery. Some galleries want a total exclusive right to represent

the artist. They plan on a large promotion of your work and want the benefit. There are many artists who are solely represented by one gallery who act as their agent on all sales.

A gallery will usually expect an area exclusive. This means that you cannot market your work in any other way in an established geographic area, for instance, no other galleries in a sixty mile radius of that particular gallery. (Secondary market art—where a buyer decides to sell your work he owns and consigns it to another gallery—is beyond your control. You are not selling the art, the previous buyer is.)

A gallery may want an exclusive right to just one edition of your work. They may even get involved with the production of the sculpture to the point of investing their own money.

I have been a problem for some galleries because I have a regular show schedule all over the West. I do market my art inside exclusive areas from time to time. My galleries understand this; it is covered in the contract. One way I can help is to post a sign at the show informing buyers that my work is available in the area all the time at the specific gallery and even hand out their business cards. We try to work together.

Some galleries are willing to work on a casting-paid arrangement. They choose the bronzes they wish to show and pay you for the exact casting cost of the sculptures. When the bronzes are sold, the cost of casting is deducted from your part of the sales money. (You already were paid that amount up front.)

This is lovely for the artist. You don't have a several thousand-dollar investment of your money that may or may not be well displayed in the gallery. (What does a gallery do with your work if they are having a one-man show for another featured artist for a month or so?) And a gallery who is willing to do a casting-paid arrangement is guaranteed to be very excited about your work and will be very enthusiastic about marketing it.

When I have been blessed with a gallery willing to do casting paid, I offer an exchange or buyback agreement as part of the contract. If a bronze does not move in a certain time, I will exchange it for another that has the same casting cost, or I will buy back the bronzes from the gallery.

The insurance carried by the gallery on your work can vary greatly. This is another matter you need to know as part of the contract.

Unfortunately, galleries can also have financial problems and can close or even go into bankruptcy. This can be tragic for an artist. Artwork has been locked up by legal means, and an artist can be out of luck completely

if the consigned work is considered a gallery asset. The legal status of consigned work varies from state to state, and the laws change. Gallery owners and artwork have disappeared overnight.

Most galleries are reputable business people. Some aren't. You must choose carefully. Starting artists are vulnerable to risk because in the early years, we tend to be so flattered when any gallery wants our work we can be too eager.

Your *contract is critical*. It is a fact that the time involved in having the contract carefully checked can prove to be very important. It is also a fact that most artists don't check it thoroughly. Yes, I have done business for years with some galleries on just a verbal agreement, which leaves me and the gallery at risk. Luckily, we have done very well for each other, and no problems have arisen. But a contract can provide you with legal protection in many situations. Or at least a leg to stand on in a court action. And I have gotten burned in the past by a gallery, in a sale to an FBI agent no less. The gallery took the money from the order, never paid me, and the gentleman blamed me for not receiving his sculpture. (I was still waiting for the check from the gallery as promised before shipping.) It took direct communication with the buyer and artist to straighten that mess out. I don't know what happened, but he got his bronze, and I got my check, and the gallery went out of business.

Everything in a contract can be negotiable. Some galleries have policies that are not flexible, and most galleries do have financial constraints. A gallery is an expensive business to run properly. But if they really want your work, you do have some bargaining strength. But don't get too arrogant. The world is full of good artists who are eager to find a place to sell their work, and any good gallery has a line of artists just waiting.

If a gallery is carrying your work, remember that you both have the same goal—to sell as much of your art as possible and make a profit. You need to be able to work *with* your gallery. You must deliver promised work on time. If a special show is arranged, be there ready to sell and do your part. Be nice to people and support the gallery and all it offers.

Of course, you are going to deal honorably with your gallery. You aren't going to try to steal their contacts that they have worked hard to make for you. There are buyers who, having seen an artist's pieces in a gallery, will try to contact the artist to get a better deal. My galleries let me know if they have someone who is interested. If I know the name of the person and I am contacted by them directly, I will owe the commission

if I close the sale on the sculpture. (But I have to know the name.) Or the salesperson may let me know which piece has had so much interest by a particular person. (They may not have gotten his name.) It is fair to ask a buyer who calls where they saw the artwork. I do have an active Web site, and buyers can and do check out the Web site before investing in one of my pieces.

If a buyer calls you about purchasing a piece that he first saw in a gallery in the last month or so, no contest. I owe the gallery a full commission. After this, the situation can get into a grey area. What if you meet the buyer at a show in two months, and he remembers your work from the gallery. If you have an edition of the same piece and he buys it at the show, if there is no commission on the show sales, then the gallery has a case to expect a commission or at least a part of one. They did do the preliminary part of the sale by establishing you as a valuable artist, though they did not close the sale. If he finds a sculpture he likes better and buys it, perhaps then you won't owe a commission. But if the buyer keeps referring to the promotion that the gallery gave you, then you can be sure that they helped make this sale at least in part. Perhaps legally, by contract, you may owe no commission, but would you have made the sale without the buildup they gave you in their store? I have collectors who come to see me at shows and also check out galleries as they travel to see if they carry my work. Sometimes it is not cut and dried. Each situation has to be evaluated on its own, and you have to be the one who decides what is fair to all. I never said this business was easy. I have sent a gallery a 10 percent gratuity or better that they did not expect. I don't know how many other artists do this, but it is the way I like to do things. Confused by now? Well, I get confused a lot too. Just do what feels right.

There are gallery managers who will not release to you the names of buyers and contacts. There is an old attitude of distrust that still prevails in many places. It is unfortunate, but it does happen. Galleries have been burnt by artists as much as artists have been burnt by galleries. Deal with it as best you can, and read and discuss your contract with them in detail, and try to cover every situation and what their expectations are. Me, I don't like to work with people that start out distrusting me, but I can understand where they are coming from. To them, it is just wise business policy.

So how do you get your work into a gallery? The very best way is for them to approach you and ask for your work. They may see your work

at an art show or see your ad in a magazine. In fact, they are much more likely to ask you if they see you are advertising in good publications; you are already doing good promotion that will benefit them. Anyone can buy an ad in a good art magazine, but somehow seeing it there gives an artist professional credibility. More about that later.

If you choose to make the approach yourself, then be very professional. Some galleries prefer that you send a portfolio of typical work (a small selection or a quality brochure that includes a brief resume) with a request for an appointment to meet with them. You will, of course, have visited the gallery to make certain that your work is in keeping with the type they market. A follow-up phone call a week later is appropriate. You will need to speak with the owner or manager. If they haven't "discovered" you first, the least you can do is be as professional in your approach as possible.

If they are not interested, it may not be that your work isn't good enough. It may be that they have all the sculptors that they feel they can display. Or it may be that your work is not just what they are looking for. Like any interview, a thank-you note is in order. You just might want them to be thinking of you if their artist roster should change. If you know one of their artists, a personal recommendation may help get them to consider your work. Remember, galleries are constantly asked by artists to look at their work, not all of it at a quality level. These are busy business people, and they won't have a great deal of free time to spend with you or even explain why they cannot use you. Don't take it all too personally. Rejection is just a test of your determination!

Personal Story

Way, way back, when no galleries carried my art and I was so hopeful about getting into any gallery, a local gallery near where I lived offered me a one-man show. I was so delighted and thrilled. At the appointed time, I brought my paintings in. (Yes, it was far enough back I had not started sculpting. I said it was way, way back, remember?) The day before the show, I went in to check out things, only to find my one-man show was being shared with a collection of sculptures of Joan of Arc consigned to the gallery. And Joan was everywhere—on pedestals in front of my work, on tables in groups, and, as you entered the gallery, in a position of honor, a large bust of Joan was sitting on an antique potbellied stove. (Yes, visualize it. The poor Maid of Orleans never

had such a figure while alive.) When I asked for an explanation, I was informed that since I was so unknown, my work would not be very much of a draw, and so Joan was brought in as a headliner.

Once I stopped hyperventilating, by then I was home, I grabbed my phone rolodex. I spent the next four hours on the phone, starting with A all the way to Z. If the number wasn't long distance, I called it. Every artist I knew, plus my attorney, accountant, horseshoer, feed dealer, six babysitters, framer, my minister, and eight church ladies that I really liked. And kept calling. I told my story over and over. And I made a request of everyone of them.

Well, you guessed it. The show opening night was a success. Bless them, as many as could showed up to drink his cheap champagne. Even a "name" artist showed up and brought several of his collectors along too. The gallery owner's face was a picture. Nothing sold, but that wasn't my aim. Joan didn't sell either, but each person made a point of letting him know how much they liked my art. I am still grateful to each and every one of them, all these years later. Okay, about two dozen of us had a great time in the bar down the block after the show closed; that was the real party.

Dear Aunt Gabby,

Why don't I just open my own gallery?

Superartist

Dear Superartist,

If you can successfully run two full-time businesses, go ahead. Me, it is all I can do to properly run this one.

The Studio Gallery

Many artists do run a successful art gallery at the same time they work as a full-time professional artist. And if you already have considerable retailing experience, you may do just fine. But there are some points for the novice to consider.

I don't believe you can do it by yourself. If you plan on being the artist in action to pull buyers into your gallery, you will have to stop painting or sculpting to deal with your clientele. The gallery must be open regular hours so you will have to be there unless you have a staff to cover for you. You won't be able to do art shows and get your name out to other areas unless you close the gallery while you are gone, and you will have to have enough inventory to take a full show display and keep your gallery stocked if it is kept open.

Some artists have solved this problem by making their gallery a coop and having several artists involved who take turns keeping the gallery open while displaying everyone's artwork. This can work well.

Like any other business, location for traffic is critical. And you have the overhead costs of having retail space, and most of the time this includes building rental just for starters. It takes a lot of sales to pay basic expenses before you get to take home a profit. (Why do you think galleries want and need such a big commission for selling your work?) Do your homework very carefully before you make the decision to open a retail gallery.

But there is a way that works for many artists. That is the studio gallery. While your home place may not be in the best retail location (mine is up a county road well off the highway), it may be possible for you to find a space to display your art right at your home. You may have zoning restrictions here, but it can be worth checking.

People do love visiting an artist's studio. I do have space here on the farm that we have adapted very well to show my work. It has taken time to collect the display "furniture" and put in the proper lighting, and I am not open regular business hours. But in between shows, I unload the truck, and the work has to go somewhere. So into my gallery space it goes. I am open by phone appointment or just by luck. What that means is if folks just drop by, I may be here and not at a show; or I may be out in the barn, and they find a rather informal artist in residence.

This is my studio gallery as we prepared it for our Christmas open house.

People seem to love the thrill of discovery, what is new and in process, both in sculpture and in painting, and I have sold many paintings practically off the easel unframed. (At least now, they are acrylics, so the paint is dry.) I have even had buyers call while out here on vacation and stopped in. And there are those of our friends who have put us on their sights-to-see list when entertaining out-of-town guests.

These sales here at the studio gallery are the most profitable. No show entry fees, travel expenses, and no extra overhead, once the room was arranged for display. It is one more area that I do try to keep to a rather better standard of housekeeping, but a working mess in the actual studio space is not a problem with anyone. And in the summer, visitors usually leave with a basket of fresh vegetables from our garden.

And yes, my flower garden is a sculpture garden too. It is right outside the studio, and it is a lovely place to show visitors just how the sculpture can look outside.

We also have several open-studio events, one before Christmas and the other on the Fourth of July, which turns out to be a barbecue and potluck as well. I'd like to schedule at least one more a year, perhaps in early fall before the late shows get going. I have invited another artist to join me with their work, too, for the weekend. Both open houses are casual and friendly.

It has been my experience that being a "local" artist (I hate that term!) means that your collectors and future collectors in your home area rarely feel pressure to buy now. You are always available. If they don't make it out this week, well, they'll just stop by the week after. When doing an out-of-area show, they know that you are here today and gone tomorrow. At least by making an event of a special date, there is a good reason for making it a point to come out now.

Dear Aunt Gabby,

My work is really different. What if no one wants to buy it?

Special Vision

Dear Special Vision,

Then you won't sell it. What can you do that people like? Or you can take your work to the places where people look at art differently too. People in

the country buy mousetraps. To sell dragon traps, you have to go where people believe in dragons.

Getting Started With Shows

Art shows and craft fairs fall into two categories you need to know. They are either juried or completely open. Few art shows are open. Many craft fairs are not juried at all. You register, pay your fee, and show up. If you get your entry money in early enough, you have a spot. These shows can be a great deal of fun, but usually people who attend them are not expecting fine art. You may be set up between vendors selling imported craftwork and printed pop posters or next to a nice lady who paints wooden plaques from a kit. You never know just what you may find. Fine art is sold at these shows; all it takes is the right buyer to find you, but they may be surprised to find an artist of your quality there.

Juried arts and craft shows should not have imported work. Read the prospectus for the show rules on what you can display for sale. They will want to see photos of your work and sometimes even photos of your display setup. Some require slides; others will accept printed photos. Try to have the very best and most professional photographs that you can. You are being judged by these.

I have found that having an area that can be set up to take photos in my studio with a good backdrop and lighting is an excellent idea. You will need it time and time again. Not only will you need jury photos, but you may also need to send photos to a potential buyer or use them in your promotional materials. A good digital camera is not that expensive. You will need a tripod for it. I have found that for paintings, it can be worth it to get the proper lightbulbs that don't distort color. You will need clamp lights too. Yes, you can learn how to take the photos you need for most of your purposes.

Some craft and art shows do want to see the actual work and will have screening days where they ask you to bring the art in. If the show has an auction, they will ask that you send the work to them for judging.

Many of the best shows are solidly booked with returning artists. Spaces may not often become available, even if the show committee likes your work and would love to have you in their show. You may be put on a waiting list. Here is a possible solution if your schedule permits.

Let them know that you will be happy to accept a spot if they do have a last-minute cancellation. And I mean tell them you can come if it is really last minute. Like the day the show is supposed to open.

Cancellations that occur weeks before the show date are filled from the waiting list. Many artists cannot pack up and arrive on a moment's notice. If you can do this, you may find yourself being able to do shows that people have been waiting for years to get into. It is worth a try. But it does mean that you have everything that you need ready to go on the truck, and you can be packed and on the way in hours.

It may or may not mean that you will be able to secure a spot in the next year's show. But you will be a known artist to the organizers; they know how good your display looks, and that you are an asset to their show.

Just remember that a lot of art shows send people around to shows to find more artists. It is rare that I am not offered several show entries while at shows, and others arrive in the mail because people picked up my card. I know of one really incredibly prestigious show where the promoter does like to go to shows to find artists, seeing how their work looks over all and how they deal with the public. And I know he has a closet full of portfolios from artists who have asked to be considered for his show.

There are publications that list and evaluate arts and craft shows. Other artist magazines have a column of Call for Artists that tells you about shows and exhibitions that you might like. I also recommend that you check through topical magazines that may have art shows advertised in them. If you do seascapes, perhaps some magazines devoted to sail, magazines featuring Western décor ads would be a good place to check for Western and wildlife art shows. Look for magazines that target your buyers. Magazines devoted to regional promotion will often list art shows in coming events.

**

Dear Aunt Gabby,

Why is it so hard to get into art shows? My work sells in a gallery here in town, so it must be pretty good.

Waiting Lady

Dear Waiting Lady,

You asked me last year who to talk with about the show, and I pointed out the promoter, but maybe I should have told you he was at lunch. I do remember you, unfortunately. What had you been doing before you got to the show that day?

A gallery doesn't care what you look like; they just have your work. A show promoter has to consider what you will look like in his or her show. Honey, greasy hair and BO just don't do it. You were out in public, and you were in effect at a job interview. (Yes, talking with promoters, personal grooming is a bigger problem than even I had realized!)

**

Art Shows, Craft Shows, and Exhibitions

The easiest events to get into when you are starting are the craft shows and fairs. You may find this will work well for you as you learn your profession and how to display and sell your work. It can be a more inexpensive way to get going. Entry fees are often lower. And yes, fine art is sold at craft shows. Many people who collect art also appreciate finely done crafts. You may see many more people than you would at some art shows. You can practice your newly learned sales skills on them, and you are learning how to sell, aren't you?

You will get ideas on ways to display your work. You *will* start your mailing list here. (Of course, you will have an active mailing list! You want to succeed at this, don't you?) Some craft shows are screened; you must get accepted into the show with your work. Follow the directions on the prospectus, have the slides or photos as requested, and get your entry and fees in on time.

Most craft shows are likely to be outdoors. They are planned for weekends when there is a good chance of fair weather. They can be casual lighthearted events where the public is relaxed and enjoying being outside on a gorgeous day. Relaxed, happy people are in a mood to spend money. And the artists can be quite relaxed too. Depending on the nature of the event, it can be an almost-carnival atmosphere, and do you have any idea how much money is spent at a carnival? They can be part of a community celebration, and all the people in town want to come out to support it. They can be part of a major tourist occasion and pull people in from a large area. On the other hand, there is no guarantee about weather. It can get chilly, wet, or worse. And I do mean worse.

If you are planning on doing outdoor shows, invest in a good folding canopy. They currently cost anywhere from $100 to $500 dollars for a ten-by-ten. Chose white for a color. The light coming through the top will affect your artwork. The best ones have side panels available. You can hang the side panels if you need more weather protection, and they give you a way to cover your work at night after the show closes each day. Most shows have

some sort of night security on site; it is up to you if you wish to leave your work under cover there all night. I do, although I usually move the display tables around and make certain all my art is lying flat and under sheets. The sheets cover the work so that someone peeking through the sidewalls can't see what is there, and it is also a protection against a heavy dew.

On some sites, you will be able to stake your canopies down into the ground. Other places it will not be allowed, usually because there are underground sprinklers systems; or if you are on pavement, then it just can't be done. I have gone to the grocery store and bought large bottles of water and a clothesline and hung them as weights from the canopy frame. Other artists who do lots of outdoor shows have taken sections of plastic pipe and filled them with concrete with an eyebolt set in the end for weights. Since they are also white, they are almost invisible in the display. Expect wind. Plan for it. It may never happen, but it often does.

It also doesn't hurt to have a few plastic sheets handy. The thin painters' coverings take up little room in your gear, but it can save your artwork. The packages are inexpensive.

How else do you find these craft shows? Pay attention the year before you plan to start. Go to the shows and check out those in your area or the area where you feel comfortable in traveling to attend a show. See how things are done. Visit with the artists and vendors, and if they are willing, ask about the show.

Okay, let's get something straight right now. Vendors, that means people selling at the show, are much more likely to talk with you if there aren't any buyers in the booth. Never get between buyers and sellers. If you are in a conversation, step back and say, "I'll let you take care of these folks." This is their living. They will appreciate your courtesy and be more likely to help you. Go to the show early or late in the day when the crowds are less.

Other Show Manners

I love seeing friends and relatives when I do a show away from home. But the busiest time of the sales day is no time to visit or have them fill the display talking with you. Invite them to see the show and take them to dinner after the show closes. If you are visiting with someone, don't block the display. Take your conversation away from the booth; guide your people gently to an open area. And never, never say anything negative about the work you see.

If you have anyone helping you with your booth, none of you can *ever* say anything negative about anything or anyone in the show unless you are in the privacy of your motel room or your car.

Seriously! Do not permit it! Any comment they make will be taken as if you yourself said it, and you never know if an artist's aunt or cousin or best friend is standing right behind you. (Or at the table next to you in the restaurant near the show.) We all have opinions; we like different things. Talk about those things you like. And by the way, praise from another artist is often more encouraging than words from anyone else.

Treat all other artists and crafts people with respect and courtesy. I did start with Xerox prints of my pen and ink drawings, and some of the folks from those first shows have moved into the established fine-art market with me over the years. We have supported and encouraged each other, bought from each other, and helped each other along the way. Artists have been some of my best collectors. We have watched each other's displays during breaks and helped in emergencies. We have loaned each other hand trucks and dollies, extra lights and cords, display tables, chairs, and sales receipts. A roll of duct tape can be community property at a show. Be there for them, and they will be there for you. I have seen an entire art display packed up and loaded into a car while the artist was on the telephone to home trying to deal with a family emergency long distance. In fifteen minutes, all he had to do was start the car and leave when he got off the phone.

Back in those days, quite a few things were more casual. Artists who were camped in their vans (or as I did one memorable show in Wenatchee, under my display table since not only could I not afford a motel, but I had a large French poodle with me) have shared the motel shower of more fortunate friends. And if the weather turned bad, even the floor of the motel room in a sleeping bag. Outdoor craft fairs offer lots of opportunities for adventure, usually caused by adverse weather conditions. Watch three more artists rush to get their work under the protective canopy of a fourth artist in a sudden rainsquall if you want to see fast cooperation. It is amazing how helpful the public can be at times like this too. I once had a sudden gust of wind start to push over my canopy, which started to knock over every table of bronzes under it. Some people grabbed the canopy frame to keep it from becoming a kite while others threw themselves at the tables to catch the toppling sculptures.

Be patient and polite during the rush to set up and tear down a show. Parking for loading is usually limited, and people have to cooperate. Move your vehicle as soon as you can to allow others easy access. Don't block

traffic areas in the show. Cut some people slack if they are short-tempered; they may be wondering how to get enough gas money to get home after a bad show. And do move your car away from the show's main parking during the event; the person who gives up when they can't find a place to park to see the show may just have been your buyer.

Other artists are also your best source of information about shows you may want to attend. They can tell you if one is good or best avoided. You are going to share your experiences, too, aren't you? I have also helped buyers find the type of work they are looking for if I don't have such a piece. And I have had other artists direct a buyer to my booth.

If you have a problem at the show, take it to whoever is in charge. Don't just bitch to your neighbor or friends and, for heaven's sake, not in front of the public. They are there to be entertained and buy stuff, not be told how bad things are. Only those in charge can fix things or explain to you why they can't. And there are some good reasons for some problems beyond anyone's control. The bottom line, if you aren't happy with the show or its policies, just don't come back next year. In the mean time, work with the show as best you can for the sake of the other artists.

Show promoters and organizers send out information packets and also usually have an envelope for you when you check in to a show. *Read the material* they contain. There are promoters who honestly believe artists cannot read.

Dear Aunt Gabby,

Please explain why human beings who can create such wonderful art can't read. I don't think one in a dozen artists have ever been able to read the show material we send them with due dates for fees and the entries and information we need from them.

<div align="right">Frazzled Show Chairman</div>

Dear Frazzled Chairman,

Oh, they can read, they just can't find the information packet you sent them. Have you ever seen what passes for a desk in most art studios? And that info envelope you handed them when they checked in at the show

desk, just think of the opportunities for them to misplace it during setup before they ever get a chance to read it.

Show up on time each day, and *don't pack up and leave early*. (Family emergencies are the only excuse, and let the show staff know why.) I don't care how unhappy you are or how far you have to go to get home. You have agreed to do the show, be professional and do it. All of it. Having an artist pack up early affects buyers and does leave an empty space. Enough empty spaces and buyers start leaving the show too. That also means *if you agree to do the show, then be there*. A no-show leaves a gap in the show setup. Somewhere there is another artist who would have loved to take your space. Gaps don't look good to buyers. And if there is an honest reason why you can't make the show, let the promoters know as soon as possible so they can adjust the displays. I do several shows where the weather can cause problems since artists come from over a thousand miles away. I am one of them.

Plan your travel to allow for the weather; leave a day early. This does not mean you still may not get caught in a bad storm; mountain passes can be closed for more than a day. (Yes, the show is so good it is worth the possible travel problems.) There are usually contact numbers on your show information sheets. You will have those with you, won't you? Let people know you are coming in late.

One memorable show we attended, we had severe vehicle trouble. Have you ever tried to find a hub for an RV in the middle of Oregon, the empty part of the middle of Oregon? The closest was five days away in Detroit. Once we could find a tow truck capable of hauling a three-legged thirty-foot class A into Bend, we had to find a rental to get us to Lake Tahoe and the show. We made the show. We arrived in a U-haul cube van with not only the artwork but our clothing in Mopar boxes out of the Chevrolet dealer's dumpster. You see how you feel going through the main lobby of a really fancy resort hotel with "luggage" like that. (And yes, we were passed by half the other artists in the show who saw us parked off the side of the road and some of them even waved. They couldn't see the wheel lying on the ground on the other side of our rig.) (That part of the Oregon highway gets pretty fast traffic.)

Besides, if you get the reputation of either leaving early, or being a no-show, word gets around, and show invitations will stop coming your way.

Dear Aunt Gabby,

I am sitting here, and *no one* is even stopping to look at my work. Help! What is wrong? I'm going crazy here.

<div align="right">Ignored</div>

Dear Ignored,

Crowds seem to have moods. I don't know why, but sometimes it just happens. People just wander around, and nothing seems to catch their eye. At a time like this, go ahead and read something. I recommend a magazine; it is easier to put down if someone does stop. Or figure out a way to be working; sketch or have a bit of clay you can work with. An artist-in-action can get some folks to stop out of curiosity. But do work where it is easy for them to look over your shoulder, not at the back of your booth.

It can also be a good time to get acquainted with your neighbors. They are probably just as bored as you are. But don't start feeling nasty and saying bad things about the public. Your face will show your feelings, and that is also just about the time someone will come up behind you to look at your work!

Indoor Craft Shows and Shopping Mall Shows

A large number of the indoor craft shows are held in shopping malls. For many years, they were a major way to get started in the professional art market, a learning experience for relatively low financial cost. The big malls brought in a constant flow of people, not all or even a large portion who are interested in art. But they would put starting artists who showed promise in with groups of other more experienced artists and present the whole group to the public. (Most of the public was in the mall to buy underwear and socks, but it did put them in the proximity of artwork.) Some people visit the malls just to have something to do and

liked to talk to artists. There is always the chance you could talk them into making a purchase. An artist got feedback from people.

I think mall shows gave an artist a true baptism into the joys and hassles of the general public. Any artist who has spent time doing them feels like a veteran. As the expression goes, "It was the best of times; it was the worst of times." It was my main art education, those years in the malls. In our spare time, which we had lots of, we taught each other, or rather among other people, they taught me. I went into the mall shows as a pen-and-ink artist; I came out a bronze sculptor. By the time I phased out those shows, I was spending the rest of my time at the Western art shows and getting into other fine-art shows. It was hard to leave them. By then, I had quite a following of people who always looked for me there each time. Many of them came to see me at the other shows.

The artists also had fun in that spare time. I don't know how many times an artist would show up late in the morning and not be able to even locate his booth. (It would have been taken down and parts hidden in other booths all over the show.) An artist would be demonstrating and after leaving the booth for a lunch break return to find his painting sketch covered with little "paint-by-numbers" marks. One artist actually tripped a bank robber making a getaway down the main aisle from a mall bank, sending the revolver sliding across the stone floor. Each of us became an information booth to answer questions about everything but art. And any questions about art ranged from the curious to the insulting. "Do you want to learn how to really draw horses?" and then she proceeded to tell me. "Do you really make money at this?" "I can do this well, how do I find a place to set up?" "Do you really think you will get that much money for this painting?" It was one hundred dollars. Some days, I felt like making a sign with an arrow pointing to the restrooms. We were all younger in those days and spent a certain amount of time in the bar, especially after the shows closed. We became very good friends.

Dear Aunt Gabby,

What do you say when someone tells you they are an artist too, but they sell all their work right out of their home studio and never have enough to do a show?

<div align="right">Astounded</div>

Dear Astounded,

"Congratulations!" (Say it politely.) There must have been some reason they felt you needed to know this.

Almost none of us do those shows anymore. You would be surprised how many very well-known artists spent time in mall shows. And how many did make most of their living doing them. They were commission shows; the promoter got 20 percent for making the arrangements and setting up the show. It was worth every penny.

If you are in an area where there are good shopping mall art shows, I would recommend that you investigate them as a possibility when you are getting started in your career. Where I live now, there are no major malls really close to me. You may live in a more urban situation. Sometimes the mall art shows are handled by a local art organization too. The next time one is advertised, attend it and talk to the vendors. I can't promise that these shows will be like the ones I attended, but they are worth checking out.

Invitational Art Shows

One of the best ways to find out about shows is to do them. It is a rare show where I do not get handed several information sheets about other shows. Read the prospectus. It may require that you send in an application and materials for screening. At other times, just being given the prospectus means you have been screened on the spot. Once you are at shows, your card may have been taken, and applications may arrive in the mail.

You will also receive requests from shows that are charity events asking for part or complete donations to their auctions. How you handle these is up to you and your own budget. There is the school of thought that contributing to them may add to your recognition as an artist. Some of them, however, do not give the artist any promotion or even emphasize the donating artist's name. The work is just auctioned.

The very best shows usually know which artists they want to invite. Their show committee members attend shows and visit galleries and watch advertising in art publications. While it is possible to send a portfolio to the committee for consideration, most of the time the show

organizers will directly contact you. When they see your work at a show, they are also looking at the way your art is displayed. They may also be looking at the way you approach the public and your overall professionalism. Again, I wish to stress that like in galleries, there are more fine quality artists seeking placement than there are places for them. Art shows don't need to deal with too much "artistic temperament"; just how good do you think you are? If you aren't going to be relatively nice to work with, and be an asset in dealing with the public, the show managers don't need you as a problem. They are primarily concerned with giving their collectors a positive show experience that will keep them in the mood to buy and bring them back to the show again.

If given an invitation to a show that you cannot attend, it is best to be gracious. You may want to do the show some other year. If you have a show conflict, or other obligations, let them know you appreciate their invitation, and could they keep your name on their list as a future participant. Most shows respect an artist who gives loyalty to a previous commitment because they know they will be able to receive the same consideration.

I am a Western artist. I usually attend Western art shows because buyers who want my type of work go to them to find the art they prefer. At a category show like these, there is also a lot of competition because everyone has by and large similar work. (There is actually a great range of media and subject and approach at this type of show these days. The scope of Western art has come a long way past the solely cowboy and Indian definition of the past.) (Some people still think paperback book covers, however.) The shows are advertised in magazines that reflect a liking for the Western lifestyle.

I have done some media shows, where the primary criterion is that it is sculpture, no matter what the subject. Again, people who are looking for sculpture attend them. So do a lot of great sculptors who are your competitors. A show like this can be a great place to network sculpting materials, sources, workshops, and foundries. Many foundries send representatives to find new business, offering comparative bids and services.

I have also done trade shows such as gardening shows, gun shows, agricultural shows, and horse sales, with my equine sculptures and paintings I have displayed at horse shows and events. There can be quite a few sales made at places like these without the competition of fifty to several hundred other artists. You also stand a chance of introducing your

work to people who will love it but would never think of attending an art show. A person may not think of themselves as an art collector but still find themselves falling in love with a piece of art. They just have to see it somewhere first. And there you are.

They just thought they were looking for a saddle or a tractor or a new hunting rifle and found you. And, of course, at all of these you are collecting names for your mailing list, aren't you?

One problem all artists face is that collectors keep collecting until their home and office is full. We need to constantly work on adding to our customer base. We need to get more people addicted to art. Much of the time they just haven't noticed anything they might like because they would never think of going into a gallery. Reaching out to people at a nonart venue can pay big dividends. If someone is curious enough to stop, you may be able to awake fresh interest not only in art but specifically your art.

While at first many folks find the cost of fine art ridiculously high, if the experience of the introduction is a positive one, then they may find themselves tempted to see what the rest of the art world has to offer. Invite them to your next area art show. Offer to introduce them to other artists who do work they would enjoy too.

At times, selling fine art is a long-term process. Galleries do it, or at least they should. Cultivate your new acquaintances. Make the world of art a friendly welcoming place. Let them know that questions are good. Never make them feel ignorant, just not informed. You will meet some awfully nice people this way, and you will have a better time yourself. The next show they attend to see you, they may bring friends along too. Okay, they may never buy your art, but they may buy your best friend's work. And you will have friendly faces glad to see you again at the next show. I have enjoyed people who came to see me for years before they were able to afford my sculpture.

It is not only the parents who are glad to see the last child graduate from college.

The staff that put on the art shows and fairs can be easy to work with, or experiences you wish to avoid. They are in this business to make money too, either for themselves or their organization. Everybody needs a profit and deserve one if they work hard enough at it. There are those people who do unfortunately consider artists just a commodity; there are so many artists out there they can always be replaced by others the next year. These promoters will never keep a high-quality

show because good artists don't need to take their bull. You will run into these from time to time, just grit your teeth for the sake of the other artists and vendors doing the show and don't come back. Most of the show promoters understand what is needed to get and keep the best artists to make the best show to draw the most crowds. Good timing of the show, good location, good advertising, and good attention to the artists needs. Rules to make it fair to the vendors, such as artist's only work, no imported work or cheap copies.

The better shows give precedence to past attending artists, knowing that they are a draw to customers. Buyers come looking for an artist whose work they liked the year before. They will quite often have artists' lounge areas where drinks and snacks are available and an artist can get a break from the crowd. (Some even provide free food, breakfast rolls and a lunch service. Bless them!) They will provide a booth sitting service to keep you display covered while you take a break. I have seen promoters get a local scout troop to volunteer to help with the set up and tear down. (Yes, a tip for the kids for their help is in order, though most won't ask for it. The money usually goes to the troop fund.) And if you happen to have kids of your own, they have the chance to make some money by helping artists after they have helped you set up, of course.

There is the time you will run into absolute favoritism at shows. Call it nepotism, call it politics, whatever. Some artists will get favored treatment. Perhaps they are "stars," they are a special draw for the public, and many people will come to see just them. (Hey, while these collectors are at the show, they may walk by your booth and like what they see.) Some artists may be kin, and sometimes they are artists who have attended and supported the show for many years, good times and bad. Yeah, there are shows that I have participated in for over thirty years. I no longer get put in the back of the exhibition room. But trust me, I spent my time back there. Where you are located does matter but not as much as you would think and not in the way you might believe. If the restrooms are located at the back of the building, you will see everybody. Likewise near the food booths.

Some display spots cost more money. Some shows sell spots on a sliding price scale; it doesn't matter what you have or how you market, you can pay for the better places. Usually returning artists get first choice, and often a former location is held for an artist if they wish. The buyers will look for you in the same area they saw you the year before. Some spots

work for some artists and don't for others. There is a lot to this business I have never been able to understand; it just is. You can always request a better placement in a future show. People who do the best they can where they are and are nice about asking for better later will often get first consideration.

New shows are easier to get into, but new promoters make more mistakes as they learn too. Some new shows grow rapidly into very good shows indeed. Figure three years at least before they really start to get going. But if you wait to do them, you will be competing with a lot more artists to get in. And promoters favor those people who were patient and faithful during the early years. All shows were new once. Artists need new shows in new areas.

Shows end, too, for lots of reasons. I miss badly some shows that were very good for me. Sometimes the show location becomes unavailable, and no other good place can be found to hold it. Organizations stop holding shows, and private promoters just get worn out after so many years. (If you don't think there is stress in putting on a show, do one yourself someday. Start to finish. I've done it four times. I didn't learn the first three times.) So consider helping a new show get off the ground.

Insurance at shows. Some shows have insurance requirements that the artist has to meet. Every show I do has a liability release for the artist to sign. You will have no legal standing if your work gets stolen or damaged. There are no guarantees about weather or crowd behavior.

For several years, I did carry insurance on my artwork. Then there was the hotel room exhibition show where each room became a separate gallery. A disgruntled former employee kept a master key. He and his friends "shopped" the show rooms during the show hours and evidently made a list. After the show closed, they returned in the very late hours and entered about twelve of the rooms, taking whatever they had wanted. Artists lost personal possessions as well as artwork. I lost two bronzes that night.

My insurance company refused to settle because it was the responsibility of the inn to protect my property, and there had been no forced entry. The hotel claimed that their waiver of responsibility on the little door sign (have you ever read that thing?) meant they weren't liable either. Attorneys eventually became involved, and the parent hotel company paid us for our losses. They also cancelled all future art shows at that hotel. I cancelled my insurance. (My partner in the display room was sort of insulted; they hadn't liked any of his work enough to steal it.)

Many artists get invited by restaurants, banks, or other businesses to display their work for sale. I have had a gallery "loan" out my consigned work to off premises locations without my permission too. Restaurants with all the food and vapors are not good places for paintings. Security can be a problem. But it can get your work out in the public, and it can sell from those locations. It is something for you to carefully consider.

Displays and Booth Requirements

In thirty years, I have had probably more than ten different display setups. Some of the changes were made when I went into sculpture; most of the years I have shown both paintings and sculpture. Whatever you are selling, go to several good art shows and look at what is being done. Learn what you can from other's experience.

Consider your vehicle. It has to carry your display and your artwork safely down the highways. (Yes, I did try a car top carrier once. The best thing to say is that when you notice all three lanes of traffic are falling way back behind you, no matter what your speed, it is time to pull over and check out the security of your load.) I know one artist who has to be a witch. She can get more into an antique Cadillac sedan than I can into a pickup truck, and that includes her display panels for her paintings. What she does is flat impossible without the use of magic. Of course, her Cadillac *is bigger*. I used for three years a '56 Chevy dually with flapping sides on a flat bed. The load never shifted off the truck bed, but the plastic wrap often let in the rain. (I bought it out of a pasture; once we got the blackberry vines untangled from the wheels, added fuel, and a new battery, it ran great. Noisy but great. It was unfortunate about the nonexistent ignition key, but it was easy to hot wire each time. The price was right, and my only other alternative was a Studebaker Lark.) (Now do you have some idea why I talk about saving money?)

Most artists use either a pickup and canopy or a van. There are some who prefer the ease of an RV. I have used all of them at one time or another. I wear them out. One van went through three engines. I hated to see it go, but other large parts started to fall off too. For my winter travel over half the mountain passes of the West, four-wheel drive is awfully nice. But for comfort and convenience, I'll stay with my second sixteen-passenger van with most of the seats removed. We usually travel with at least three people in the rig, especially now that we are older. It will hold just about everything I have to carry and all the stuff my crew

picks up in the towns we visit on our way. Vans are the simplest to load and the most flexible to arrange. For those of you just getting started, they are the most comfortable to sleep in unless you can afford that RV. There was one purple van from the seventies that toured the shows that looked like a business location of another sort, complete with velvet and bobble fringe. Her excuse, it came that way, she could afford it, and it did carry her art nicely.

I just returned from an art show where my son had parked the van to unload while I picked up my information packet. When I went out to find my white van, it took me ten minutes of wandering around the parking area. I have never seen so many white vans. Ours is a used city transit retired unit, and I reckon that that has been the source for many other artists. Many companies like white vans since the business logo stands out well, and once the original logo is removed, until you get close, they sure look alike.

Whatever you drive, when you are getting started, it helps a great deal if your vehicle is paid for.

Another way to haul your art display is a small (or if needed, large) trailer. I have done this too. It can work well if you can handle the needed skills for backing a trailer into tight areas at shows. In bad weather on some roads, pulling a trailer can be a bit of an adventure too. I know many Western artists who double duty their horse trailers as cargo units. (They have better horse trailers than I do.) I did rent a small U-haul trailer for a few trips to see if it would work for me. It is one way to find out how big a trailer you will want to buy. Do make sure you have interior lights; you will be often unloading and loading after dark.

Some save money by using RV trailers and stay in them as well. It really depends on the shows you do and the setup and parking they offer. When I drove a big class A RV, many of the shows did not provide a good place to park it; it became a liability. Of course, there are some artists who actually live in their RV for an art show season, doing their artwork in them too. You can have several vehicles, depending on which show you are attending, and if you can afford it. I have twenty acres and still have a parking problem, with farm vehicles, guest vehicles, town vehicles, and show rig, not to mention the costs of licenses and insurance for the several of us.

There are lots of options you can try. And in one emergency, another truck breakdown, we fit nearly everything needed for a major show into a Durango with a car top carrier and a trailer hitch receiver tray with a very big box chained to it. Since there were three of us headed for Texas, I ended up unable to have my arms at my sides for fourteen hundred miles;

there just wasn't enough room left in the backseat. We rented tables at the show and prayed successfully for good sales so that I could breathe on the way back. (The guys were only allowed one cowboy hat each that trip. But then I didn't have to do any relief driving that trip; I was the only one who could fit in the space available.)

You can rent display items at many shows, especially the big exhibition hall ones. They have decorator services on site. This can be expensive but less than a car payment. And you will have the flexibility of being able to order just what you need for that location. And each setup will be at least a little different. A lot depends on your neighbors' displays. Some look great from inside their booth, but all you can see is the back side of their walls. You will need to cooperate with them to make your display look good, like hang drop cloths on the back of their panels. (Back to Wal-Mart for more sheets.)

One view of my display setup. This time, it is mixture of carpeted stands and tables. The carpeted stands help support the panels for the paintings. I prefer to have an aisle corner booth if I can so that people can easily see into my area as they move down either aisle. Corner booths usually cost a little bit more, but it can be worth it.

My display again. Notice the small carpeted riser boxes that match the stands. I use the Native American type rugs to add color and emphasis to my bronzes and draw the eye to my booth. I have a space to sit behind the right hand tables so I don't block the view of my artwork. By the time all the artists get their displays set up, there will be another booth with panels all the way out to the aisle on the left.

 Whatever display you choose, it must be light enough to handle, small enough to fit your rig, large enough to cover what it has to, and sturdy enough for the public. Oh yes, it also has to show your work off to its best, and your work will change from show to show. You can spend a lot or try to make it yourself.
 I am in love with lightweight low-loop carpet. Its only backing is a thin layer of sizing, so it is light and easy to cut with a box knife. It staples and glues to surfaces well. It is about the cheapest carpet out there. You can usually find it at the major chain building supply stores. It comes in several colors that are a good background for art. I use a soft light heather grey. It is neutral and hides an amazing amount of dirt and dust. My display stands are carpet covered Masonite, a quarter inch composite board. They fold flat for transport. I used the leftover pieces to make small folding stands for the top of a table, also called risers. And I use matching carpet pieces on the floor. (Floor carpet is

not necessary, but it makes the display look better.) Some artists have taken lengths of cardboard concrete pillar forms (really strong cardboard tubes) and covered them with carpet. The different diameters can nest inside each other for packing in your rig. They can look very good! You can choose natural wood for the tops or cover wood or Masonite with carpet.

Folding display stands and a riser being assembled at the show setup. Notice the black strips of Velcro that stick to the carpet to hold them together.

When I made my stands, I planned out the cutting pattern on the Masonite four-by-eight-feet sheet so that there would be no waste. Most of my stands are from thirty to forty-eight inches tall. The smallest is twelve inches square, the largest around thirty inches. It can take a really large bronze, or I can put smaller riser boxes on top of it. I like the look of different heights of display stands. The building supply company will recommend which is the best glue for your carpet. I have found I need to use staples along with the glue to keep the carpet firmly attached.

The riser and boxes fully put together.

Either I have used the wrong glue, or the extremes of humidity and temperature just abuse the stands too much. I have screwed two-by-two-inch framing under my lids and put Velcro strips on it. Since the carpet folds over the tops of the Masonite, the Velcro sticks very well to the carpeted inside of the stands, keeping them quite rigid. I have seen people just use strips of Velcro to hold the stands together. Since my Velcro is sticky backed, you can hide it by covering it with narrow strips of the carpet.

Nearly all my riser boxes were made from the leftover Masonite and carpet. Most of the riser boxes are just Velcroed together, and the tops just rest on the rectangles. The riser boxes work well on the tables, giving me a great deal of flexibility in the way I can arrange my display. I can also stack those on each other.

For years, I used beautiful plywood boxes covered with a textured Formica, just like your kitchen counters. They were expensive to have made, they nested perfectly in each other, and they were stable and safe displays. They also weighed a ton to handle. But they looked elegant! One artist I saw carved and painted stands of solid rigid foam. When they got

dirty, they were repainted. The only real problem I could see with them is that they took up a lot of room in the vehicle.

I also use very good lightweight folding tables. With a few display stands and several tables, I can set my display up quite a few ways. I cover my tables with inexpensive black sheets. If I need different tables, I know the shows where I can rent other sizes. Some artists tailor fabric to fit as table covers; they can look very good. The one problem with black is that it doesn't reflect light up on your work. I get around that by using brightly colored mats under each piece. But I always know where I can get more to match if I should need them. (I can also offer you a good deal on faded black sheets that are past their prime and can't be used for covers anymore. Interested?)

The main problem I had with tailored table covers is that after a while, some are likely to get stained or damaged, and no more similar fabric can be found.

Exhibition shows provide curtain backdrops. For my paintings, I cover foam insulation panels with the same carpeting. It is easy to hang the paintings with curtain hooks, and it makes a nice unified display. The foam panels are four-by-eight feet and can be cut to the size you need easily, and Velcro strips hold the carpeted parts together firmly. (You can buy rolls of just the hook part at some craft stores or large building supply stores.) I have made wooden forms that fit over the top of the panels to support the lights that you will need to best show your work. And yes, I have tried many things that didn't work once I got them to the show. Test-drive everything. Panels should be arranged so that some are at angles to the others to hold them upright.

I do recommend gluing your carpeted parts together quite a few days before the actual show date. Slow drying glue doesn't hold together well, and the glue odor can be rather strong. (Make that a lot of days before the show!)

Good folding chairs can make a difference. Get the tall bar-height ones. You will be up at a level to talk eye to eye with your customers before you have to get out of your chair to help them. I finally found the ones made of aluminum tubing. They don't show wear and tear and fold flatter than the wooden ones. You will be grateful for a comfortable place to sit by the end of the day. And space does become critical when you are loading your rig and things that fold very flat get really desirable.

It is also a good idea to have a relatively safe place to put your personal items during the show. I have used a plastic box under a

table to keep my purse safe or even opened one of my tabletop display "boxes" to contain it. You will also find it helpful to have a convenient place for your sales material, cards, brochures, sales book, and any credit card equipment you have. Some artists give these things more room; they are constantly writing out sales receipts. Me, I may only make five or six sales during the entire show and still end up with a great show profit. Keep that area neat. You'd hate to lose a check in a pile of papers. I use a notebook with a lot of closable pockets. Checks and money go into a really safe place immediately. How basic is that? One artist lost over three hundred dollars when it was set on the table while he helped the buyer wrap his purchase. You may have a booth full of people crowding around to look at your work. Not all of them are honest. Theft of all sorts of things can happen at any show. If you need a cashbox, keep it in a location that the public cannot get to easily. Keep all large bills on your person.

I have seen some small cabinets on wheels brought into shows that have drawers. They can even be covered with carpet too. They may take up room in your vehicle, but the drawers can be filled with items you need for the show, your lights, for instance.

There are companies that make a full line of carpeted displays, both the stands and the tall panels. I am certain they do not have some of the problems my homemade have had; they have spent years testing their products. If I could have afforded to buy them then, I would have. But mine have worked well for years.

When you set up your display, pay attention to the possible flow of traffic in and out. Make it as easy as possible for people to get in to see your work. I have been told that buyers dislike the feeling of being trapped in a booth. I try to sit in the back of my booth so that people don't have to walk past me to get to see the work. I have even seen artists sit across the aisle from their space where there is room so that they don't intimidate people subconsciously. (And if you or anyone helping you in your booth likes to stand with their arms folded across their chest, discourage this. It is not good body language.)

Of course, if you are demonstrating your work, then you will want to be closer to the front of your space, but remember that people who stop to watch shouldn't be forced to block the flow of traffic in the aisle. And remember that at many shows, anything in your booth, including your chair, may not be allowed to come out into the aisle because of fire department regulations.

And speaking of fire regulations, all exhibition hall shows are faced with a very firm fire marshall who has ideas that must be followed. This may mean a trip to a department store to get the proper cords for your lighting, different table covers, and limits to all sorts of things. Be prepared and don't argue. At a show, the fire marshall is *king*; and his word is, in truth, law.

You will want to add lighting at nearly all indoor shows. Most shows are lit enough for people to see your work but not necessarily show it to its best advantage. Bright lights draw attention to each piece and are worth the trouble. And it can be a pain. You usually need to pay extra for electricity in your booth, and you will be limited to the amount of power you can use.

I have been at shows where people put up too many lights and blew circuits all over the place. If you are asked to turn out some of yours, or use lower-wattage bulbs, do it. If you and your neighbors are still having problems, the show organizer is probably doing his or her best to solve the situation. Give them time. Just make sure you have let them know a problem exists.

Some lighting systems depend on the type of display stands that you have. I just love the panels that have proper places to drop in the angle arm lamps. I wish I could afford them. Clamp-on lights work well for me, since I now have panels with brackets that hold them securely. You need lights that can be directed as you want them, of course. It does look better if all of them match. I use brackets on my panels that I bought at the building center as the basis for mine.

There are many overhead systems available, metal framework like track lighting that are great. Here again, I suggest that you visit shows to see all the solutions that are out there and decide what will work for you. But I do recommend that you do have lights if you can.

It is worth your while to make your entire display as attractive as you can. (Remembering that all of it has to go in your rig somehow.) I like to use small brightly colored "Indian" rugs to enhance my bronzes and bring more life to attract the buyers' eye. Artists often bring in plants and flowers too. A trip to many grocery stores or department stores can provide fairly low-cost mums or greens. If you are traveling, give them away when the show is done if you don't have room to take them home. I have seen some Western artists look like they have half emptied the tack room to add interest to their display. Other artists prefer the uncluttered look so that nothing distracts from the artwork.

A floor carpet is also often worth the trouble. It can dress up your display and make it more inviting for people to enter. (It also can make your feet hurt a lot less by the end of the day, since you are standing on it too.) I buy the inexpensive bound remnants, though they don't last forever, or use a long piece of the same carpet I glue on my displays. You can expect to have to tape down these carpets so that there is no danger in anyone tripping on the edges. Some shows require that you do this. I have also seen artists use lovely decorator carpets for a complimentary accent to their work. Anything that you can do to help make a potential buyer visualize the art in their home may increase the chance of a purchase.

Stand back and look at booths that catch your eye. What caught your attention? What do you see that works for you? You may not be drawn to the art itself, but the overall look is one you like. You need a space that makes you feel good too.

Tim Sullivan's aisle booth. He uses carpeted cardboard rigid tubes for his stands. (These are used to form concrete supports in home construction.) The bright rug draws attention to his display. Notice the smaller-sized tube sections he has used for risers for small bronzes.

Kim Shaklee's display, including one of the world's larger rabbits as a center of interest. Her light-colored stands highlight the sculptures. She also has a double corner booth.

Jurgen Hasbron's display. He prefers a light tan carpeted stand and using matching panels around his single corner booth. A truly beautiful setup. His track lightings mounted on a steel frame that is designed to fit his panels.

Michael Westergard's booth, also a double. He showcases his sculptures each in panel framing. He does display his smaller works on a draped table.

Shows often will provide a name sign for your display. There are those organizers who like a continuity throughout the show. Others expect you to provide your own. It can be as little as a painted or carved signboard on a table, but it should be big enough to be easily read. You are after name recognition here; people may have heard your name from someone else, and that may be enough to bring them in for a closer look. (People can look at a lot of things and not really *see* them. You want to attract buyers to take a very close look at your art; they may see things that will appeal to them once they do. I have had people mention that I only do horses when half of my display is figurative or wildlife, but the horses are all that they are aware of at first glance.)

I use banners that can be tied to the frame of an outdoor canopy or attached to the drapery walls surrounding an exhibition hall booth. They are relatively inexpensive, professional looking, and can be as colorful as you wish. They are usually on a tough vinyl fabric, and many background and letter colors are available. They stay good-looking for years if you take care of them and are easy to pack and transport.

Price your work where it can be easily found. It is good if the sign also includes the name of the work and the size of the edition, or if it is a print or a painting, it should tell if it is an original or Giclée or whatever. Buyers do get confused, and if they feel embarrassed, you will probably lose the sale. If you have a computer, you can print out some nice ones.

All display setups get tired and worn. After many shows, they start to look past their prime, and you will have to repair or replace them. Hey, I've been at this for over thirty years. I am not the only thing that has gotten worn out. I hate it when I go to unpack something and realize it should have been replaced after that last show.

Handling the Money

Once upon a time, I sold paintings and prints. Lots of inexpensive prints. I needed a cashbox with lots of change. I collected sales tax so nothing came out even dollars. Now I may only make five to ten sales at a show, and I am rarely offered cash for the purchases. It is nearly always check or credit card. I haven't carried a cashbox for years.

I feel an artist who sells bigger dollar art must have the ability to take credit cards. Your personal bank can possibly arrange this for you. There are also many companies that offer credit card systems.

Originally, I would take a paper imprint of the card, call the bank for an authorization, which meant in the dark ages, I had to locate a telephone and call it in. Now they have wireless machines you can use at your display, most of the time. There seem to still be locations where these machines and cell phones have problems. I will not recommend any system to you, but I would suggest talking with artists that work in your area and on the circuit that you may follow to shows. It will cost you to have a credit card system, but if it makes it possible to close that $4,000 sale, I think it is worth it.

Taking checks. How do you know they are good ones? Well, I gamble. I have the buyer's name and address. Remember, I am a Western artist, and I sell to Western people. In thirty years, I have had to deal with less than a dozen bad checks. And nearly all of those were accidents that were made good ASAP. I have taken checks and released work knowing that the buyer had to transfer funds to the checking account before I could deposit their check. I have let buyers take work home and had them mail me checks since they had run out by the time they found me at the show. I also take deposits, and if the buyer makes a large-enough deposit, I release the work to them on the spot and let them make payments on the balance. (Sometimes the cost of building a crate and shipping it back to the show location would be several hundred dollars for the collector.) Not all artists do this; many require the work be completely paid for before they will send the sculpture to the buyer.

I have found that people are not only surprised to be trusted but eager to prove you have not made a mistake trusting them. Your experience may be different. There are all kinds of people out there. You may choose to be much more cautious, with good reason. I have made sales trusting people that I would not have made otherwise.

If you are collecting payments, it is a good idea to send out a monthly invoice. Many times, people just forget to send payments if there is not something to remind them when they go to pay bills. They can lose your address. I don't send out invoices. I am not well-enough organized. I should do it, I know. I am not a good business person; I will admit it. I hope you will do better or have someone who can run your business properly.

Ideally you will have a separate bank account and credit card for your business to keep track of profits and expenses. My accountant tells me that at least, the interest on my business-only credit card is deductible. He tells

me a lot of other things, too, and tears his hair when I don't do as he would wish. You need to start out keeping good records. I won't advise you how to do this; tax laws change, and you have your own unique situation. But I do advise getting a good accountant. You may need one with a sense of humor like my accountant has, one that understands something about an artist's nature.

You will need a business license and a tax number for collecting sales taxes. Even if you live in a state without a sales tax, you will probably end up someday at a show where taxes must be collected. The tax laws and business laws vary from not only state to state but town and county will differ too. Find out what you need for your area.

Galleries and some shows collect commissions. Usually on these sales, they will take care of paying the sales taxes for you.

One other sales tool I use is the repeat-buyer discount. Many artists do this; the discount they offer does vary. If you buy one piece from me, any other art you buy from me gets an automatic price reduction. (This does not include precast prices; they are already discounted.) Of course, buyers like this, and it does keep them coming back to see what else you have they might like a lot.

My Pet Invoice

I am including a close copy of the invoice that I have been using for the sales I make. I have put on it everything that I need to know about the sale or order. There is even a place at the bottom for a record of payments made. Most quick print places that handle business needs can make a multiple copy self-carbon form for you. I have found a double sheet is enough, the main paper for me and the other for the buyer. Once I am home, I can scan and copy it myself if I need more copies. Those orders that have special patina instructions get copied, and I send one with the order to my foundry. Since they do most of my shipping, that gives them the address too.

INVOICE

Name-address..contact information

Date_____ Sale location_____
To:_____ Shipping address if different:
_____ _____
_____ _____

Telephone_____
Item Edition number Price
_____ _____ _____
_____ _____ _____
_____ _____ _____

Special Instructions:_____

(for patinas, bases, whatever may be needed to remember)
Additional charges for special orders _____

Retail Sale__ Sales tax State____ %_____
Wholesale__ Business number _____
Mail order__ Special order __ Gallery order___
Shipping and handling _____
 TOTAL _____
LAYAWAY TERMS: Buyer agrees up on deposit of _____
With monthly payments of _____ or more at ___ interest on balance.
Signature_____
All other orders are balance due upon satisfactory acceptance of the
artwork by buyer. Balance due _____
Paid: cash_____Check #_____
 Visa/Mastercharge _____ ____
 Expiration date _____ $_____
 Signature_____
Ordered_____Shipped_____CA__ R'cd___Ldg___ Rep____
Payment: Date Check Amount
_____ _____ _____ _____ _____ _____ _____ _____
_____ _____ _____ _____ _____ _____ _____ _____
_____ _____ _____ _____ _____ _____ _____ _____

You may find that you need more or less information and will want your own form. I have found using this invoice form keeps all the information on a sale in one location. Remember, I am not the best-organized person in the world. It even has check-off boxes to remind me the other places in my records that need entries.

Be certain that your contact information is easy to read. Many times, people will wish work to be shipped to a business address or friend if it is a surprise gift, so I make a space for that. Many times, people buy a bronze and order another one. Special instructions can include a note to *don't call*, patina, shipping timing, and all sorts of information. Some changes in the sculpture will cost the buyer more, a special stone base involved patina for instance. Sales taxes and wholesale numbers will need to be on record. My layaway terms may vary, but I always write in zero percent interest. I have learned that having the buyer's check numbers makes it easier to check payments. I like to know when I ordered a piece and the date it was shipped to the buyer. "CA" refers to a certificate of authenticity, "R'cd" means it is checked off the edition of the bronze, "Ldg" is entering the sale in accounting, and "Rep" means which salesperson made the sale. The lines across the bottom are to record the layaway payments as they come in.

Well, it works for me. Really, really well.

After the Sale

Your buyers need to be able to insure their art collection Sometimes the copy of the sales invoice is all they require, but you may want to write on it separately. If someone orders at a precast price, or at a repeat-buyer special price, the actual retail value of the sculpture will be higher. I like to make an immediate note on the invoice of the full retail price and sign it. Later, back in the studio, I prepare a certificate of authenticity to send out to them.

Create your own on your computer with a fancy purchased set of computer stationery. They have some marvelous ones available. A simple statement of the bronze, the edition, the artist, the foundry, and the value and the date. Of course, if you are smarter than I am, you will have checked your show invoice notebook and made certain that the blank certificates are at the show with you, and you can fill one out for the buyer there.

If you are *really* good at taking care of your customers, you will follow up each sale with a thank-you note. And *really, really* good, you will include

a small remark on your note. (That is a miniature quick drawing you have done to make it very special indeed.) Because you appreciated the sale and want your thank-you to reflect this. I just hope all my buyers reading this do understand just how much I appreciate their support all these years because I have never done this. And I regret it. But the idea was just suggested to me while I was discussing this book with another artist. Okay, I'm still learning. Do better than I did. (Evidently, Charlie Russell put a drawing on every piece of his correspondence, and people not only collect his notes and letters, but they pay rather high prices for them too.)

Self-promotion

You Need a Computer

I have mentioned it before, but you really do need a computer. The time it saves is even more important than the money. Let us be real, we all have to deal with life as well as be a producing artist. Your time obligations may be more or less than mine, but you will have them. I have found out that the more I can do here in the studio or my home office, the more time I have to do my creative work. And you will need to promote yourself and your artwork if you want to make a living at this. Along with your computer, you will need a good printer and a digital camera. You do not need top-of-the-line printer unless you intend to print your own marketable fine-art prints. What is considered today to be a fairly basic computer setup is far superior to the top of the line from five years ago. For example, I have had to buy three digital cameras in the last three years. (Don't ask; life happens.) Each one has cost half of the price of the one before and has taken better photos. I am functioning fine with Greybeard and the Dinosaur as far as computers go. They do my copy for my newsletters and correspondence, give me the tools I need to rework my photos so that even my camera skills make good reproducible copies, keep my records, and handle a mailing list of over one thousand five hundred names and addresses.

One computer is online for managing my Web site and e-mail and also for doing the research I need on shows, materials, and other information. If it gets a virus or gets hacked, all my records are kept safe on the other one. It isn't that I say you need two new computers, but don't discount getting an older one or two for less than the price of one new unit. But then, in my case, there were two computers that were so old, no one in the family wanted them.

My photographs are also on the off-line computer. I can refer to them for examples of patinas as well as just the editions themselves. They have been critical in putting this book together. My mailing list addresses are also protected on this computer.

Don't waste as much time as I did fighting the computer age. I was a fool. I can't believe how much time I spent, money I wasted, problems that weren't necessary. I hate the computer age, really prefer to handwrite letters, have still never played a computer game for more than five minutes. In my own defense, while I struggled and fought, the systems got easier and cheaper and all around better. My typing is far easier for my correspondents to read, especially as time goes on. Start simply. Ignore the keys you don't need, and just do what you are comfortable doing. You will pick up more task abilities as you get more comfortable. Take small bites.

Or take a few weeks and take a basic computer course. I have learned more doing this book than I ever needed for the last year to do what needed to be done. If you have someone to teach you handy, great. Just don't let them overwhelm you. One job at a time. People who know and like computers tend to assume knowledge that I just don't have yet.

Bottom line. You need to treat the selling of your art as the *business* that it actually is. Very soon, your business will not be able to afford not to use the computer. Give in.

Dear Aunt Gabby,

I don't have a lot of money to spend on a computer setup, and what if I foul it up and ruin it?

Dark Ages

Dear Dark Ages,

You can do as I did and get an older used computer to learn on. I got the oldest in the family to start with; it is so slow, no one wanted it. (I'll probably still be using it for years 'cause I know how it works!)

Don't tell anyone, but the actual reason I finally jumped into the computer age is that my beloved old electric typewriter finally died on me, as did the other antique I borrowed from the only other person I knew who had one. (She didn't use it because she uses her computer now.) If there is no one to repair your buggy, you end up having to buy a car.

Mailing Lists, Mailing Lists, Mailing Lists

The promoters of the best shows keep hammering away at their artists to do mailers, and I will too. *You cannot afford not to do them.* It is the best way to assure that you will have buyers waiting for you at the shows. Yes, waiting at the doors for the shows to open, and they will be coming directly to your space first. No kidding! It works.

Start collecting the names at the first show you do. Can you really afford to lose contact with a potential buyer who is interested in your work? All lists start somewhere. It may take years before you really have a big list, but make it a good one and use whatever you have. You only have five names in an area where you are going to do a show. Easy, print out a special invitation to the show on your computer and send them out. If you have fifty names, run by a quick-print place and get them done. Have a special new piece you want these people to be looking for, print out some extras (You did have a photo of the piece on your mailer, didn't you?) and have them at your booth to give to people who are interested in that sculpture so that they can take it home and think about it. *Always* have full contact information on every mailer, including your telephone number.

I am including a copy of the mailing list card I use to collect names. As you can see, it not only has contact information but also a space for comments and preferences. There have been times I have gone through my cards and pulled those who were interested in a particular type of work, say *Bears*, and sent out a special advance mailer just to those people. In today's world, at times people are hesitant about writing contact information where anyone can see it, like in an open guest book. Filled out cards are put away in my booth, sometimes with my notes on the back. "This person raises Skipper W Quarter Horses," for instance. You can choose to do many of your mailers by e-mail. If you do, include a line for e-mail address. This form has worked well for me.

Gabe Gabel Studio Mailing List

Name: _____

Address: _____

Telephone: (home)_____ (work)_____
Preference: _____
Requests: _____

Comments: _____

Always try to read the card as they hand it to you. You can address the person by name, you can make sure you can read the name and that all the information is there. I hate spending time going through a zip code directory to finish filling out an address.

Your mailers can be postcards. There are companies who have very good prices on color postcards. Leftover cards with the photos of your art can be handed out at shows. (Remember, you did have all your contact information put on everything.) People will remember your art vividly.

You can choose to send out area mailers on each show. If you are going to Denver, send out mailers to everyone who lives in easy-traveling distance of that show. That can include a geographical area of close to a hundred miles or more.

I send out general mailers about four times a year. These are in the form of newsletters. I no longer do shows in some areas where I picked up a mailing list in the past; my contact with those people is only through the mailers and my Web site now. While it is easier to sell something to someone when it is on the table in front of them, I do get mail orders from all over the country. Buyers move. We are a very fiddle-footed culture. I want to keep these collectors thinking about me.

These general mailers include photos of my new work. I talked about offering my new sculptures at a precast price. This is my opportunity to give those buyers a chance to take advantage of this offer. I also try to

include photos of older sculptures in any space available. It may remind someone of a bronze they loved. I give my show schedule for the next couple of months. I try to include, if I can, a comment about the show. I often mention the galleries carrying my art. People traveling sometimes visit galleries.

I do one more thing, I try to make my mailers, my newsletters, desirable reading so people will open them. I talk about what is happening in the studio and on our place. I mention awards I might have won in the last few months. Since most of my collectors have some sympathy for my lifestyle, I talk about my critters here, from the horses and mules to the wildlife on the place. I try to make them enjoyable, at times, even funny. I am including parts of several of my mailers over the years. Some excerpts are included by special request.

Summer 1990 (excerpt)

What a summer so far! We finally got the barn pretty well finished, which was very good since I bought another horse. This time it is a nice Quarter Horse mare. The Arab is going to love her; he likes redheads.

Out beside the barn is the nearly completed new studio building. Nothing fancy but lots of room and windows that view half the meadow. I warned the contractor he had ten days while I was off at Rendezvous before he'd start finding me all over the jobsite. I understand he started work at 6:30 AM every day I was gone.

I am working a new Medicine Shield piece, Four Winds Medicine. It is off to a very pleasing start. *Buffalo Horse* is getting down to the last casting now. I'm a bit behind on new work; part of my time this spring was spent on another portrait commission of a man and his dog. It turned out well; everyone was delighted. Maybe someday I'll even get a commission where the subject knows about the project and can pose in person, but I have enjoyed the thrill of the surprise presentations.

Otherwise, I've learned to identify six new noxious weeds, many more new wildflowers, and I have a whole lot of questions about butterflies. And tomorrow I return animal care favors with the neighbors and get to

learn to milk a goat as part of it. I understand its only half as much of a job as milking a cow.

(This was followed by a list of shows and galleries.)

EXCERPTS

I know, I am not getting much new work out this summer, but there has been just a bit to get done up here. I have added one new pasture, and my driveway now has a lovely rustic sawbuck fence all the way up to the house. With thirty acres of lodge pole pine, you have to do something like that. Half the new arena is fenced too. Tomorrow I have to do out and check to make certain that the rails are low enough. In the next day or two the "Grandmother's Pony" will arrive, and it is one short little critter. It is truly amazing what my daughter can find at garage sales. I'm just lucky she didn't try to load it into my Subaru station wagon. I have owned dogs that were larger.

One word of advice, the smaller the pony, the smaller the hole they can get through. Right now I swear we could keep a ferret in the one corral. There isn't a spare corral pole on the place so I finished up with bean poles. So far so good.

And then there was the Thanksgiving cattle drive. I can't call it a roundup because we didn't. (Read couldn't!) We got a call while out to dinner that there was a cow critter in my courtyard enclosed ornamental fishpond flower garden. By the time I got home, it was dark, the fence had a large hole in it, and the cow critters were finishing about twelve dollars worth of deer blocks. Except for the ones that had found their way into my haystack in the horse barn. Which I found out when I went to feed the horses. Suddenly, about that time, it became obvious that these were not our neighbor's fat and somewhat placid old Hereford cows. Even as fast as I was dodging, I could tell that. Right away. Okay, let's open the pasture gate and encourage them inside. The ones that went in came right back out again, some of them through the smooth wire; the others went over the sawbuck log section. Effortlessly. By this time, I sort of figured that maybe I should just let them have the meadow

once I shut the barn doors. It is a good thing my daughter is really quick on her feet 'cause for a while, I counted about fifteen of the critters. And as they went under the yard light, I could tell no Hereford in their dreams ever grew horns like that.

This is how I found out the cowboy up over the hill in back had gotten a good start on his dream to raise rodeo bulls. Brahma-longhorn cross rodeo bulls. And those crossbred cows aren't any sort of house pets either. I also learned that this whole county is what is called *open range*. What that means is, if you can't fence them out, you have to let them have it. Luckily, the young cowboy really wants to stay in nice with his neighbors, so he has promised to come fix the down wires and bring me a bit of freezer beef.

All my best wishes from Winter Wonderland. Now that I am most definitely limited by the weather, I have really been able to get some new work done. Of course, there is the small matter of winter property maintenance: shoveling snow, cleaning stalls, shoveling snow, hauling wood, and oh yes, shoveling snow. However, friends visiting up here provide one special benefit. So many people have snowplows in the front of their pickup trucks; it seems to be a common courtesy to plow your way in to see a friend (and of course, plow your way back out again.) I don't have a plow in the front of my truck, a little matter of doing long-distance art shows, but I do try to have good morning coffee always on the fire. We will have some more firewood to cut next spring as the snow has brought down a few Trees. Most are no problem, but I do have to handle the ones across the driveway. The one good thing about a bow saw—it always starts. It may be hard to keep it running, but it starts. But then a lot of my friends and neighbors up here carry chainsaws in their rigs. All the time. (And they can get theirs started.) Mine starts for everyone but me.

Since I am now wishing hard to find the right saddle mule for my mountain trail riding, I have done my first mule sculpture. This first mule is wearing a packsaddle and is part of *The Long Trail Home*. I'm still enjoying my saddle mare, but trails are not her best scene, and our Backcountry Horsemen Club sure has some nice mules. Somewhere there has to be a short mule long on experience and patience. Especially patience.

Doing the pack string has been fun and a learning experience too. I've bugged all the packers in our club for details to get it right. I can now throw a one-man diamond hitch pretty good, and I can't wait for fair weather to see if I can do it on a horse bigger than ten inches high.

Has El Niño rearranged your spring too? This was supposed to be done on the computer with the new program, but I haven't had time to figure it out. We have been running more than a month early with the season, and I can't get caught up. But it is beautiful up here, and when I can get into the studio, I have been working with the big door open and having to stop and escort various birdlife outside. This is an improvement on last year when my guests were frogs and snakes, however. The tree swallows have taken over nearly all the birdhouses, but then this has to be our fourth generation of the same family. A flying insect doesn't stand a chance around here. Although the one who made the mistake of checking out our chimney I hope won't do that again. We had a living room full of sooty-peeved swallow for a space of time yesterday.

August 1997

Hello Everybody,

I hope that this letter makes sense. I am only on my second cup of coffee, but things have been a little hectic. (Aren't they always?) Maybe if I start this early in the morning I can get it done. It has been a grand and interesting summer. Our summer barbecue ended up being a Native American wedding for dear friends in a meadow deep with daisies, and my son-in-law's young Appaloosa had a supporting role in the proceedings. One of my contributions was to dress the horse for the occasion. So now, my collection of horse tack includes the beaded and belled breast collar and bridle. Of course, they are going on our wall; I am not putting them in the tack room.

But we did end up with a permanent pit barbecue out of it. We buried two sections of three feet concrete pipe in the ground, burned a fire for twelve hours in the hole, then lowered the wrapped meat in a basket, and put the lid on for another twelve hours. It worked great too, it only used one

quarter of the wood a dug pit did and, best of all, no dirt to dig back up. It is the easiest way I know to cook for 140 people. Den does it.

Our old double-wide is no longer part of our view. Tee and her husband Pat bought it and some land and have spent the summer trying to organize the two together. I think Den is having flashbacks to the summer he spent when we first moved it up here. Except their well went down five hundred feet, and I was afraid they were going to require medical attention. A midsummer move, right? The poor kids, their horses, two dogs, three cats, rabbit, and bird have been camped here. But power was connected *yesterday*. I end up with a perfect new site for a double-wide-sized garden complete with water right there. Well, you have to put the horse manure somewhere.

September 2003

Hello Everybody,

What a summer so far. Not that I've gotten as much riding in as I'd like. Certainly not as much as Mandy wished. Four neighbors got together and created a training-exercise trail through a total of 110 acres. Given all our timbered wild areas, not one single gate was involved; and we tried to use all the terrain and pretty spots, at least two good creek crossings (on years when the creek still runs). It twists like a snake. It is still a challenge to find all the marker flags, and there are always variations because trees will blow down, a ride in the park it isn't. The one swampy area runs along one side of my property, plumb full of tangled Hawthorne. Clearing the trail, I looked like I'd been wrestling bobcats. We even met another neighbor who gave us cross access to get to the forest service land across the valley. The door is open to the wide world, without using a horse trailer. Not that I mind using the horse trailer (Mandy loads me), but then you have to find a pullout to park the darn thing, not to mention turning it around somehow. It's a wonder there aren't more trailers found at the ends of mountain roads with for-sale signs on them, facing the wrong way.

Every stall in the barn is now full. Horsemen know that nothing is more dangerous to the checkbook than an empty stall. Leave the door open, and what do you know? She answers to Casey or any sound that means horse groceries. Now all I have to do is convince her that her world is not

gonna be boys and babies anymore. We discuss this a lot. Shall we say her point of view lifted me above myself? Not a new perspective but one I haven't seen in a few years. She really didn't mean to throw me; her whole expression said she had thought I was a much-better rider. I'm okay, it's just that the only thing it doesn't hurt to lift is my spirit. Mandy is still my first, and best, love, and I appreciate her even more.

July 2006

Hello Everybody,

What a beginning of summer this has been. For those of you who remember last winter's newsletter, I can now verify that the big buck did have a good time after dark. I have never seen so many babies. And I guess that since the ladies have been so comfortable here, we have been elected as babysitters too. (And a maternity wing?) The old gelding has been discovered babysitting at least three at a time in the middle of his pasture. They have also been parking the fawns in the taller grass just outside backyard fence; I nearly stepped on one baby close to the barbecue pit. We even found one doe in the middle of the afternoon giving birth inside the storage area of my old studio. Our driveway is a hazard area, and I have learned our neighbors have the same population problem too. It is like living next to a school zone with the clock stuck at 3:05.

January 2006 (excerpt)

Hello Everybody,

Our backyard "Discovery Channel" has gotten a bit X-rated this fall. We have had a truly amazing number of deer at the feeder. And they have been very much at their ease, so to speak. We have been ignored as they pursued their lives, or rather, tried to. We had two very nice four-point bucks, each doing their best with the ladies. It was a very poor best. Talk about technique, they must have been watching through the windows of some bar somewhere. They would strike the "noble buck" pose in the middle of the meadow (leaning on the bar with about their fourth beer in their hand), and then one

would saunter on over toward the object of their attention. Ten feet away he'd charge. The doe, who had been watching this idiot out of the corner of her eye, would dash around in a big circle over to the other girls, while the buck tried to pretend he'd just been headed for the jukebox all along. The does would giggle together for a while until the other buck decided he could do better than his buddy. However, since he had the same moves, the end result was the same. It was almost as if the does were flipping a coin to decide who was going to graze out in the meadow to get these jerks going again. But like the girls in a bar, these ladies were waiting for the real talent to show up. And he did. The five-point was not only bigger, but also when he leaned over to play the jukebox, all the ladies wanted to dance. By this time, it was getting dark. Emmette, who has eyes like a cat, reassured me that I wasn't going to have to worry about next year's fawn crop.

For all my friends in Denver, you will be getting a chance to meet *Little Brother* in person. The foundry has promised me that I will have the life-sized coyote ready to coax into the truck. Since I sold my last casting at the Peppertree Art Show, I have really missed having the little guy hanging around my living room, creeping up on the dogs and surprising the cats. While he was out in the rose garden last summer, I did notice I saw no stray cats exploring around here.

(Usually at this point, I introduce what new sculptures are being offered at the precast price.)

Precast Bronzes Offered In The Mailer

Usually each mailer has one or more new bronzes available at the precast price. My offering to my mailing list is that they will get a chance at all new work, even if they cannot come to see it at the art shows. Remember, I do have customers all over the country. Some people have moved; some shows have closed. This is the only time I can reach them unless they visit my Web site.

Try to have the best photographs of new sculptures that you can. (Hopefully, potential buyers will also check out the Web site for even better photos, but you have to give them a good reason to do so.) I include the size, edition number, both prices, the offer deadline, and some words that try to convey my feelings about the sculpture. Here are some examples to give you an idea of what I mean.

Spooked
Ltd. ed. of 20, 13" by 12"

This is one upset pony, something right under his belly has set him off. I was going to make it obvious as to what it was, but then, I had

a horse one time that always seemed to find something to spook at when the wind was right. Usually I could never tell just what set him off. Maybe he would just feel a spook coming on and have to use it. I never knew just how dangerous an old pop can could be in the ditch along the road, but that old pony of mine must have known something that I didn't about how often they attacked horses. He had some ideas about other people's mailboxes too.

Dream of Wolf Medicine
Ltd. ed. of 15, 19" by 21"

To run as a member with the family, to know the wind and world as the wolves know them, the gift of acceptance by one's spirit kin, and the gift of the Medicine Shield. This is to know a man has brothers to walk with him on the seeker's path. The warrior is the fourth wolf.

One to Dream On
Ltd. ed. of 30, 15" by 18"

 You are all grown-up now. You know horses are feed, farrier and vet bills; they get cranky and ornery and obstinate. You know all the reasons why horses are often not a good idea. But somewhere deep in your heart, you see the fiery stallion dancing still as he did, oh so long ago. You rode him in your dreams, waking and sleeping. You can feel his body move under yours with the long mane whipping your face. And the glorious thunder of his hooves. But life is real, and they say that dreams aren't. The truth, were we to admit it, it doesn't matter if you never did get that horse of your own, or you did and now saddle up a rather nice mare or very useful gelding. Somewhere, sometimes, you still see that stallion of

your dreams. He is still there to come at your call. For he is the *magic* and oh so well-known to all of us who love horses.

If you aren't comfortable writing, send more pictures in your mailers. You can include pictures of you in your studio working on that new sculpture. I do use a plain white paper because the photos show up better. And yes, every page has contact information on it somewhere. If someone wants to find you, make it as easy as you can. Encourage people to call with questions and be available. Their next words may be "when can you ship" and "do you want my Visa, or do you want me to send a check?"

I choose to send my newsletters and mailers first class, even though it costs more in postage. If there is a change of address, even if the mailer is returned, I can change my records. If the person is beyond the post office's change-of-address time, at least I won't be sending mailers to be returned again.

Sometimes people can't make the show even if they want to, but they do know how to reach you to let you know they are interested. Keep a *mailing list*!

Advertisements

They cost a great deal of money in a good art magazine. They are noticed, they are read, and they do pay off. There is something that establishes credibility when it is seen in print in a major publication. I have been contacted by galleries and important art shows when I have run a good advertisement. By spending money to make your name well-known, it makes you more of a draw and easier to sell your work. They will be seen by more people than you can imagine, and people will know your name. I have known artists who have taken out second mortgages to pay for a year's run of very good ads. And yes, it can cost that much.

If you are interested, contact the magazine, and they will send you out a packet with rates and requirements. After you have run an ad, you can expect to be contacted by other publications who will try to get your business. They will have very good salespeople who do this. They usually work on commission. Consider if they are your actual market. An ad is an investment; it should pay off in sales orders. At least hope for one sale directly from the ad to return your money. I tried some magazines that sounded good but weren't. You might consider sticking with those you know your collectors read.

Design your ad carefully, and only use the very best photographs you can get done. It may be worth your money to have professional photographers take these. I had better experience by taking my own view of exactly how I wanted the photograph, just the perfect angle, and then letting them use their expertise to set it up. I also had good results from having a constant format in each ad so that it was recognizable each time.

There are artists who primarily sell their work in a niche market and concentrate on specific magazines to reach those types of people. Most of their sales come from magazine advertisement notification that a new bronze is available. I understand that this can be a very successful way to go.

When an art gallery decides to use your work in an ad, they may request that you pay for a portion of the advertising costs. Quite often, they will split the cost between several artists when they are using multiple pictures of artwork they offer.

Organizations can do the same arrangement. If you are a member of an art organization, you may have the chance to be part of a full-page ad and also be asked to pay your share of the ad. Sometimes artists who will all be at the same show will get together and split the cost of a larger ad than any of them could afford on their own because the bigger ad has more impact.

Newspaper Releases, Interviews, and Articles

A newspaper release is a story you submit to a newspaper about your work or an upcoming show. They have the option of writing a story about you or not. It can generate a future article, especially if it is local newspaper and they want to do something featuring area artists and businessmen. It is one way to let them know you are a resident artist (and of course, a local businessman, right?).

It is very nice to be mentioned in a newspaper story about the show you are attending. You can also send releases to your own area paper about your shows and awards. Releases you send to other newspapers may not have a chance of being printed, at least this has been my experience, but it is worth a try, particularly if you have some tie to that area. Did you go to school there? Were your parents born there? Positive mention of your name may help you to be recognized by a potential buyer. And certainly being mentioned as a contributor to local fund-raisers is nice if you sell your art in your home area.

Many times at an art show, the local TV station will visit the art show; and from time to time, they may wish to actually have a short interview with one

of the artists. Not only have I been interviewed several times, but I have even sold work to the interviewer. I recall one sale to a newscaster who proceeded to keep that bronze on his desk in front of the camera during both nightly newscasts. His coanchor pointed the sculpture out each time, and my buyer not only mentioned he had gotten it at the show but also mentioned my name specifically. This was prime-time advertising for the show in general and was lovely for me personally. It also made me very popular with the show promoter who received some extremely valuable free advertising.

At the promoter's request, I have been at the show, fully made up and dressed well at some very early hours to do a promo interview. (I have also done the same thing and blundered around a strange city to find a TV station during rush hour for a morning-show promo spot.) The only bad part is that I don't dare drink enough coffee to get me going at that early an hour, but otherwise it is easy. Just smile at the camera and answer some easy questions and look friendly. I do believe one reason I am asked to do this is not only because of my art, but also I have a reputation of dressing well at the shows. (This does not mean dressing expensively, but I do look like a successful and professional Western artist. Think about this sort of opportunity when you select your show wardrobe.) That also means I am more likely to be selected for an on-the-spot interview during the show hours too. Whoever is standing in front of the television camera is representing the entire show to the public viewers.

I have also been featured on a poster at my local bank as part of an advertising campaign about their service for unique customers. The photo of me in my studio may or may not have done my sales any good, but it sure impressed the heck out of my nine-year-old grandson.

Several times, I have been interviewed over the telephone for magazine articles. I have always been delighted to send photographs to compliment the article, as soon as possible. It is a good idea to also place an ad in the same magazine at the same time the article is running; people see your name twice. Let your galleries know that an article is being published; they may also want to run an ad in the same issue.

One more note about charitable donations. You will be asked once you are out in the public eye and especially if you run ads. I have been contacted by organizations from all over the country. I guess they have found it doesn't hurt to ask. You can ignore them or send polite regrets or send them whatever art for their sales and auctions that you can afford. I am not certain that it ever generates any more art sales. I do try to help out, wherever I can, those local events that help people in my own community.

It may help your name get known, but that isn't why I do it. A lot of the time, I have more artwork than money, and I do believe in giving as I can to our local fund-raisers. It helps my friends and neighbors, and since all of the money goes to the actual needs and not to fund an organization's costs to operate, it is well spent. Besides, I may need search and rescue myself while trail riding or that special piece of hospital equipment.

Moose was used on a special edition wine label by a specialty winery as part of a local environmental campaign. Moose are rather typical of our area.

Web Sites

When you can afford one, get one. Every time you run an ad and include your Web site address, you are also advertising every piece that interested people can see on your site. They will also have access to your resume

and award list and also your coming shows. My mailers and newsletters are in black and white; the site shows color photographs.

I had a Web site before I even knew how to turn on the computer. It has become almost a matter of credibility in today's world. I have also found that every article I have ever had in any magazine also pops up when people are looking to find you on the Internet.

I had an excellent professional Web designer do my site for me. It is well organized and attractive. (Check it out, okay? gabegabel.com) It is amazing how much information can be put on one. I even run a monthly newsletter (when I am not writing a book). Hopefully, people will keep checking the site to read the newsletter, and while they are at it, check out other things too. My Web designer also updates it. The monthly fee is dependant on how much she has to do, and I consider it all a bargain. I also keep my show schedule up-to-date and show my new works in progress so they are there for people who aren't on my mailing list. My web page designer has contact information on my home page if you are interested in contacting her about her services.

I don't have any links on my site now, but I will probably have some soon. It would be good to have links to the sites of the shows that I do. Mutual artists' links are also good. I have been linked to some equine sites by others.

I don't know how well those sites work where several artists share the space, but I know they are out there for you to consider. It is one way to at least get started. You may want to investigate some of these.

Of course, you have an e-mail contact on your Web site. Any time you can interact with a potential buyer, you stand a chance of selling. It seems many people today feel more comfortable sending an e-mail than using a telephone, and they can do it immediately if they have a question.

Flyers and Other Business Materials

I have already discussed newsletters and mailers. I use extras of those for handouts at shows rather than just discarding them, at least until they become dated.

Fancy color brochures and flyers are great. I don't use them. They are expensive to print, even if you use your own computer printer. The sculptures that I feature change over the course of the year; some editions sell out. I find I do just as well by having quick print black-and-white brochures, as long as the photographs are well done. The new copiers at some of the basic office supply stores are producing excellent materials. So

many of my bronzes have such different patinas. And if I featured a certain patina on a handout, someone ordering it might expect exactly that patina. We know that patinas will vary; it is just the nature of the craft.

It is relatively inexpensive to do a target brochure that features the current work in progress. It is also simple to keep them current with the show schedule and any other biographical data I want on them. It also means I don't have to store safely boxes of brochures. I have to store and access enough stuff already.

The computer with its ease of type case (the size and form of the alphabet) and its ability to refine my photographs means that I can take a good past-up original to a quick print business and be ready to go in hours, not days. Quite often, I am working on a new piece right up until a couple of days before departing for a show. I don't have time for a photograph to be developed and then take copy for a brochure to go through a printing company. I can do it myself immediately. In a pinch, I have even taken the original with me and found a quick-print place in the same town as my show.

I print my own business cards on the computer. It is more expensive, but the effect is pretty good, and they can be in color. They can be done as I need them. (Mostly interested show visitors take a brochure instead of a card.) And I don't have to worry about remembering to get them in for printing early enough so that they are ready in time. (Yes, I am one of those last-minute kind of people, especially when I have been concentrating on a piece of artwork.) I find it important that my business cards have a photo of my work on them. They actually work best for me on non-show contacts. You may meet someone waiting in line somewhere, get into a conversation, and who knows. Maybe they will go home and check the Web site; customers are where you find them. I do recommend that you always carry business cards.

I keep my flyers out on the table at an art show, but usually my cards are held back behind the display. Quite often, school classes are brought to art shows on field trips, and two classes can wipe out a stack of fifty business cards. I love the kids, and I am more than willing to invite them to touch the sculptures and answer their questions. But for some reason, business cards are fair game to the kids to collect, but they are more hesitant about picking up flyers. If a child really loves the work, they may ask for a flyer, or I may just offer them one. (Warning, if you do, you may get asked for your autograph. Oh, well, I guess I am some sort of a celebrity to a twelve-year-old who loves horses.)

Having said all this, beautiful color flyers are truly impressive. The expense may well be worth it to you. And if I really like your work, I may ask you for

one at a show. Yes, I usually ask an artist if they have one to spare when I want one. I'd rather they save them for buyers if they are running short. (A full box back at the studio eight hundred miles away isn't much help when you forgot to replenish your supply to take to the show.) Even if I can't buy, I love to tack special ones to the wall of my studio office.

Photograph Albums, Brag Books, and Awards

You will have a photograph album of other works you have done or other patinas that have been done on your work. Of course, you will. It will include a photograph of everything so that even when you sell a piece at a show, you have a good picture in case it needs to be shown to someone else. My book pages used to be eight by ten; over the years, it has had to go down to two or more photos per page. I no longer carry photos of all my sold-out editions, just those that won awards. (I also have much-better photos than I used to have.) After thirty years, you will be making choices too. If you wish, you can even include a set of photographs that explains steps in the casting process. (Hey, never mind doing that, just keep a copy of this book handy!)

Collectors can shop your book; not only can they see your other work, but they can be impressed by the variety. I know that I have had many pieces I did for a special market that have not belonged at a Western art show. It is also where I can show the commissioned portraits I have done and some of the life-sized ones I am not going to haul around to shows. People order from this book since they can see on the table at the show the quality of my foundry work as well as the art itself.

A brag book, as I call it, can be a completely different type of volume. Here is where you can have all those newspaper articles, magazine articles, photographs of your award ceremonies, and the award certificates. (You are going to have them framed in your studio.) At first, you may have room for everything in one book, your printed matter and your art photos. Many artists have these books to give buyers confidence in their choice of art. I used to have some of these in my book, too, until I started to think that awards twenty years ago were kind of past their pull date. (Besides, I don't look like the person in the photos anymore, and I'd hate for buyers to think it was someone else.)

One note here, spend some money on the binders you use for your display books. And when they get tired, as they will, replace them with new ones. The one exception might be old leather binders that just look classier with age. (Yes, *real* leather!)

Those ribbons are hanging in my studio, though the silver plates got put away. I never remembered to keep them polished, and folks wondered what those big black disks were on the wall.

Some people are very impressed by the awards you have won. But only a few people have ever walked over to look closely at the ribbons. I have been grateful for winning all of them, but only I know which ones are the most impressive. They aren't necessarily the biggest, but they are the ones where I remember the competition at that show.

Winter Horse's Dream is one of my award-winning bronzes in past years. Yes, I am bragging, but hey, why not?

With Flags Flying has also won an award. Many other award-winning sculptures have already been used as examples in other places in this book.

When you are getting started, winning awards does make you seem like a good bet for collectors to buy. It means there are other people who are supposed to be good critics who have been impressed by one of your pieces. Many people who buy art really aren't certain that they know "good" art, especially as they are just beginning their collections. And these are the buyers who really look at your early work because for many of them, the prices of the established artists seem awfully high. But then, experienced collectors are also looking for "new" artists that they can discover. Awards will get their attention.

Many shows give awards to artwork in certain categories, such as those offered in the Western art show auctions, and the work in an artist's booth at the show is not judged at all.

Other groups and individuals also can be giving awards to that same group of art. For instance, at some art shows, not only are there awards for the best of each media but also a Best of Show, the Cattlemen's Association Award, the poster contest for the region's rodeo, a Wildlife Award (it has its own limits),

and so on. There are some really lovely long-time art collectors who also establish awards; some are memorial awards, and they are usually the ones who choose the winners themselves. Some awards include cash prizes as well as a visible ribbon. Cash is always nice. Some cash awards are worth a great deal of money. There are artists who submit works for auction just to have a chance to be considered for an award. Winning an award does not necessarily mean that the work will sell for a really good price, but it sure doesn't hurt.

Another award that can be of really long lasting value for an artist is a purchase award. If the artist is willing to have their work selected for consideration for this award, they agree to sell their art for the purchase award amount. It can be a fair price for that particular piece, but more than that, it will remain part of a special collection in a museum or exhibition site. Like a gift that keeps on giving, you will always have your painting or sculpture part of a special honored collection. I still hear from people who first saw my sculpture as part of a museum display and loved the piece.

Equus won a purchase award.

This particular show no longer exists, but it gave awards after the judges toured the entire show, every item in all the display booths were examined, all artists, all works. There were I think ten judges' awards each year, for works all three judges found superior. It was a massive undertaking for the three judges, but to my mind, if an artist got a piece selected, it *really* meant something. It was a top-quality show. (Yes, I did, several times.) I miss that show.

On the other hand, I have some pretty fancy ribbons I won at shows that were really very small, first-time shows that only included a few artists; and because I knew someone who was a really good salesman, I agreed to attend. On several occasions, I was the only true professional artist. That was many years ago. You can't tell by looking at just the ribbons. They are all pretty. And listing the awards on your artist's resume doesn't tell the details. (But again, established artists get asked to first-time shows and fund-raisers as a name draw for the public, and often attendance by the public is very light.)

A note here, be careful about saying bad things about art shows. If you know that it is a first-time show or a fund-raiser, don't have high expectations. Spend more time telling people what the promoters did right. You don't have to go back again. If there is outright misrepresentation of the show by the promoters, poor locations, no advertising, other vendors show imported craftwork, yes, tell the other artists. Actually, all you have to say is, "I don't think your work would do well there." Kiss-of-death commentary.

I can't speak for most of the really big media shows, some of the national sculpture, or painting exhibitions. I have never entered them. (Usually, I needed all my castings for display at the next scheduled art show, and they require the commitment of a piece over a long term.) Perhaps my career would have benefited greatly if I had entered them and been accepted for display. Not doing them has probably kept my name from recognition in wider circles than just Western art shows and galleries. Okay, I missed a good marketing opportunity here. You may want to do things differently than I did. And some of them have really good cash awards.

You have to make many decisions about self-promotion as you go along. My way worked for me. Many artists I have shown with over the years are now taking their work nationally, traveling to shows up and down the East Coast and in the major metropolitan cities there. Some of them are doing very well, with show profits far higher than some of mine. Personally, I am older and don't want to work that hard, and traveling that far is hard work. And it is expensive. I guess my point here is that you have options. You may not need to travel that far to find a certain amount of success and profit. How much do you want?

You don't need to make it in New York to make a living. But if you want to, go for it. I just can't help you much with those markets except to teach you what I know about doing the sculpture. And then there are some basic business policies I think are always important. At least, if you are living in that area, some of those national shows are a darn sight closer for you.

Your Home Office

Be smarter than I was. (That is one of the reasons you bought this book, right?) Start right with the business of your art. Your system does not matter as much as the fact that you have one. You will need to act on the assumption that you will make sales, and therefore you will need records. You will get show information and material sources.

Get a file cabinet. You need one place to keep your records organized. (I've bought plenty over the years at thrift stores.) I won't tell you just how many file cabinets I need now, though it would be a lot less if I would ever clean the files of out-of-date stuff.

I have a file for each show I do. When I schedule a show and need to make a show site hotel reservation, I staple the information to the outside of the file folder. That way, it is simple for me to check to see if it is done and what I did. You think this is too basic, and you'll remember? Just wait until you have a twelve-show roster each year, and you have done the show for several years, and they do sort of run together in your mind. Like I said, it works and keeps me sane. And some show promoters arrange special rates for their artists at the closest hotel, and you do want to call just as soon as you get the information; yes, I do mean the day it comes in! The only thing that stays on my bulletin board is the reminder to send in the balance of the show fee when it is due. So I do recommend a bulletin board too. It saves writing on the walls.

I have a file on each bronze I have. I do try to keep a record of each buyer and the patina on their bronze. Mostly it works when I get around to doing my filing. Before the computer, I used to keep the photos of the bronze there too. It would also be a good place for award sheets. (You will be winning some, right?)

I have files for shows I just might do someday, so I have contact information if I need it. I have files on sources for bases, foundries, and other materials. If it is in the file cabinet, I can find it. If it isn't, I'm in trouble.

It is also a place to keep the calendar of your show schedule, and you will find that noting when various shows occur can keep you from

overbooking or missing a show you wanted to enter. Yes, put on the calendar the deadline for entry forms and fees. I've missed show entries, and others I've been late to send. (But after twenty years, the organizers are pretty sure I am coming. I have made some last-minute panic calls to say the check was in the mail.) The twenty-year attendance is the only reason I have gotten away with it; the best shows have a waiting list of very eager artists. And some shows *really* mean it when they say entries must be on time. Yes, I have lost my spot in a few shows because I missed the date. (I keep the calendar *and* bulletin board!)

Keep your receipts for anything that might be deductible, and check with your accountant because sometimes really odd things are. My dry-cleaning bills for my show wardrobe are deductible for me. I really do live in jeans and sweats at home. At the end of the year, you can discard the receipts you can't use, but you can't deduct the ones you can't find. My accountant has set up a great system for me on my computer. Three years later, I still throw things in a big basket all year long and spent hours sorting them once a year. Computer or basket or whatever have one place and use it. At least if you can get those pesky little sales slips as far as your office, there is hope you'll find them.

If you have room for a desk, great. Try to find room. But the main thing is to have a place for your records and use it. When we built this house, I planned a tiny corner office room where I can have one chair and spin it around to face either the computer or the desk with shelves in reach for catalogs, computer manuals, office supplies, phone books, and my hard copy ledgers (which I still keep because I can never hit the wrong key on them). I also bought one of those marvelous cubbyhole shelf units so that I have a place for letterhead, certificates, various types of paper, envelopes, and extra invoices and mailing list cards. And heaven help anyone who takes stuff out of here. This is my business headquarters!

Being organized will enable you to keep your mind on your artwork instead of having to worry about things you can't find. This little corner is mine, and the family respects it. The less time you have to spend in your office means more time creating.

You may think this is not a problem for you at first, but if you stay with your career, you will end up with more than you can remember. After a while, you won't be able to recall the names of all those wonderful people who bought each piece or even how many of each piece has been cast. Plan on it.

Today, with the home office equipment available, with digital cameras, and home computers, many things are much easier, unbelievably so. State-

of-the-art electronics aren't necessary; my office is case in point. Now I don't know how I ever got along without them, even though they are years from being new. (Except, of course, for that digital camera to replace the missing one I still can't find!)

Your art is *your business*. If you want to *succeed, treat it as a business.*

Dear Aunt Gabby,

What do I say when my friends and family ask when I am going to get a real job?

<div align="right">Challenged</div>

Dear Challenged,

They finally gave up asking me that question. The real answer is when desperation outweighs satisfaction. But if you are treating it as a business as well as an avocation, they may come to feel better about it. And there had better be someone in your studio who treats it like a business, which it is. If it isn't a business, then it's a hobby; and sooner or later, you'll need a real job.

THE ART AND SCIENCE OF SELLING

Dear Aunt Gabby,

I sit at the art show for hours, but I see very few people who look like they have the money to buy my work. Where are all the qualified buyers?

<div align="right">Still Waiting</div>

Dear Still Waiting,

Right in front of you, dummy. The only qualification a buyer needs is a love for your artwork. The rest is just figuring out the accounting details. You wouldn't believe who has cash in their pockets, but you have been ignoring lots of them. But that is okay with me; they leave your booth at the show and come and buy from me. Are you just trying to impress the people who impress you? Really bad attitude, dude.

Respect the Public

Treat all your buyers with respect and consideration at all times. Like your buyers, enjoy them as people. Smile at them and be glad to see them. Talk to them and open a conversation first. I usually invite someone to touch my sculptures. Ask them if they like the way the piece feels, can they feel the animal's muscles? Most people are diffident about asking questions, and you need to make it as easy for them as possible. The longer they can enjoy your art, the more the desire to own it grows, and the more they will notice about the piece that they like.

Who are your potential buyers? *Anyone who stops to look at your work!*

And I do mean anyone. Buyers come in all ages. Buyers can look like they have money, and they can look like you need to give them a donation. Some people just really don't care how they dress, and that is their business. Your business is providing them with the artwork that they will love to live with. Your business is giving them the opportunity to see the work and the chance to own it and make the process as easy and comfortable for them as you can. Your business is not to make snap judgments about their appearance or even their mood. Some people are shy about talking with a "famous" artist. Some people don't realize they are frowning. Open the door to your work for them all.

So maybe this person can't afford your work. You are an artist. Did you do the work just to make money, or did you try to create something beautiful or something with a message you wanted to get out to people? Your work is reaching them; they have stopped to experience it closely. Share yourself and your art. Appreciate their appreciation. Make time just to enjoy their delight and talk with them.

You are not just selling your work for today; you are selling your work for the years ahead. I have had buyers stop by to see my work for ten years or more. And then one day, they have walked into the booth and said, "Now we can buy, and we want this one." They have wanted my art for ten years. They have gotten their last kid out of school, that second mortgage is paid off, they got an inheritance, they are now able to buy for whatever reason, and they know just where they want to come. And boy, am I glad to see them. Again.

Dear Aunt Gabby,

I can't sell my work. I do get into art shows, but no one wants to buy my work or even talk to me.

<div align="right">Shy and Discouraged</div>

Dear Shy and Discouraged,

I know. I tried just last week. First of all, it was hard to see you hidden behind your table in that low chair with your hair covering your eyes reading your book. It must have been a good story because you never once looked

up. I liked your work, I really did, but you didn't seem like you wanted to be bothered. Actually, the way you were dressed, I didn't think you were the artist. I thought you were maybe someone who had come down to unload the display. I'm sorry about that, you had some great stuff.

You are at the show to do something that a gallery usually can't do. You, the artist, are there for the buyer to meet and get to know. Artists spend so much time with other artists that they forget they are special people to nonartists. Many people are in awe of you and me. We do something they admire tremendously. Think celebrity. Okay, maybe in just a small way, but the touch of it is there. (There are people out there who hesitate to call me with a question about a bronze they like because they don't want to be a bother. Hey, I am trying to sell these things. Call me!) So don't wait for someone to speak to you. Go ahead, start a conversation.

Let them get to know you. They are buying you along with the artwork. It means even more to them as a work of art because they have actually met and talked with the artist. In effect, you become their artist. They will show their purchases to their friends with pride and tell them about you. (They may even bring you some friends of theirs as potential customers.) The more they know about you as a person, the more the work will mean to them. You will get to know some wonderful people this way, and you may even make a lifelong friend every once in a while.

There are customers you will wish you could see more often as friends. I know artists who stay with friends while at shows who started as collectors of their art. (I have had to turn down invitations to be a guest because for me, after a day at a show, I am just not good company for anyone—ask my husband. I am exhausted.)

You will be surprised who will follow your career with a great deal of interest. After all, they discovered you while you were getting started. Your successes just reinforce their taste in finding an artist with your potential. Their support and delight in your growth as an artist will mean a lot to you over the years.

It does mean a great deal when people arrive at a show and come directly to find you before they even look at anything else on display. Not only are they glad to see you, the person, but they also want to see what you have brought because they hope to find something of yours to add to their collection, before they spend money on anyone else's art. I talked to an artist just last week who sent out mailers for the first time. Her collectors

came straight to her booth, and she sold three originals immediately. The first hours of the show. (And believe me, I know where she was located in the show, and those folks had to pass by some fantastic art to get to her display!)

If you have opened a conversation with a possible buyer, it is easier to bring up the various ways you offer to make it easier to purchase your art. Do you offer a layaway program?

Do you give someone an opportunity to reserve an edition number for a purchase option? (I have taken a token payment to hold a sculpture number for a future purchase, say after income tax refunds arrive or a home is sold.) It is easier to find a way to facilitate a purchase if you and your customer are on a comfortable basis.

I believe that my buyers know what they can afford. My bronzes are expensive, even with my price structure. I try not to hard sell, but I do look for possible solutions that will make it easier for someone to load one of my works in their car. (There are many books to teach the art of selling anything, from the system of getting a buyer to say yes to questions, etc. Consider checking out some of those ideas especially to learn the art of closing a sale.)

I am willing to help make suggestions about possible locations for the bronze; some of them are great as outdoor sculptures, or I know some collectors have placed a certain one on a hearth. Some work so well from all sides; they do well in the center of a dining room table. I have several bronzes that are made to be put with plants in an entry. There are times when a buyer just needs a fresh idea to justify the purchase of a piece they love.

Dear Aunt Gabby,

People ask the dumbest questions about my work. How do I deal with so much stupidity? They know so little; they aren't going to buy it.

<div align="right">Arrogant Artist</div>

Dear Arrogant Artist,

Who are you calling stupid, stupid? They are showing interest in your work. If you assume they won't buy, I can guarantee you are right. Look at it this

way, if they don't know anything about bronze, then for darn sure they don't already have a house full and no room for another sculpture. One collector of mine opened our first conversation with, "Why do these things cost so much?" So I explained why. Another visitor asked four artists at one show why our work cost so much when she had a three-foot Remington bronze that she only paid $800 for in her family room. She must have gotten the same answers from all of us; she left the show carrying a rather more expensive bronze to her car.

**

Ah yes. The customer known in the trade as a "be-back." As in "I'll be back!" Some artists consider those people to have mastered the act of vanishing forever. And often, they have. I believe that they intended to return, but first of all, an artist has a ton of competition at a show. People do find other work. Or their wife or husband does. Or life happens. One be-back did call me to apologize, but she got a phone call from her daughter that night announcing her engagement and impending marriage. And all the available funds got committed elsewhere. Immediately!

Let me tell you a be-back story. It was many years ago. A couple came into my display and fell in love with the bust of a horse. They spent quite a bit of time talking to me about the piece and then left, saying, "We'll be back." An hour later, they were, for more discussion. They decided to talk it over at lunch. Two hours later, they came back and spent quite a while talking about the sculpture. They left again. They did return again, talked some more, and, again, left. By this time, we had no expectations anymore of ever making the sale. I was pretty sure we had talked about everything we could where the bronze was concerned.

They did come back. They ended up planning how they could take out half their front closet to make a lighted niche that would show the sculpture at its best in their entry way. They bought it. Twenty years later, these people have more of my work, paintings and bronzes, than I do. At last count, I think the total was nineteen works of art of mine. And a rare friendship that I treasure.

Some people don't smile very easily. That doesn't necessarily mean they don't like your work. One collector of mine rarely smiles, and I am never sure how much he likes a piece. But I have seen him literally guard a sculpture until he can pick it up from a show display to keep other people from even seeing it. (Some shows have special purchase arrangements.) When he can finally pick it up and take it to his car, his smile is flat marvelous.

There are a few buyers who just don't want to talk. They just want to look and experience the art for themselves. You will learn, just let them be. It doesn't mean they aren't buyers; just politely let them alone. If they do have a question, they will ask. Sometimes the only question they ask is if you take Visa.

Dear Aunt Gabby,

When I'm in the display booth, people walk right by me to talk to my husband about my work. How do I handle that?

<div align="right">Invisible</div>

Dear Invisible,

First of all, teach your husband how to sell your work. Then have him politely introduce you to the prospective buyer. Be gracious. (Name tags are also invisible, didn't you know?) Loudly clearing your throat is bad form.

Show Clothing ... Your Image

"This is a joke, right? She is going to tell me how to dress?"

Okay, you may not have any problem with the way you present yourself to the public, but I am writing this book for any and all artists; and believe me, many of you don't know the obvious. I see the mistakes some people make unknowingly, and I am writing for those folks. Over the years, I have seen it all.

You Are Selling Yourself Along With Your Art

I have seen artists spend hours making certain that their display and work look as fantastic as they can make it and forget to look in the mirror.

As long as you are meeting the public and doing the selling, you are part of the picture. Yes, there are those artists who like the look of just leaving the studio, their clothes are covered with paint, they market that distracted, just put the brush down, and "totally involved with creation"

appearance. "The artist is too busy for such mundane considerations as appearance" costume. It may work for you. And it must work for some artists; they do it so well. It goes hand in hand with the arrogant "selling is not important; I am the creator, and you are lucky to be able to even see my work" attitude.

Me, I couldn't do it with a straight face. I have to sell to keep going as an artist, and I am honest enough to admit it. Besides, does anyone really buy that attitude, or are they just entertained by the theater?

A gentleman who once wrote a very successful book on selling advised that artists dress like artists. Done well, it can be a lot of fun.

Artists are considered by many to be an odd group of people. (Yes, there are many negative aspects attributed to us too. We are supposed to be a wild group; we have no regular job or hours. The old "bohemian" tag still exists in many people's minds.)

Well, we can get by with a certain amount of costuming. Artists don't have to dress like our buyers, who hopefully have regular well-paying jobs that make lots to money to spend on art collections. There is also a certain amount of romance in being an artist. We live a fantasy life to many people, we work for ourselves, we work our own hours, and we do what we want unregulated by an office clock. (If they only knew the gritty reality. We still have housekeeping chores, we raise kids and go to PTA meetings and get the car to the repair shop, do taxes and bookkeeping, and still somehow find the time to let our spirit flow into creativity.) If flowing hand-painted clothing and cloaks are your thing, and you are comfortable in them, fine. Whatever. You will find what works for you and your market.

This same costuming aspect does free us from having to be in the most current fashion of clothing. Since we are expected to be different, we can be. In many walks of life, people will make judgments about success based on the way a person is dressed. We don't have to be stylish, which can be a very good thing when we would rather spend money at the foundry rather than at Nordstrom's.

To a degree, most of this clothing discussion is about the problems women can have. A man can get by with a much-more basic wardrobe. In my world of Western art, the casual look of jeans and a shirt, not even Western cut, works just fine. Although I do remember one gentleman who was very successful who dressed with a Wild West look of flowing fringes everywhere, bright scarves, and fancy boots. I think he just loved that type of clothing, but it was a trademark for him. It did make him memorable in a group of other very good sculptors. A cowboy artist can dress just like a

working cowboy would (in the morning before he goes out to the barn), and buyers feel like he must be working from his experiences.

I have clothes just like his, but somehow I don't feel like it would have the same effect. With me, it would just look like I forgot to pack my suitcase.

People Do Judge Your Appearance

You are spending time reading this book to learn how to be a successful artist who can sell their work. Your appearance on the sales floor can make a difference, and you don't want to miss anything that will help sell.

Pay attention to the way you look. Basic hygiene, take a shower and wash your hair. Clean clothes, not just the top T-shirt in your drawer. You are not just dressing to please yourself; you want to be someone people are comfortable talking with. You might even consider the color and fabric you wear. Does it distract from the art? Or does it add to the overall picture you are trying to present? Do you have tattoos that might be offensive to some buyers? Wear long sleeves, for heaven's sake.

There is a line between being yourself and making a personal statement and *selling* your art. Which do you want to do? Perhaps it shouldn't matter, but it does. That T-shirt with your favorite message or cause printed on it. Again, are you at the show to make a socially important statement or sell your artwork? Do as you wish, but just be aware that you can affect how potential buyers respond to you.

I am sure you can find some compromise with what you like and what works on the sales floor. Yes, you need to be comfortable. Hard concrete floors for a twelve-hour show day are a pain, a real pain. Back, legs, feet. If you have the money to spend, spend it on good shoes. My favorite fancy cowboy boots have never been to an art show. I'd be biting someone before lunch. (Yes, I have finished some days barefooted, without apology to anyone.)

Pay attention over time to how people respond to you each day. Consider just what you were wearing on the good days.

Some artists are very superstitious. If they have a very good sales day, they will wear their "lucky" outfit until it falls apart. Or they may never wear again an outfit that was worn on a day they felt like they were invisible to possible buyers. Lucky or unlucky, it may have more to do with the sales appeal of the outfit. (I'll admit it, usually red is a good color for me to wear, but I have one red dress I might as well give to Goodwill; the

show was such a disaster I will *never* wear it again.) I didn't say I wasn't superstitious, did I? And then there is that one silver bear necklace I wear at least once every show.

Back thirty years ago when I was young, I had a special look for the shows. The kids were young, I was a single parent, and food was more important than fashion. I could sew, somewhat. I wore long full skirts. I mean really full skirts with lots of petticoats but with a more historical look; think *Gone With the Wind* meets Calamity Jane. (Yes, I know just who she really was.) Six yards of inexpensive fabric and a lace-up homemade leather vest. Really sweeping skirts, seven-year-old little girls loved me. I had fun with it. It must have worked somehow; I am still in the business. But also back then, I did paint lots of unicorns, too, which I am still living down. (But they were lovely unicorns.)

Now, I wear the ranch look. It is comfortable for me, and I enjoy the silver and turquoise jewelry. No, not the "buckle bunny" look. I am too old for that, being over sixty. (Although I must admit I travel to the shows with two busted-up old bull riders, so maybe I am the world's oldest buckle bunny, still goin' down the road.) I can and do wear Native American style beadwork some show days. Here again, I don't try to stay in fashion. For one reason, I don't like a lot of the current look.

Back to thrift stores, one more time. I have and do find much of my wardrobe in places like those. (We also check out nearly every Western wear store we pass while on the road for sales, which also means with my two guys, I have to have room for extra hat and boot boxes we acquire on the way.) My point is, there are lots of sources for show clothing. I must admit I also find much of my work clothing at thrift stores too. In my life, studio and barn clothes have a short life, so why buy new just to destroy them.

When in doubt, at least be well groomed. My people with money to spend are also people who respond better to a nicely dressed, clean and tidy salesperson. And make no mistake, in your display you may be the artist, but you are also the salesperson. Act like successful salespeople do.

OTHER STUFF

Resource Collection, References

If you are going to do realism, know your subject. There will be, guaranteed, some viewer who *will* be an expert. If you are going to do historical subjects, do your research. (You will find people who will disagree with you, but at least you will have a source to quote back at them!) If you are going to do Western work or rodeo subjects, for instance, if you haven't thrown the rope yourself, better get yourself a cowboy.

Knowledgeable people are a great resource, even after you have done your book research. And people are always glad to help critique your work. Those who know what's what are often aggravated by inaccuracies. It is good to get things fixed before they are cast in bronze. And it doesn't hurt to have several critics. Hunters are quite often very good at pointing out things in wildlife work you may have missed. (Well, they may have skinned out quite a few critters.)

We have an extensive library of books that reflect our varied interests. Rooms of books. I paid full price for few of them. I have shelves of videos I have picked up all over, from National Park Visitor Center gift stores to garage sales. If I even think I might use a material, I'll buy it at a garage sale or thrift store. I have not only found the most amazing books in a stack on a driveway, but some classic sculpture books at Goodwill. I even found one priceless volume at our local waste site where they have a covered unit for people to drop off usable stuff. It was in a big bag of old computer manuals, the very volume on horse packing I needed for the pack train bronze I was doing. Many of these books are out of print, and the only way to find them is luck or online. Mainly luck.

Start files of tear sheets. Old magazines and articles can be great research material right at hand. But tear out the best stuff, put it in a file, if you really want to be able to find it. Boxes of magazines just end up staying in boxes. If you want wolves, you'll end up grabbing the file. Spend a day or several just tearing out stuff and filing it. (I recommend starting in the middle of the living room floor and building piles, then toss a file folder

on each pile, and you are ready to go.) It is hard to throw away a whole box of *National Wildlife* if someone offers you one, but if you don't tear out the stuff you need, you'll never get to use it.

It doesn't matter if you are needing source material from a book or tear sheets from periodicals; they do you no good if you can't find what you need. Organize the pictures in files, organize your books in shelves, but keep them both in your studio area. The same for your video material. And have that old small TV with a tape player there too. (As more people go to disc players, VHS tapes are being discarded everywhere.) Having said that, between my husband's and my collections, we have books in shelves all over the place.

Some artists keep actual items for reference. And I have seen museum-quality collections on a studio wall. (It also adds an impressive note when potential buyers stop in.) I have had quite a bit of antique Western gear in mine at one point. But then I know a historical reenactor who makes a new set of buckskin clothing each year, complete with beadwork and fur trim, uses it all season to give it authenticity, and then sells it for a big price to an artist or collector. I have had gear donated to me that I treasure.

Perhaps some folks would consider a lot of this stuff old junk, and when it starts encroaching onto your work surfaces, maybe you have enough or at least need to get organized. It is part of an artist's life for many of us and priceless in its way.

Dear Aunt Gabby,

Why is there so much bad sculpture? Don't people know what an animal looks like?

Art Critic

Dear Art Critic,

In answer to your second question, mostly, no. But those sculptures look like what they think an animal looks like. Your first question, well, people buy what they like; if it gives them pleasure, then it isn't bad art to them.

For me, money is well spent on anatomy books. If you are going to do animals, get it right. My videos show me how an animal moves, how the muscles bunch and flow. I may run a few minutes of film over and over, and I can slow the motion and study it. It is the same for the way human figures move. Know your skeletons. I have the half-size human skeleton in my work area. Talk to your doctor. Many drug companies give doctors free charts of muscles and bones for their examination rooms. Your doctor may have older ones or spare ones he or she will let you have. I don't need to know the names of the bones to form them correctly. I do have some found animal skulls from hiking trips. It helps to be able to actually run your hands over the shapes.

Cougar Leaving took hours of video research in the way cougars move.

The Herd Bull was checked by several of our successful hunter friends for accuracy. They are a very critical audience.

It is wonderful to be able to study creatures live and in their natural world. If you can, I hope you will. Zoos and wildlife collections are a

great source of your own photograph material. Here again, computers are wonderful and make taking lots of photos much less expensive. I used to have to get prints of rolls of film just to get copies of the relatively few usable images. It does make it easier to understand just how much footage a wildlife photographer has to take to get those priceless moments on your videos.

Yes, you can go to libraries for information, but I have found out that when I am in the middle of a project and need to know something, I want it now! But then for me, a trip to town can take quite some time. And it usually means I have to change out of my work clothes so that I don't look like a bag lady.

Just a note here. I have also grabbed time to check out a gallery that has indicated an interest in my work when I have been wearing work clothes (that were still clean, but several degrees beyond just casual). And found myself totally invisible to the gallery staff on the floor. Well, I am country raised, and this is still a country town. I can guarantee to those folks in the gallery that not everyone who can buy art is going to look like it. I didn't expect to be greeted with rejoicing, but it would have been nice to at least have been acknowledged to exist. The gallery didn't get my work. When they take the time to train their people properly, then we might talk again. I am pretty sure they'll never sell to that rancher who owns half the county north of town when he stopped in to kill some time while his tractor part was being welded. He was there, in their door, but don't expect him back either.

Schools and Workshops

A very long time ago, when I was looking at the possibility of really getting involved again with my art, I asked the one professional artist that I knew where I should consider going to school or get lessons from someone. His advise, "Just get started, and when you need to learn something specific, find someone to teach that certain thing. But in the meantime, develop your own style of work, not pick up someone else's. If you start with a teacher, you will always be that person's student."

His words made sense. Plus the fact that I probably could not afford any formal classes at that time of my life. All you need to get started is either a pencil or in the case of sculpture, a lump of clay (and this book, hopefully). I don't want to see you sitting at a table in front of me while I show you what to do. Bring me your work in progress when you have

a problem, and we will discuss it. Call me with a question (okay, e-mail), but I don't want to tell you just exactly how and what to do.

There are some of you who are not comfortable with this approach. You would like to have rather more guidance. You may need the dedicated time that a class or workshop gives you. Or you may have come to realize the specific information you need and want the workshop that advertises it will help you with that. Sign up and take the workshop. You will know from his or her work the skills and knowledge the instructor has. They can help you get going or help you improve your skills.

There are some wonderful workshops that let you immerse yourself in a three-day or weeklong sculpture or painting experience with similar artists without distraction. If they are what you want, I hope you can afford to take the opportunity. But before you do, I hope that you have taken the time to experience working with the media involved so that you aren't starting from ground zero and have some goals about what you want to learn.

I once taught a workshop to a group of horse people who wanted to try sculpting a horse. I provided all the materials and tools and taught them how to handle them. These were people who trained horses, who showed horses, and who worked with them on a daily basis. You know who finished teaching the course? A horse.

They could judge a horse's confirmation, but they couldn't build one from scratch. We were outside on the lawn of a gallery in the mountains; the neighbor had a retired police horse who had seen it all in his day. The instructor spent his day in the shade of a tree while artists crawled all around and over him, with lots of pets and handling and the occasional treat. Yes, we discussed anatomy, but it was the hands on that actually did it.

It is wonderful to be able to work from life. I know artists who have a pen for a subject inside their studio. Live human models are easier to work with, and I hope you can get people to act as models for you when you need them too.

I cannot speak from experience about art schools, but the best are hard to beat. Again, there is a commitment of time and money here. You will get an art education far beyond what I can give you. If the emphasis is on the commercial aspects of art, well, some of the very best artists I know started as commercial artists and had a thorough background in all the skills needed. They also had an absolute professional approach to their work. We are looking at a serious time commitment here; you won't achieve mastery in a day or a year. But you will come out with a level of ability that few others will have.

It has been my experience that most university and college art programs won't give you that skill level. There are probably many that do, but most of them I know, don't. Make certain that you research just how effective their art department is, and how many students can go on with professional careers without additional schooling. After all, a student is required to pass many classes that aren't about art to get a bachelor's degree. They aren't specialized art schools. There are some superb instructors there, really incredible people, who do their best in the time available with their students. I have met some of them, and I admire them tremendously.

In the case of bronze sculpting, those schools lucky enough to have a foundry rarely have state-of-the-art casting equipment. There just isn't room in the art department budget to fund it, a commercial fine-art foundry works nonstop to keep itself solvent. Every hour of foundry time has to be efficient. Most universities give a student an introduction to the lost wax-casting process, and that is usually all the time available. There are so many medias to be introduced to the student. If you have attended a school like this and found that you love lost wax casting, at least you have a good idea of what is involved. But be prepared for a bit different reality in the commercial world.

Then there are the classical art school programs. Many artists have been accepted into Italian sculpture schools over the years, and from what I have seen, those students learn to *sculpt*. It also takes years and years. And money. For me, that sort of thing ranks right up there with having a chance to ride a classically schooled top-level dressage horse. The stuff of dreams. Even if I ever got the opportunity, I probably couldn't handle it, either one. Neither is going to happen to me now. (And that's okay. I am happy just where I am, with what I can do, and the great mule I ride.) But if you are on fire, investigate the possibilities. Some of my readers have the potential to be great artists. I can only hope God gives you the chance to be what you can be.

Family Affairs

Nearly all of us have families that will be affected by our choice of career. Often it is our parents' generation who will not consider it to be a *real job*. On the other hand, some of us have families who think development of our talent is the greatest thing in the world and are incredibly supportive. There are parents who think not using our abilities is practically criminal.

Parents aren't always the best critics, bless them. I don't know how many times, at a mall show in particular, I have overheard a parent telling a young person, "See, you can do that well! You ought to be doing this!" (If you were that child, don't be embarrassed, My mother used to say the same thing, and look what happened to me.) But I knew I wasn't that good yet. But given the choice of being a bit mortified and having a parent who stood solidly behind me all these years, or having the type of parent who kept challenging me about a *real job*, no contest. My mother did recommend that I at least learn to type so I could support myself in a pinch if things went critical. Well, if I hadn't learned to type, you wouldn't be reading this book.

Once my mother retired, she traveled with me to shows, kept books, worked the computer and mailing lists for me, and folded and stamped an unbelievable number of mailers over the years. She also got any painting and bronze she ever wanted for her art collection. She always said she thoroughly enjoyed herself the whole time. I hope she knew just how incredibly grateful I was.

My husband travels with me, loads and unloads the van, talks to customers, brings me new ideas for show displays, and keeps a truly amazing amount of coffee brewed when I am working on a piece. He helps in any way that he can. (During the writing of this volume, he has also done most of the cooking and laundry too.) He is no good at keeping records or bookkeeping; most people aren't. He handles phone calls with buyers when I am working, and they love talking with him. He takes visitors through the studio gallery and loads them down with produce from our vegetable garden in the summer. He enjoys them, and they know it. He runs errands in town and picks up my supplies and takes in shipping. He thinks I am a great artist. I have no complaints whatsoever.

My daughter worked with me for years, too, until her own family required her time. She had professional experience working in a high-quality gallery, as well as a degree in fine art, and has taught me a great deal. She is also a fantastic salesperson, who not only has sold my work well, but also the work of many other artists at shows. Those other artists want her back. They miss her as much as I do.

I know many artists who have husbands or wives who stand behind them all the way. Many of them are the business managers for their spouses. It can be the best of all worlds. These teams are the most effective. If it is possible, they travel together and enjoy the trip, as well as providing the very best emotional support. They should never feel out of place because

they aren't an "artist" at the shows. I can guarantee that every other artist understands just how priceless they are and envies the lucky artist married to a person like that. My family members have made many good friends at the shows. Of course, they have also found artwork they just have to have too. From other artists. (I have run out of wall space at home, but we love our collection.)

Just because a spouse is not at the shows does not mean they aren't handling the business at home, and running the ranch, while the artist is on the road. This is especially true while children are young. Older children quite often attend the shows; they must be taught proper show behavior so that they aren't a detriment to you or to your neighbors. And do make plans for their entertainment at least for part of the day, have someone return them to the hotel for TV or video, their meals need to be more regular than yours, and the show hours will most likely last past their bedtimes. Tired, hungry, and cranky youngsters can become a problem for everybody set up around you. Remember, you do have a responsibility to the other artists at a show all the time. But many artists occasionally take their kids out of school for a few days for a special show, and it is surprising how young a person can become a salesperson or at least keep watch on a booth while an artist takes a break.

My daughter started booth minding and even selling for me and other artists at about the age of twelve. (Of course, while she was booth sitting, other adult artists were keeping an eye on her to make certain she had no problems. This works in a high visibility exhibition hall or open-plan shopping mall arrangement.) They paid her for her hours, either with money or artwork. Maybe that is how the addiction to art began. Polite young people can be very charming to potential buyers. Here again, if your child is representing you, she or he should have a professional appearance, be dressed cleanly and neatly. They will take the job more seriously and be taken more seriously by visitors to your display. And they will be more likely to have other artists wanting their time. And yes, when she did help make a sale for me, she was a commissioned employee, though her commission was not necessarily cash. She was in truth my partner in the family business. Like I mentioned before, there are artists who really would rather see her at a show than me; she has sold a lot of other artist's works.

I spent my early career as a single mother. Many of the shows required that I arrange adult supervision at home while I was gone. There were many single friends who were agreeable to stay at my home with my daughter for a few days. Once she was old enough, most people may

not have thought she needed supervision, but I did not believe that she should be left to manage on her own even after she was in high school. Since we had livestock, someone had to be there for feedings. Otherwise, she could have stayed with one of her friend's family for four or five days. (This isn't easy to do when you have a young family, but it can be done. Blood families and extended families are priceless.) I can only wish that you have the best wishes of your family group as I did.

And I still have the ranch to run even when I am gone on the road today. Okay, it is a small ranch, but there are horses, mules, house pets, and poultry to consider, and it is also a good idea to have a caretaker who at least checks out the home interior twice a day. I have come home to a damaged plumbing for instance. It is one reason I no longer have any milking livestock to be handled. It is easy to find someone to pick up eggs and feed, but good milkers are hard to find in most places. (I know, I have had to do it for friends who couldn't find anyone else.) (I did teach a couple of teenagers to milk for me way back when, but they were family members who I could bribe and coerce. Besides, like my husband, I really hope I never have to milk a cow again.)

When your family members work with you, you will have to accept that people do things in different ways. You will have to understand this, and as long as the job gets done okay, don't complain. You can't fire them. But they can quit on you. Be reasonable. (I am sure my family members can't believe that I am writing this!) There are many ways to do the same thing that work. Yes, it has taken me years to learn this, so I am giving you a heads-up now. It doesn't matter how the van is loaded as long as everything gets on board, and nothing is damaged. If you want something done precisely a certain way, you may have to do it yourself. My crew has learned that once the stuff is in a pile at the show, I do it my way. How it gets there is their job. I have learned to keep my mouth shut, except to say a heartfelt thank-you. (And this is important!) Even your family does not *have* to work for you. So love them if they will.

We have a great extended family, related more by love than blood. Over the years, as family members' schedules have permitted, they have been on the road with me. From time to time, people have referred to my "entourage." Partly because nearly all of them will jump at the chance to see some of these art shows, and often just because I can no longer travel alone to do the shows, I usually come as a group. They share driving, set up, and selling. I pay expenses in exchange for their help, and sometimes a commission on sales they help make. It makes the trips more fun to have

good friends along, but they do come along as working members of the show staff. They know this is my business and respect it as such. I owe them a great deal of thanks. The key here is that they are working staff. It may be vacation going and coming, but at the show, it is a business trip. You may consider working this way, especially if family obligations or job requirements keep your immediate family at home. Many artists do this.

Having another salesperson in your booth does one important thing, it does give you that third-person validation. You, as the artist, can say this is my best work, and I am very pleased and proud of it. Another salesperson can say, "This work is *great*." Since the buyer likes it, one assumes the artist likes it; and now here is the third person who is in effect saying, "Yes, you have good taste, you understand good art, and you have made a wise choice." This is the critical thing a gallery salesperson can do, and with that salesperson in your booth, you have the same benefits.

What Is Bronze?

If you check the encyclopedia, bronze covers a broad range of copper alloys. All are mainly copper; most have tin as the major additive. If you add traces of other elements, it will change the characteristics of the metal, and much research has been done to create today the very best alloy for art castings.

We use art grade bronze for our sculptures. There is silicone in nearly all art grade bronze; sometimes you will hear a piece of art described as a silicone bronze casting. There are several commercial formulas that most foundries use. Everdure and Herculoy are two that have been used by foundries that have cast my work. They are made to pour cleanly, and weld easily, and yet are soft enough to tool, and they will bend quite a bit without breaking. (Yes, I know there are correct metallurgical terms for this.)

When we were doing our own studio pours years ago, we learned that some trace elements can be lost in the melting process over time. When this happens, you can get a metal that nearly defies grinding. Scrap bronze can be added to a pour, but we did learn not to add too much. Right now, the price of art grade bronze has increased tremendously as the cost of copper has risen.

I am often asked the difference between bronze and brass. Brass is copper and zinc.

TWO DEAD SHEEP

What kind of a chapter heading is this? Bear with me. This part is about commitment to your work.

When I left high school, I felt that I was pretty much leaving my art behind to get on with the business of making a living. I knew no one who was a professional fine artist, just art teachers and a few commercial artists working in advertising. Neither really interested me as a career. My university courses headed more into biology, once I got the rest of the requirements behind me. My art was only a hobby that I really had no time to pursue. I regretted it, but it was right up there with selling my horse and the other things I loved but had to leave behind at that point in my life.

Life happens. And one day, about fifteen years later, I had a space of time and energy to start drawing again. It felt incredibly good and right. I finally realized that something very important had been missing, and it was time to do some serious thinking about where I wanted to go. I came to the conclusion that though I didn't know how good an artist I could be, I needed to find out what kind of an artist I was and could become.

No matter what.

Okay, I wasn't going to let my family starve or abuse them with deprivation or in any way abandon my responsibilities to them. But within the parameters possible, I was going to find out what I could do. There would be some costs and some risks; there are in any self-employment endeavor. This time, I would keep that commitment to my art. I had to know, and I had to give myself the chance to learn and grow as far as I could. (You can sublimate a need just so far with craft projects and home décor.)

Risky business here.

I knew I had a long way to grow before I would be good enough to make a living at it. I had to devote the time to learning. Yes, I found places to sell what I could do as I developed my skills. And as my skills grew, so did the available markets and the income.

The word is "commitment."

The other word is "determination."

More than talent, more than sales ability, more than luck, artists make it because they are determined enough. There will be bad shows, falling markets, negative input and emotional blackmail, and other attempts to bring you down. And make no mistake, you will have some miserable days, weeks, even months. There will be many out there who will discourage you and be critical of your efforts. There will be periods of financial problems; the sales just won't be there. You will make trade-offs. And there will be some things that you will end up doing without.

Name a business start-up that doesn't have problems. You are not only starting a business, but you are developing your talents and abilities. Through all the hassle, you are trying to grow as an artist. Those that are determined enough stand a pretty darn good chance to succeed. If you don't have the determination to stick it and work through it, you won't. No matter how talented you are.

I have seen so many tremendous artists leave the scene. Hopefully, they are selling their work in galleries. They aren't at the shows anymore. They had talent that left me in awe.

My family stood behind me. They ate a lot of hamburger and very little steak. If the kids wanted soda pop, they bought it. They had a pretty good idea of just how our finances stood.

Which brings us to the two dead sheep.

Some days even the hamburger got pretty light in the hamburger mixes and the pasta got more plentiful. We had some interesting recipes. Then we were offered a three-year-old ram and a two-year-old ewe. (Knowing our sympathies, they would have died of old age on the place if they had arrived still kicking, and I had no money to feed even more mouths.) They had to go; the guy was going to slaughter them, and we were being offered meat. Well, for the family, I was willing to try. They were skinned and cleaned, just in two big pieces.

I am not a farm-raised woman. I had never been faced with anything larger than a roasting hen. But I took the best of the knives and gave it my best efforts. To say that these had been well-fed animals is not quite covering the situation. I figure it came out to 60 percent tallow and 30 percent meat. (Bones, of course.) We ended up with chunks of white stuff with threads of meat here and there.

And we tried to figure out ways to eat it. We tried everything. Every way we could think of. At the very best, even over our outdoor fire pit, there wasn't enough barbecue sauce in the world to cut the tallow that

remained on the roof of our mouths. The best thing we could say is that it filled the freezer. But we ate it.

This was one of the lowest points in the last thirty or so years. You will most likely have yours.

Expect hard times. Personally, I recommend you decline the sheep and go for the mac and cheese right off the get-go.

You will learn how to be a better business person as well as an artist. You will make mistakes and learn from them. I hope this book will help you avoid some of them or at least be ready for them when you make them. Stay on course. Find ways to remember your determination and keep it healthy.

For me, I used to come back from poor shows with the attitude of, "I am going to be so damn good they can't ignore me!" It has worked for me.

It has been an incredible journey and a wonderful life. I sometimes can't believe how fortunate I have been. I do what I love, I work with people I love (that includes the wonderful people who enjoy my work), I live where I love, and I live the way I love to live. I don't have to punch a time clock, but I work for myself, and the hours some days go far beyond what I could give to an office. I work hard. I answer to no one but myself, but then I have no one else to blame if things don't work out. I wouldn't have it any other way.

Good luck, and God bless you.

Walk in beauty.

HOW I GOT STARTED SCULPTING

Thirty years ago, I was a working professional painter. At one show, I was set up next to a bronze sculptor who fell in love with a painting I had on display. She had her own small casting outfit set up in her home, an artist's budget, and an offer. She handed me a lump of victory brown wax and offered to exchange casting whatever I made for the painting. Her instructions included that no part of it could be more than an inch thick, it had to be only this wax, and could not have any armature at all.

She did direct casting. Working small, the actual wax original could be the casting wax, the one melted out in the burnout process. Since there was no silicone mold made, it would be a one-of-a-kind solid bronze. Her words were, "Try it, you'll like it." I did. I have the original little unicorn I made. It is crude, the details aren't sharp, and the critter's confirmation makes me shudder today, but I did like doing it. A lot. She also introduced me to a man in the area who had started a foundry in his garage, working alone, who was casting for a few other artists to support his own sculpting habit. This actually happens a lot.

I got a larger amount of wax from him and completed my first half life-size horsehead. (What else?) I think I cast two, sold one. I keep it around, if nothing else it reminds me of the very best I could do then. *Everyone has to start somewhere.* What can I say, it has ears, eyes, and nose roughly in the right places, but it actually looks like a Disney cartoon on steroids. I painted better than that; in fact, I never drew a horse that bad.

Sculpting uses a different part of your brain. I know fine sculptors that can't draw a map. I can't explain why, though there must be scientific reasons. I can't explain why I am ambidextrous when I sculpt and can hardly eat with my left hand.

Now you have the sum of the instruction I was given when I started. It has been a thirty-year learning and experimenting process most of the way. I had no money to invest in workshops or equipment. I didn't even know where to get things. Trust me, everything is easier to locate these

days. I fought learning to use the computer, so I couldn't use the computer for doing photos and flyers, my mailing list addresses, and labels. Now I do, and I constantly use it as a source for all the information we can now find on the Internet about materials and shows. Of course, there are a lot more bronze sculptors out there, the medias are better, there are more good foundries, and many more art collectors who want to live with bronzes. Communities want more public art, so more "monumental' works are being commissioned. General art catalogs carry more tools and materials to meet the market.

But in those days, it really was garage sales and thrift stores. And no, melting down candle ends did not give me a good sculpting media; yes, I tried that too. I knew nothing about armatures and had ones that inconveniently came apart and destroyed my work. Originals that melted when left in the wrong places or came apart on the trip to the foundry.

Several artists and I started our own small castings foundry. We called the place The Studio and set up in my daylight basement, and no, my insurance company never knew. Our largest castings were no more than eight inches high, and we rapidly learned we were only capable of doing one-piece bronzes; welding was beyond us. Our electric melting pot held five pounds of bronze; burn out was done in an old Olympic pottery kiln. We turned out hundreds of tiny figures that we sold at craft fairs for gas and groceries and kept going while we all pursued our fine-art careers. So much credit goes to my kids and their friends, who would help tool the tiny waxes in their spare time, help us set up and run the booths at the fairs, and in so many ways help support my career. In retrospect, I don't recommend this road to anyone, but it worked for us at the time. The main thing that it did was to give me an appreciation of some of the hassles of foundry work, oh yes, and to keep us fed.

I was still painting and doing serious shows and bigger sculptures. And at one of them, I met the original owner of Valley Bronze Foundry in Joseph, Oregon, Glenn Anderson. A relationship started that lasted for years. The people there taught me how to create originals suitable for lost wax casting. The people in the wax room, the mold room, the metal room took the time to show me what can cause problems in casting, and how to design my work to avoid them. I owe them a very large part of my success, and I thank them from the bottom of my heart. There are closer foundries now to where I live; the road trip to Joseph from here is not good much of the year, and I am not as gutsy a driver as I once was. But I do miss so many of my friends from Valley Bronze; their castings are top quality, their

patinas fantastic. Parks Bronze in Enterprise, Oregon, also did many fine castings for me during the years I could make that long trip to the Wallowa Valley. I miss my friends there too.

I am known mainly in the world of Western art. Most of that market values a certain realism in sculpture and painting. Even there, buyers have become more open to impressionistic artwork, newer medias, and fresh approaches. It has all been very good to me over the years. Western artists are an incredibly generous group of people, networking methods of art and marketing. And they support and encourage each other. I owe hundreds of people for where I am today. And then there are the buyers, the art collectors, and those who can only afford one painting or sculpture. The rest I owe to them. They bought my work thirty years ago, and they still buy today. I love the ones who for years kept saying someday and ten or fifteen or twenty years walked up and said, "Now I can." For all those years, they came to shows and loved and admired the work, and their support emotionally kept me going too. You may choose not to sell your work or just sell through an agent or galleries, but getting to know the people has been one of the best parts of the trip.

I remember the year when I sat down and did a rough total of sales to date and realized that I had sold over a million dollars worth of my art. Now I realize that a million doesn't buy what it used to do, and that was gross sales, not net profit. But individuals had reached into their pockets and pulled out a million dollars for *my* work, and it impressed the heck out of me. That is an awful lot of "I really like your work!" It is also an awesome amount of work to have completed as an artist. I thank all of you.

I have written this book to make your trip much smoother and easier than mine was. I hope you understand ahead of time some of the problems and frustrations so that you are ready to deal with them. I have tried to save you from some of my more expensive mistakes. I just hope you have even half the fun that I have had.

I am including a brief set of photographs of the foundry process at the end of this book that I hope you will copy if you wish. They may be of help to you in explaining the foundry process to your customers. (I've always meant to do a set for my own use with visitors to my display, but as you now know, matters got out of hand and became a whole book. Oh, well.)

ARTISTS MENTIONED IN THE BOOK

Gabe Gabel
232 Cowboy Way Sagle, Idaho 83860
1-208-265-9613
www.gabegabel.com
(Please feel free to contact me directly to order copies of this book. Thank you.)

John X. Geis
Route 1, Box 81-A, Grangeville, Idaho 83530

Jurgen Hasbro
Yucca Creations Studio
3544 Westfield Fort Worth, Texas 76133
817-923-4040 hasbronc@charter.net

Terry Lee terryleeart.com

Kim Shaklee www.kimshaklee.com
14599 Picadilly Road, Brighton, Colorado 80603
303-654-1219 kim@kimshaklee.com

Bonnie Shields, the "Tennessee Mule Artist"
230 Gold Creek Road, Sandpoint, Idaho 83864

Tim Sullivan
2306 Highwood Drive, Missoula, Montana 59803

Michael N. Westergard
529 Sunnyside Avenue, Plentywood, Montana 59254

SHOW ORGANIZERS

These are some of the people I work with currently.

Trace Eubanks
Peppertree Art Show www.peppertreeartshow.com

Joella Oldfield
Celebration of Western Art www.fredoldfieldcenter.org

Mike and Joyce Oswald
Western Reflections Fine Art Show
Westernreflectionsart.com

Don Walsdorf
Spokane Art Show artshows.net

Randy and Paula Wilkerson
Texas Indian Market
Colorado Indian Market
www.indianmarket.net

FOUNDRIES

Cire Perdue Castings, Inc.
10142 N. Taryne Street, Hayden, Idaho 83835
1-208-762-7475

Parks Bronze
331 Gold Course Road, Enterprise, Oregon 97828
1-541-4264595
E-mail: parksbrnz@eoni.com

Valley Bronze of Oregon
P.O. Box 669, 307 West Alder Street, Joseph, Oregon 97846
1 541 4327551 www.valleybronze.com

INDEX TO SCULPTURES

About a 50/50 Chance ... 59
All Around ... 92
And Then the SOBs Took Out the Whole Damn Corral 154
Arabesque .. 116
Arabesque variation ... 116
Bear Foots .. 62
Bear Foots in the gold ... 142
Bear in Mind ... 63
Born Ornery .. 67
Calls the Buffalo Dream ... 93
Chiaro and Scuro ... 87
Cougar Leaving .. 238
Daughter of the Land ... 79
Dream of Wolf Medicine .. 211
Equus .. 222
Estella del Agua .. 80
Foundation Blood .. 19
Good Example (wax original) ... 43
His and Her High Spirits (wax originals) 23
Jack Horner and Meredith Hodges ... 52
Little Brother ... 84
Majesty ... 28
Moose ... 216
Old Wolf Remembers ... 64
One to Dream On ... 212
Parade .. 75
Pirouette ... 89
Regal, a Friesian .. 29
She's the Circle of Life .. 158
She's the Circle of Life (wax original) .. 22
Showin' Promise .. 91

259

Something Magic	115
Sonrisa	81
Spanish	88
Spooked	210
The Bear	62
The Blanket Gun	94
The Entertainer: On Her Own	57
The Good Neighbor	90
The Guardian	65
The Herd Bull	239
The Hunter	82
The Long Road Home	156
The Messenger	58
The New Blanket	143
The Power and the Glory	117
The Power and the Glory variation	118
The Prized One	73
The Wolves of Winter	60
To Dream	86
To Live Free	69
Trouble Bruin	57
Waltz Time	113
Watchful Eyes	63
Winter Horse's Dream	220
With Flags Flying	221

QUICK PHOTO REFERENCE TO CASTING PROCESS

INDEX

A

About a 50/50 Chance 59
advertisements 213
after-sale tips 198
All Around 92
And Then the Sob's Took Out the Whole Damn Corral 154
Appaloosas 29
appearance 234
Arabesque 116
Arabian horses 28
armature 18
articles 214
artist's proofs 156
art bronze 60
art galleries 159
art grade bronze 246
art shows 168, 170

B

Bayeti Inkinyama 121
Bear, The 62
Bear Foots 62, 142
Bear in Mind 63
beeswax 14
Blanket Gun, The 94
blended materials 14
Born Ornery 67
Boss Lady, The 155
brag book 219
brass 246
bronze 13, 59, 142, 246
 caring for 146
business materials 217

C

Calls the Buffalo Dream 93
castability 61
casting process 104
casting wax 110
ceramic mold 124
Charlie 29
Chiaro and Scuro 87
classic ferric 145
cold cast bronze 148
color 27
commitment 247
computer, importance of 199
contract 161
Cougar Leaving 238
craft shows 170

D

Daughter of the Land 79, 110
determination 247
displays and booth requirements 182
Dream of Wolf Medicine 211
drying time 40

E

edition size 151
enlargements 44
Entertainer: On Her Own, The 57
Equus 222
Estella del Agua 80
exhibitions 170

F

family affairs 242
Foundation Blood 19
foundry 96
 working with 95
foundry proof 157
fountains 77

G

Good Example 24, 43, 104, 106, 112, 120, 127, 138, 145, 146
Good Neighbor, The 90
Grandee 139
Guardian, The 65

H

hazards 39
Herd Bull, The 239
His and Her High Spirits 23
His High Spirits 113
Hodges, Meredith 44
home office 224
horse art 28
horse breed
 Appaloosas 29
 Arabian horses 28
 Morgans 29
 Quarter Horses 29
hot water bath 16
Hunter, The 82

I

image 232
indoor craft shows 175
insurance 181
interviews 214
invitational art shows 177

L

last-minute changes 41
legal issues 157
Lipizzaner horse 88
Little Brother 84, 209

Long Road Home, The 156

M

mailing lists 201
Majesty 28
maquette 44
marketing 149
Messenger, The 58
metal room 138
mold 13, 100, 105
money handling 194
monument 44
Moose 216
Morgans 29
Mudgy 122
multiple sizes 44, 155
Mustang 139

N

newspaper release 214
New Blanket, The 143

O

oil clay 14
Old Wolf Remembers 64
One to Dream On 212
options 21
outdoor sculptures 77

P

Parade 75, 107, 119, 139
partial casts 155
patina 84
patination 142
pet invoice 196
photograph album 219
photoreactive 85, 96
Pirouette 89
Plastalina 14
point-ups 44
polychrome 92
pouring room 128
Power and the Glory, The 117
Prized One, The 73, 128

Q

Quarter Horses 29

R

recast 147
Regal, a Friesian 29
rejection 163
Renaissance Fair 151
resource collection 236
respect 227
running horses 28

S

schools 240
Sculpey 14
sculpting materials 13
sculpture
 About a 50/50 Chance 59
 All Around 92
 And Then the Sob's Took Out the Whole Damn Corral 154
 Arabesque 116
 Bear, The 62
 Bear Foots 62, 142
 Bear in Mind 63
 Blanket Gun, The 94
 Born Ornery 67
 Calls the Buffalo Dream 93
 Chiaro and Scuro 87
 composition 56
 Cougar Leaving 238
 Daughter of the Land 79, 110
 design 56
 Dream of Wolf Medicine 211
 Entertainer: On Her Own, The 57
 Equus 222
 Estella del Agua 80
 Foundation Blood 19
 Good Example 24, 43, 104, 106, 112, 120, 127, 138, 145, 146
 Good Neighbor, The 90
 Guardian, The 65
 Herd Bull, The 239
 His and Her High Spirits 23
 Hunter, The 82
 Little Brother 84, 209
 Long Road Home, The 156
 Majesty 28
 Messenger, The 58
 Moose 216
 New Blanket, The 143
 Old Wolf Remembers 64
 One to Dream On 212
 Parade 75, 107, 119, 139
 Pirouette 89
 Power and the Glory, The 117
 Prized One, The 73, 128
 Regal, a Friesian 29
 She's the Circle of Life 22, 158
 Showin' Promise 91
 Something Magic 115
 Sonrisa 81
 Spanish 88
 Spooked 210
 To Dream 86
 To Live Free 69
 Trouble Bruin 57
 Waltz Time 113
 Watchful Eyes 63
 Winter Horse's Dream 220
 With Flags Flying 221
 Wolves of Winter, The 60
sculpture pricing 152
self-promotion 199
selling, art and science of 227
She's the Circle of Life 22, 158
Shields, Bonnie 44
shopping mall shows 175
Showin' Promise 91
show manners 171
Six-eight Time 113
softening media 17
Something Magic 115
Sonrisa 81
Spanish 88
Spooked 210
studio gallery 165
surface finishing 38

T

tools and materials 32, *See also* sculpting materials
To Dream 86
To Live Free 69
Trouble Bruin 57

V

vanity pricing 152, *See also* sculpture pricing
View of the Valley, A 76

W

Waltz Time 113
Warmblood 29
Watchful Eyes 63
wax
 flash point of 16
 melting temperature of 16
Web sites 216
Winter Horse's Dream 220
With Flags Flying 221
*Wolves of Winter, The*S 60
workshops 240